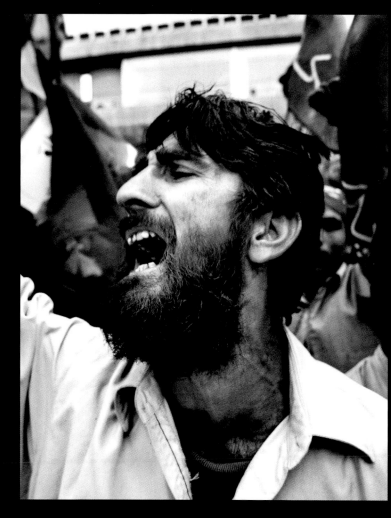

PROTEST!

Sixty-five Years of Rebellion in Photographs

Introduction by JOHN SIMPSON

ANDRE
DEUTSCH

Executive Editor: Gemma Maclagan
Picture Manager: Steve Behan
Art Editor and designer: Russell Knowles
Chapter opener text: Thomas Cussans
Additional editorial: Stella Caldwell, Catherine
Rubinstein and Victoria Marshallsay
Production: Maria Petalidou

Front cover: Alex Majoli/Magnum Photos

Back cover: Top: Paul Mattsson/Photolibrary.com
Bottom right: John Dominis/Time & Life Pictures/
Getty Images **Bottom left:** Jean Louis Atlan/
Sygma/Corbis Images

THIS IS AN ANDRE DEUTSCH BOOK
Text and Design © Andre Deutsch 2011
Introduction © John Simpson 2011

This edition published in 2011 by Andre Deutsch

A division of the Carlton Publishing Group
20 Mortimer Street
London
W1T 3JW

Printed in Dubai

A CIP catalogue for this book is available from the British
Library

ISBN: 978-0-233-00344-3

Contents

Introduction

As we move further away from the calamitous twentieth century, day by day, a clearer picture of it is starting to emerge. We can see now that the first half of the century, convulsed by Europe's terrible and protracted civil wars, was taken up with the culmination and slow suicide of imperialism. The second half was indelibly marked by the results. The wars and revolutions since 1945, dozens of them, have had their roots in the break-up of the great empires that started then – not just Western Europe's empires, from the 1950s to the 1970s, but also the Russian empire in the early 1990s.

In the first half of the twentieth century, autocracies and dictatorships spoke in the name of the masses, manipulating them, giving them their slogans. But in the second half of the century there was an intense reaction. Protest became the engine of political change. Sometimes, delayed by effective secret police forces and public fear, it moved slowly. However, a decade into the twenty-first century the process has even reached the Arab countries, with their active systems of spies and informers. The key realization is that people can come out onto the streets and challenge the state, and survive. They haven't always been successful, of course; a government determined enough to stay in power can shoot the demonstrators down and win the confrontation – at least temporarily. But

the odds have shifted. Success is more likely, statistically, to be with the protestors than with the state.

Only the Chinese empire, taking in large numbers of often-unwilling non-Han people, has survived – so far. Yet China is full of political contradictions. The basic force behind its state control is still Marxism-Leninism, with a police system that reaches down to street-level and tries to ensure that everyone obeys the orthodoxies. Yet its extraordinarily successful economic liberalism is increasingly bound to collide with that. It is hard to think that the Chinese Communist Party can stand out indefinitely against the dominant principle of the last 65 years.

No other autocracy has ever managed to turn itself into a genuine democracy and remain in power. Maybe China will remain untouched by the demand for personal and political freedom that this book celebrates; but I very much doubt it. After all, we saw one exercise of that demand, in Tiananmen Square in 1989. At some point, sooner or later, photographers as brave and enterprising as those whose work appears in this book will surely be out on the streets in Beijing and Shanghai and Lhasa, watching a new revolution unfolding.

Is it possible to discern a single, identifiable principle that has been in operation across the world ever since the end of the Second World War? With all the necessary caveats, the answer seems to be yes. Human beings, whatever their

state of economic and political advancement, seem to want the right to run their own lives. From the Dutch East Indies and Burma at the end of the Second World War, to Vietnam from the 1950s to the 1970s, right across the continent of Africa to South Africa in 1994, to statelets like the component parts of the former Yugoslavia, and through to oddities like Greenland and the Channel Islands, the principle seems to apply. Sometimes it merges with politics, sometimes with ethnicity, sometimes just with a basic desire for justice. The American Civil Rights Movement and the fight for equal rights in Northern Ireland have clearly been part of it. So has the dissident movement in the old Soviet Union, in today's China and in countries like Aung San Suu Kyi's Burma.

At times it has been ugly and violent. The colonial powers and their successors struck back with atrocities: one thinks of the French in Algeria, the British in Kenya during the Mau Mau uprising, or the indiscriminate massacres and the use of Agent Orange by the Americans in Vietnam and Southeast Asia. Often the uprisings were marked by a primitive violence on the part of the insurgents: the burning alive of Dutch women and children during the struggle for Indonesia, the murder of a Catholic Belfast housewife who cradled the head of a dying British soldier, the torture of Croats by Serbs and Serbs by Croats. Incidents like these were used by the opposing sides to justify their continuing fight, but in spite of everything the basic line has flowed on:

that fundamental desire we seem to have as a species to run our own lives. Now we can look back and see how far we have come. It hasn't necessarily been a pleasant process, but it has succeeded in large parts of the world.

This book traces the long path, sometimes dangerous, often tragic and only very occasionally glorious, that we have followed. The photographs of many of the key moments are small monuments to the courage and skill of a legendary group of men and women. The job of the press photographer, from the greatest and most famous of them to the bog-standard snapper, has never been safe or easy. Photographers are easy targets – the first people to be hit by police truncheons or the rocks of demonstrators. Television cameramen often have a support system of producers and correspondents, and a big organization to protect them; photographers, friendless and alone in the world, have nothing but their courage and their native cunning.

Sadly, their industry is in decline. These are days of falling circulations, of dying newspapers and magazines, of citizen journalists putting pictures directly onto the internet. The glamorous figure of the snapper in a torn jeans jacket with a canvas bag slung over one shoulder and two thousand pounds' worth of lens hanging from the other, is becoming increasingly endangered. In this way, too, ordinary people are demanding a say in their own affairs. They want to take their own pictures, do their own reporting of their struggle, be as free of foreign experts as they want to be of their home-grown tormentors.

In another 65 years, the job of the press photographer and the foreign correspondent may perhaps be as dead as Ernie Pyle and James Cameron. But their glory will never fade, because it was they – and especially the photographers – who showed the entire world the reality of the things they saw, unflinchingly. Take that sequence of pictures from the Hungarian Revolution in 1956, for instance, when John Sadovy captured the final instants in the lives of a bunch of secret policemen, executed by the insurgents. Ever since I first saw those pictures, I have been haunted by them. The men and women from the AVH, the Hungarian version of the KGB, were vicious; they beat, tortured and killed. Yet when you look at John Sadovy's pictures, that isn't what you see; you are watching the deaths of human beings exactly like yourself. You feel the impact and pain of the bullets, just as though they were being fired at you.

It has been my extraordinary luck to watch while some of the pictures that appear on these pages were taken. I say that, not in any spirit of boasting or self-glorification, but in homage to the men and women who captured them, since I know that I would never have the raw courage to stand out and get precisely the right picture at the key moment, after all the waiting and frustration. I saw the bare-chested Chinese student challenge the elements in Tiananmen Square. I watched as people ripped the Communist insignia from the Romanian flags, and pulled down the statues of the *ancien régime* in half-a-dozen Soviet-bloc cities. I saw the exultant crowds in Tahrir Square in Cairo. But it needed a photographer to catch the exact moment, the precise image, which will never fade.

The television cameramen I was with bravely filmed the same images. But a video sequence never quite has the impact, the punch in the gut, that a single excellent photograph can have. Nowadays we habitually use the word "iconic" to refer to everything from a starlet to a bar of chocolate, but the most famous images of struggle and protest from the past 65 years are genuinely iconic. They sum up in themselves everything that is important about the entire subject; and by looking at them again and again, by having them on the wall of our office or sitting-room, or in books like this one, they perform the precise function of an icon, wrapping us in awe and understanding.

This is a deeply rich, entirely unforgettable account of protest from seven decades of peace and war, and as such it is an unparalleled document illustrating the principle that has created our world. But for my money it's more than that. It's a monument to three generations of press photographers: the bravest, most persistent, most irritating, most impressive journalists of all. And it's the single best monument they would want.

John Simpson, Bir al-Jenam, Western Libya. June 2011.

Revolution and Uprising

Revolution and Uprising

If authoritarian government, the stifling of dissent and systematic oppression are the common denominators that provoke nearly all revolts and uprisings, from 1945 to the collapse of the Soviet Union in 1991 the single most consistent cause of such unrest was the Cold War. The ideological chasm it represented – capitalist West opposed to Communist, Soviet-dominated East – saw both camps attempting to outflank and destabilize the other by means of a network of client states, above all in the Third World. In Latin America, the Far East and much of Africa and the Middle East, the Soviet Union persistently sought to foment revolt. Meanwhile, the Western powers, America above all, energetically attempted to buttress authoritarian regimes whose principal virtue in Western eyes was little more than their opposition to communism. That these regions were almost invariably among the poorest in the world merely added to the resulting misery and instability.

Europe itself, prime focus of the Cold War, was hardly spared. Here the Soviet Union had the advantage of having already established itself across Central and Eastern Europe, with territories liberated as the Nazis were repulsed and then converted into Soviet puppet states. Grimly repressive regimes were established in Poland, East Germany (sundered from its Western, capitalist partner), Czechoslovakia, Hungary, Bulgaria, Romania and, for a time, Yugoslavia. Tensions sparked into outright revolt first in East Germany in June 1953, when a spontaneous uprising in East Berlin was put down by Soviet troops, who killed an estimated 500 demonstrators (sources vary greatly on this:

information was not easily obtainable at the time). Much the same was true in Hungary in the autumn of 1956, albeit on a much larger scale, when for over two weeks a state close to outright war existed. This uprising was also crushed by Soviet military might, with a death toll close to 3,000 Hungarians, many members of hastily improvised militias. A more peaceful but in the end similarly unsuccessful attempt to end Soviet domination occurred in Czechoslovakia in 1968, the so-called Prague Spring. It, too, was summarily halted in August that year with the appearance of Soviet tanks, backed by Polish, Germany, Hungarian and Romanian troops. In all three cases, Soviet domination was significantly boosted.

More than a decade later, events in Poland, (where in June 1956 massive anti-Communist demonstrations in Poznan had been violently suppressed) provided the first eventual chink in the otherwise monolithic Soviet empire in Europe. The trade union Solidarity, formed in August 1980 in the ship-building city of Gdansk, almost instantly became the focus of Polish resistance to Communist rule. At its peak, it had almost 10 million members. Faced with popular resistance on this scale and despite declaring martial law (in part to ward off Soviet military intervention), by the mid-1980s the Polish government had little option but to recognize Solidarity. By now, urged by its youthful leader, Mikhail Gorbachev, the Soviet Union itself was creaking toward reform. Gorbachev's goal was not to end communism. Rather, he wanted to overhaul the Soviet bloc's sclerotic economies and reduce the crippling cost of military expenditure. Additionally, seeing the Soviets' European client states as a drain

rather than an asset, he encouraged them to embrace reform themselves. The consequence, by the autumn of 1989, was the disintegration of Communist rule. When the Berlin Wall, the most obvious symbol of Communist oppression, was breached on 9 November, over half-a-million demonstrators were there to witness it. The defiant declaration by Erich Honecker, hardline head of the East German Communist Party, that "the future belongs to socialism" was brutally disproved. As the Soviet states collapsed, only Romania, ruled almost as a personal fiefdom by the sinister Nicolae Ceauşescu, resisted this wave of liberalization. On 21 December, attempting to placate a 100,000 strong crowd in the capital, Bucharest, he was howled down. His incomprehension was total. On Christmas Day, he and his equally alarming wife, Elena, were tried and executed. It was a potent demonstration of the power of popular protest.

In Latin America, the power of the masses to make as well as unmake regimes was highlighted in October 1945 when Juan Perón was released from captivity and launched on the road to power in Argentina by popular acclaim. Perón embodied much of the turbulent political climate of twentieth-century South America, a region of stark inequalities long prey to the ambitions of strong men or *caudillos*. His populist championing of the country's dispossessed – the *descamisados* or "shirtless" – tended only to reinforce the country's endemic instability. As elsewhere in South America, the country would subsequently veer between a variety of more or less repressive regimes successively boosted or opposed by mass demonstrations.

Cold War imperatives obtruded more obviously in the Cuban Revolution of 1959, in which a similarly authoritarian right-wing government was overthrown in a Communist takeover spearheaded by Fidel Castro and actively supported by the Soviet Union. It brought to the fore, too, the Argentinian-born Che Guevara, who became in effect a professional revolutionary. Guevara, whatever his later romantic image as socialist martyr, was a chilling figure, entirely loyal to Moscow and wholly hostile to America. The cold-blooded execution of his rivals was a precise measure of his glinting fervour. Nonetheless, during what amounted almost to a world tour in 1964–65 – which included visits to New York, Moscow, Egypt and much of sub-Saharan Africa – he was hailed almost everywhere he went. The radical-chic icon of student protestors throughout the West had emerged. His significance in the promotion of an anti-capitalist revolutionary ethos extended well beyond student bedroom walls. In fact his image has now come to epitomize protest. During the 2011 Egyptian revolution, a poster of Che could even be seen in Tahrir Square, held aloft by one of the anti-Mubarak demonstrators.

The Soviet Union was hardly less busy in destabilizing Europe's newly independent colonies worldwide. Not that the West helped itself. France in particular, desperate to reassert its military might, launched a series of unwinnable colonial wars that came close to tearing it apart. Humiliated in the defence of its far Eastern colonies, it was brought to its knees in its attempts to sustain its rule in Algeria. The more brutally it sought to reassert itself, the

more violent the reaction it provoked. Mass disobedience in the streets of Algiers turned out to be more than even French President Charles de Gaulle could command. France was forced to back down.

North Africa and the Middle East have been among the most turbulent regions of the world, politically repressive, scarred by obvious inequalities, subjected to an increasingly militant Islam and destabilized by the Arab–Israeli conflict. Against a background of simmering discontent and in spite of repeated peace initiatives, in December 1987 violent clashes developed in the Israeli-occupied Gaza Strip and West Bank, the first Intifada uprising. It is a pattern of rebellion that has never ceased. Inter-Arab tensions have remained constant, too. The overthrow of the Shah of Iran in January 1979 saw one authoritarian regime replaced by an equally intolerant Islamic republic, which never hesitated to imprison and execute its opponents, and encouraged violent Islamic fundamentalist movements across the Arab world, in turn prompting their equally brutal suppression. As many as 20,000 Islamic opponents of the Syrian regime headed by Hafez al-Assad were slaughtered in the city of Hama in 1982.

It was tyranny of this sort that lay behind the immense protests that began to sweep the Arab region late in 2010, initially in Tunisia. Hailed as a movement of mass protest of the kind that had swept aside the Soviet bloc, an Arab Spring or Arab Awakening, its long-term effects remained a matter of conjecture; would it lead the region to something akin to modern Western-style democracy, or subside into just another instance

of endemic instability in the Arab world, likely to bring more upheaval and eventual oppression? The involvement of Western nations in what soon became outright civil war in Libya, for example, may have done little more than make the world's most dangerous region more unstable still. The protestors in Egypt at least could, however, claim to have forced the resignation of President Mubarak in February 2011, news greeted with an "explosion of emotion" by the hundreds of thousands thronging the streets of Cairo. Whether an orderly transition to sustainable democracy would follow remained to be seen.

Soviet communism may formally have ended in 1991, but its legacy has proved deep-rooted. The presidential elections in the Ukraine in late 2004 were so blatantly rigged in favour of the incumbent Viktor Yanukovych that they prompted a massive campaign of civil disobedience – the Orange Revolution – leading to Yanukovych's subsequent defeat in new elections. Russia itself has embraced democracy only half-heartedly.

Meanwhile the world's remaining Communist superpower, China, for all its aggressive pursuit of capitalist enterprise, remains firmly oppressive. Its ruthless suppression of the Tiananmen Square protests in June 1989, in which troops fired indiscriminately at student protestors, killing unknown hundreds and possibly thousands, starkly underlined its determination to stamp out dissent. As in Burma, which since 1962 has languished under one of the most repressive socialist regimes in the world, no less than in Communist North Korea – a totalitarian one-party state since 1953 – oppression is a constant of daily life.

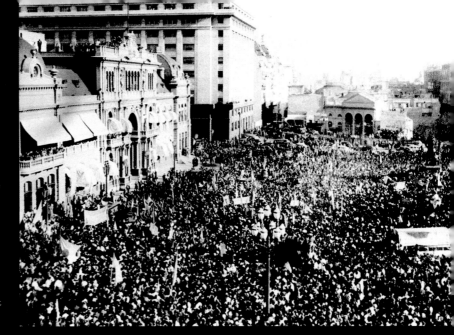

Right: 17 October 1945, Plaza Mayor, Buenos Aires, Argentina. A crowd of 20,000–30,000 gather in front of the government palace, calling for the release of former Vice-President Juan Perón. Photographer unknown

Below: 1953, East Berlin, Germany. The city's inhabitants riot against Soviet occupation. Photographer unknown

Opposite: 17 June 1953, Leipziger Platz, East Berlin, Germany. Demonstrators hurl stones at Soviet tanks. Growing unrest in East Germany erupted when around 50,000 East Berliners openly revolted against Communist rule. The Russian military moved in to quell the uprising. Photographer unknown

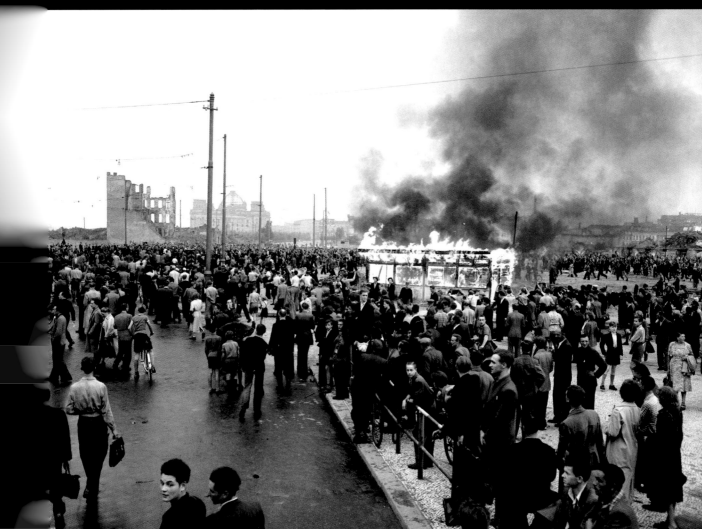

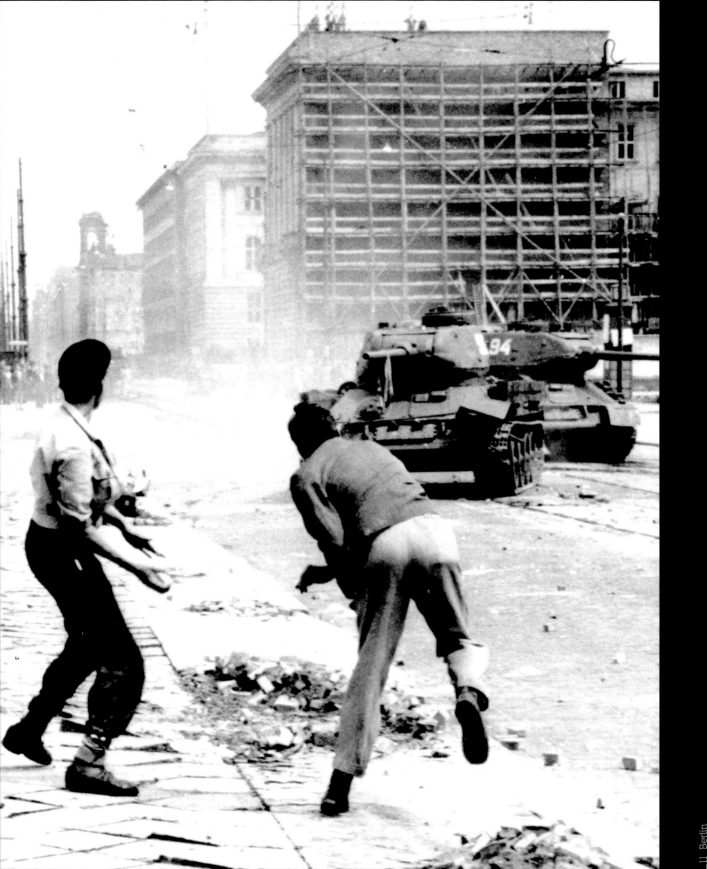

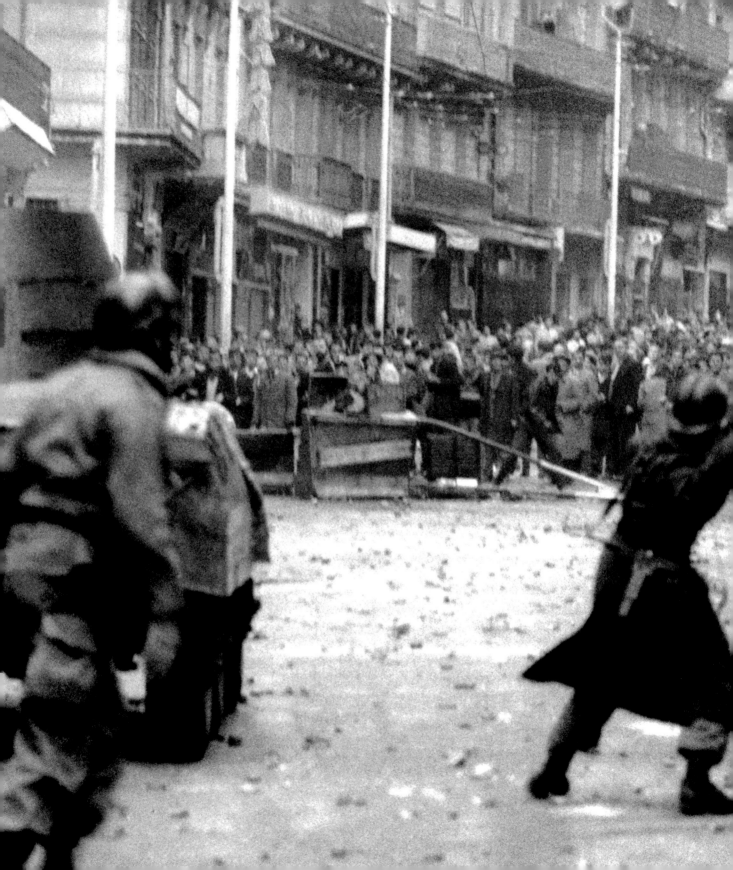

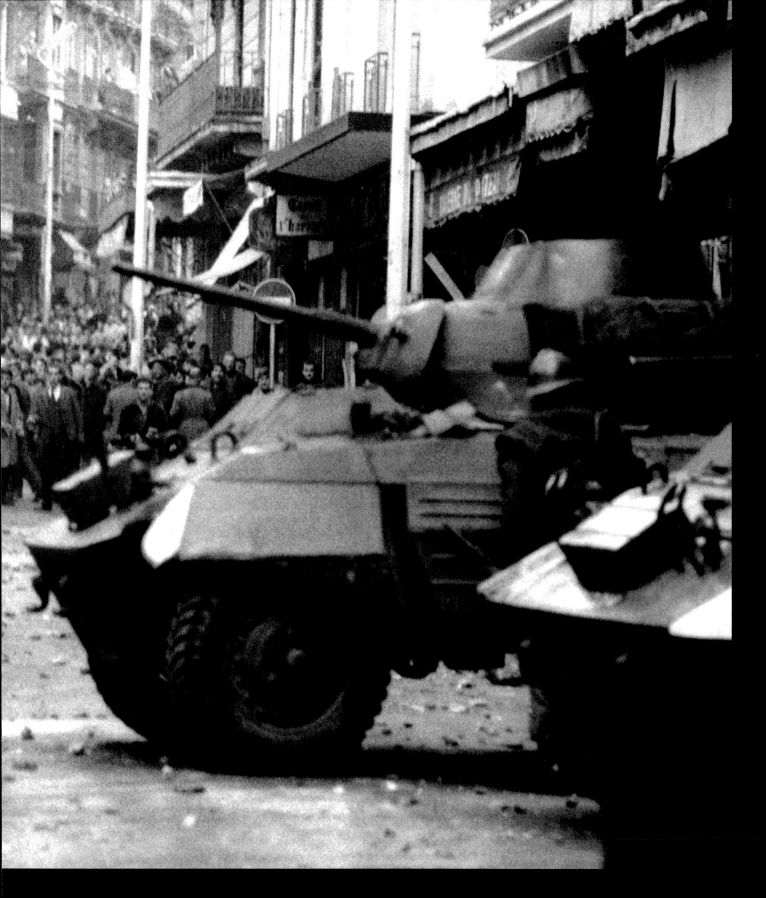

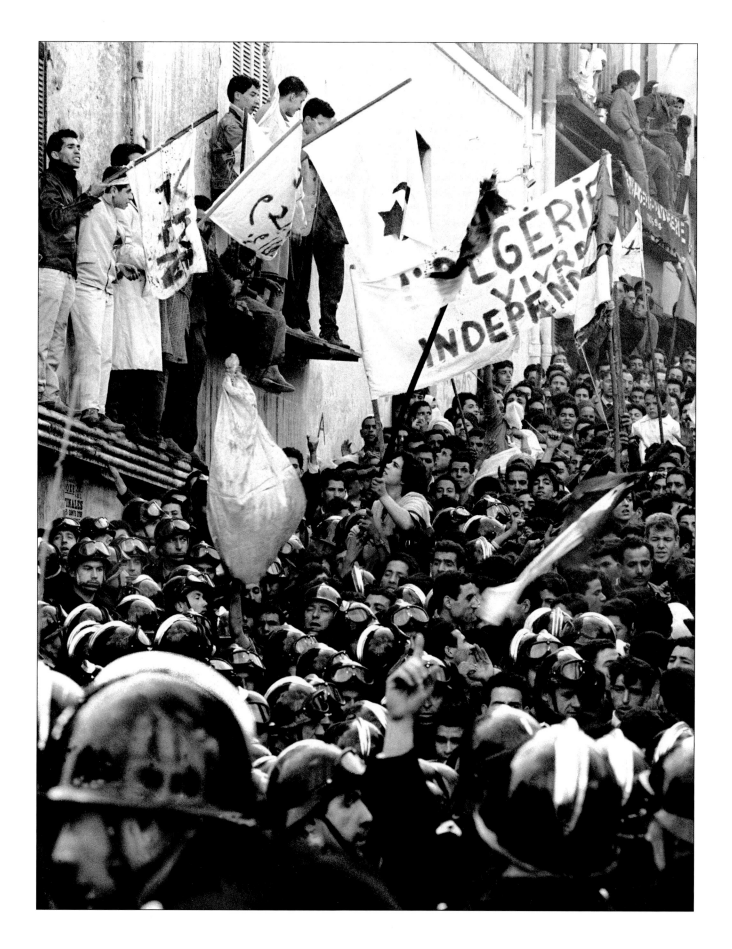

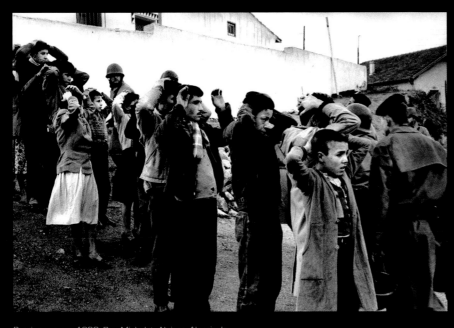
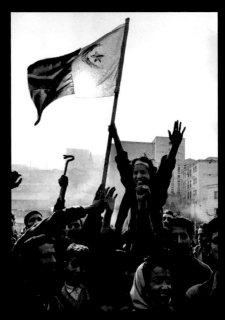

Previous pages: 1960, Rue Michelet, Algiers, Algeria. In the main street of the city, French *gardes mobiles* try to halt demonstrators opposing a peace deal with France. Nicolas Tikhomiroff

Left: 12 December 1960, Belcourt, Algiers, Algeria. Security policemen try to control a demonstration demanding Algerian independence during a visit by French President Charles de Gaulle. Photographer unknown

Above: 11 December 1960, Clos Salembier, Algiers, Algeria. French soldiers round up young Algerians for interrogation after an anti-French demonstration on the occasion of Charles de Gaulle's visit. Nicolas Tikhomiroff

Above right: 1960, Clos Salembier, Algiers, Algeria. On a Sunday afternoon, the National Liberation Front flag is waved in public for the first time – although the demonstration was soon broken up. Nicolas Tikhomiroff

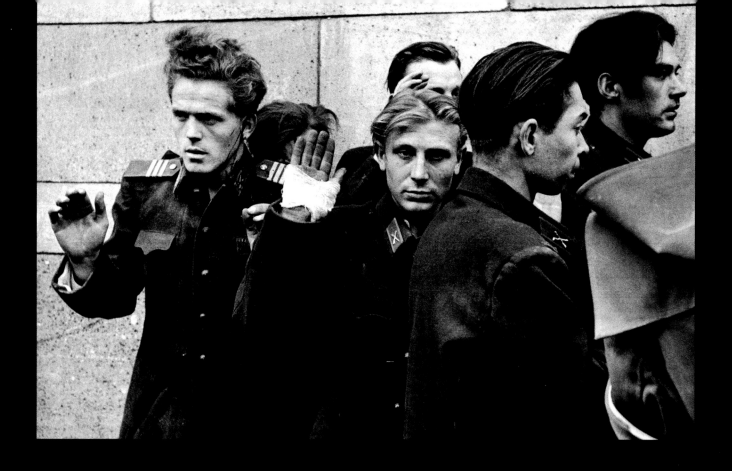

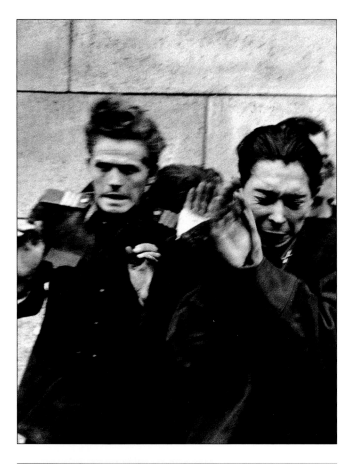

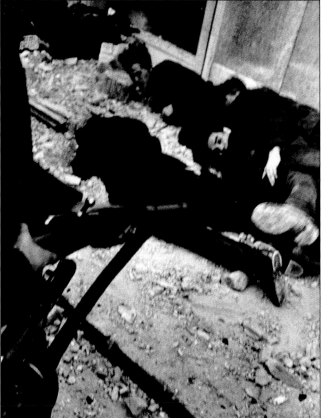

"

...Other groups of rebels were coming in from the side, screaming and going into the building. There was only occasional machine-gun fire from the top floor, but people were still being careful. At the front of the building there were 30 to 40 people (rebels) dead. They were lying almost in line. As one had been hit the man behind had taken his place – and died. It was like a potato field, only they were people instead of potatoes.

Now the AVH men began to come out. The first to emerge from the building was an officer, alone.

It was the fastest killing I ever saw. He came out laughing and the next thing I knew he was flat on the ground. It didn't dawn on me that this guy was shot. He just fell down, I thought.

...Six young officers came out, one very good-looking. Their shoulder boards were torn off. Quick argument. We're not so bad as you think we are, give us a chance, they were saying. I was three feet from that group. Suddenly one began to fold. They must have been real close to his ribs then they fired. They all went down like corn had been cut. Very gracefully. And when they were on the ground the rebels were still loading lead into them.

...They were all officers in that building. Another came out, running. He saw his friends dead, turned, headed into the crowd. The rebels dragged him out. I had time to take a picture of him and he was down. Then my nerves went. Tears started to come down my cheeks. I had spent three years in the war, but nothing I saw then could compare with the horror of this. I could see the impact of the bullets on a man's clothes. You could see every bullet. There was not much noise. They were shooting so close that the man's body acted as a silencer. This went on for 40 minutes.

... Going back through the park, I saw women looking for their men among the bodies on the ground. I sat down on a tree trunk. My knees were beginning to give in, as if I was carrying a weight I couldn't carry any more.

"

John Sadovy witnessing the rebel capture of the AVH (secret police) building during the Hungarian Revolution in 1956.

Opposite: 31 October 1956, Budapest, Hungary. Members of the AVH (Soviet-backed Hungarian secret police) routed from their station by anti-Communist rebels. John Sadovy

Left, above: 31 October 1956, Budapest, Hungary. The officers flinch as the shooting begins. John Sadovy

Left: 31 October 1956, Budapest, Hungary. Executed officers fall to the ground. John Sadovy

Overleaf: 1 November 1956, Budapest, Hungary. A partisan shoots the corpse of a secret policeman. John Sadovy

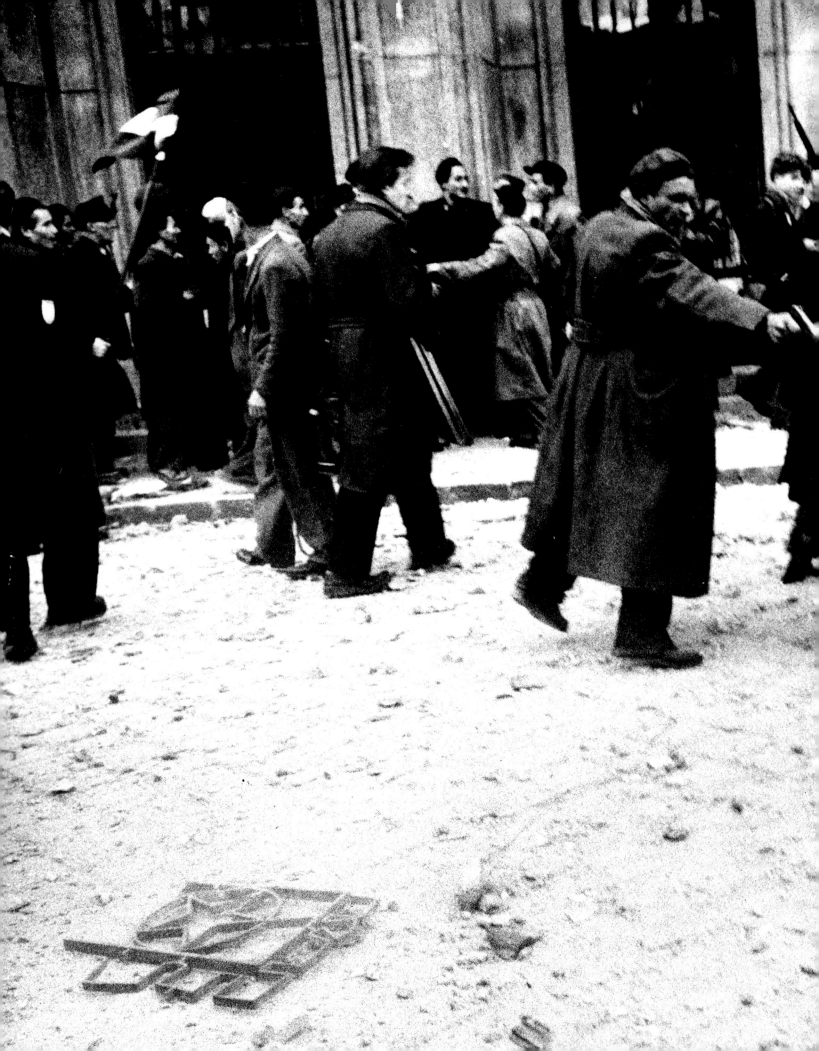

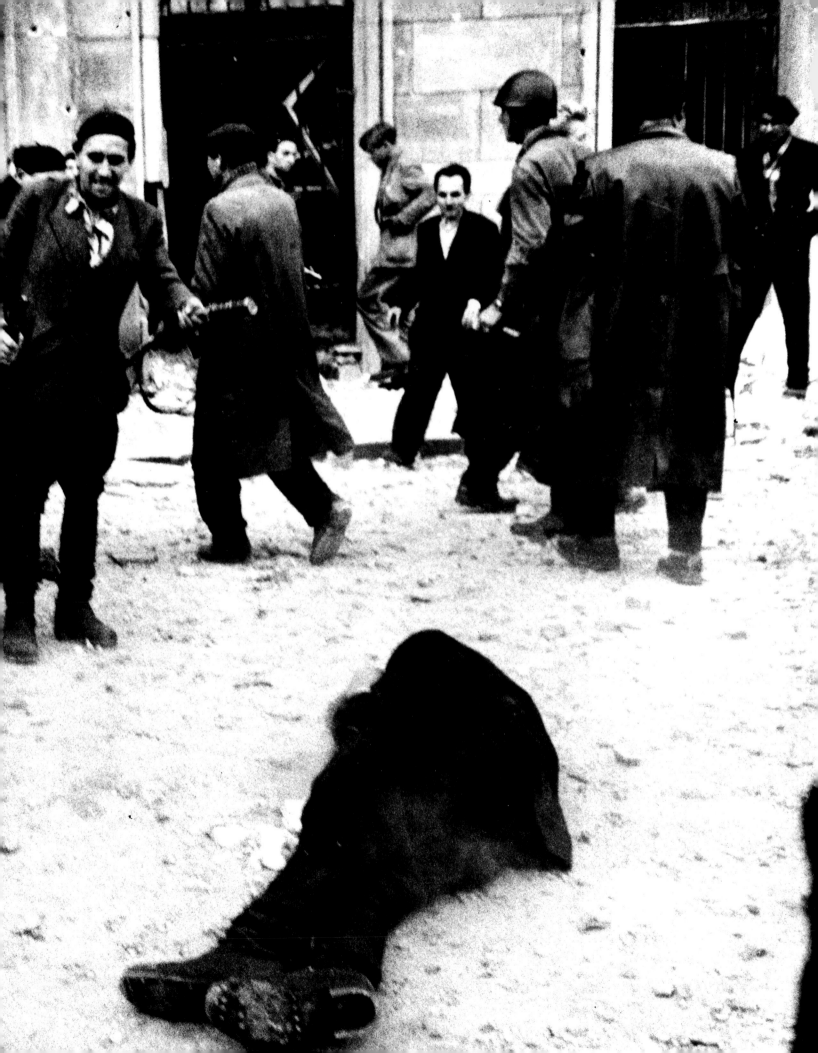

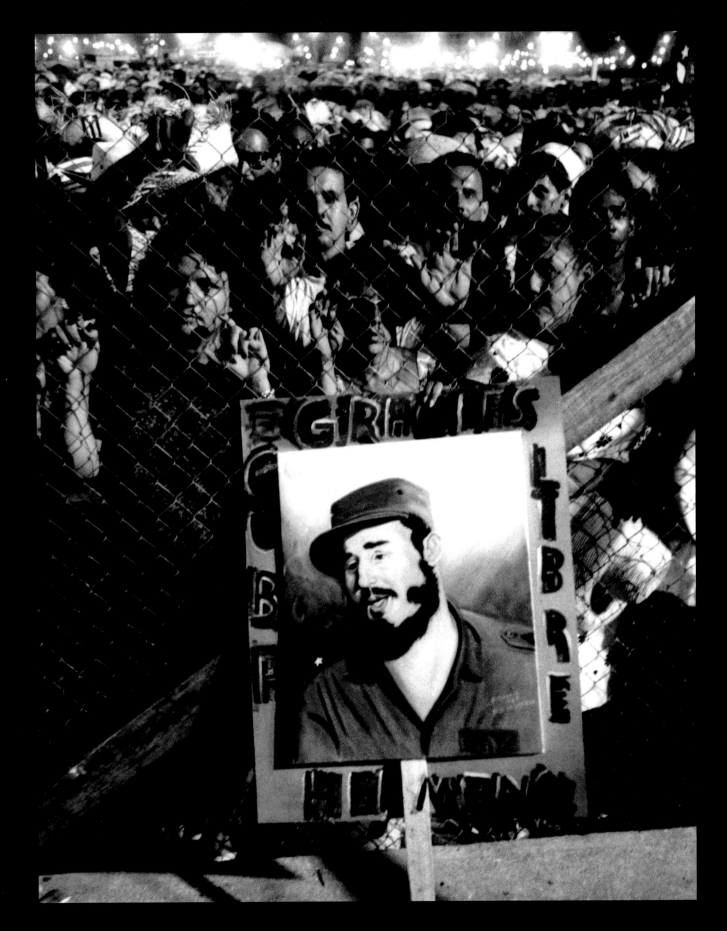

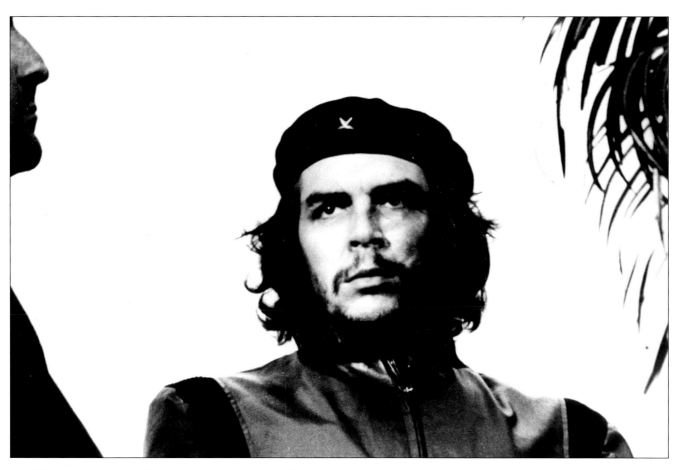

Left: 1959, Havana, Cuba. Rallying Cubans express their gratitude to guerrilla leader Fidel Castro for liberating them from the harsh hand of President Batista. Flip Schulke

Above: 5 March 1960, Havana, Cuba. This world-famous portrait of the Argentinian Marxist revolutionary Ernesto "Che" Guevara, entitled *Guerrillero Heroico*, was taken while he was a member of Cuba's post-revolutionary government. Korda (real name Alberto Díaz Gutiérrez)

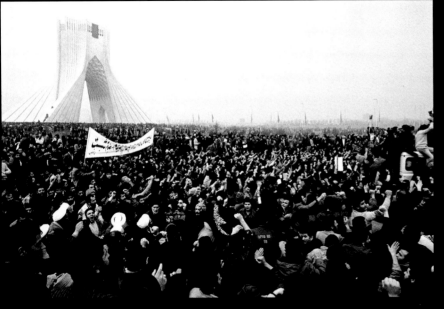

Above: 11 December 1978, Shahyad Square (now Azadi Square), Tehran, Persia (now Iran). Part of the massive anti-Shah demonstrations, attended by several million people – around 10 per cent of the country's population – and said to have been the largest protest event yet known worldwide.
Patrick Chauvel

Right: 31 December 1978, Tehran, Persia (now Iran). A rioter on the streets of the capital city during the build-up to the 1979 overthrow of the royal family and especially its head, the Shah. Patrick Chauvel

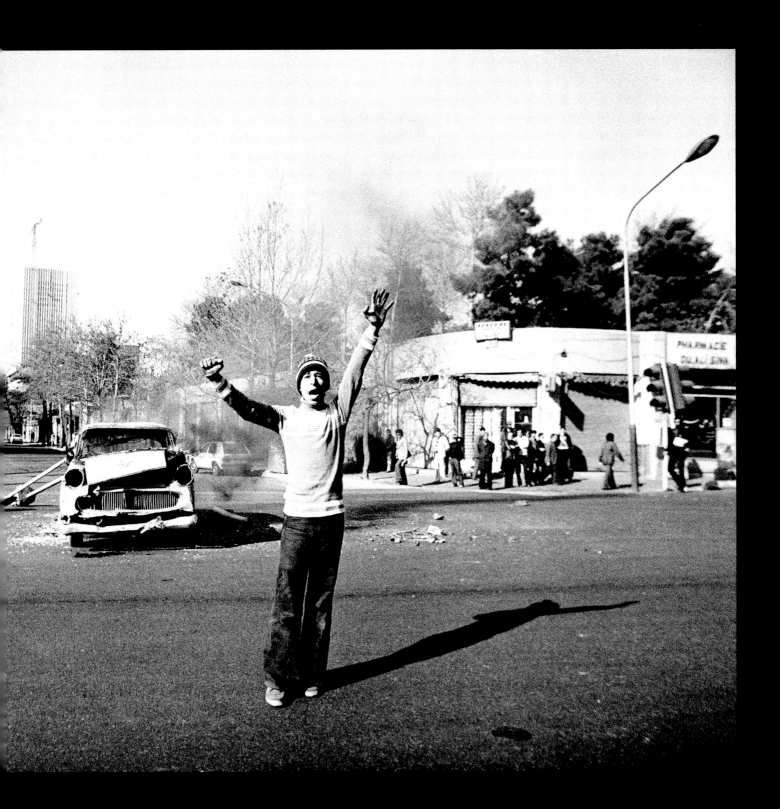

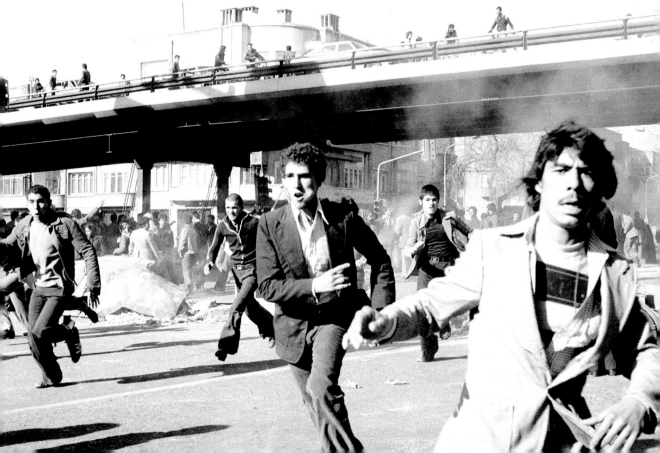

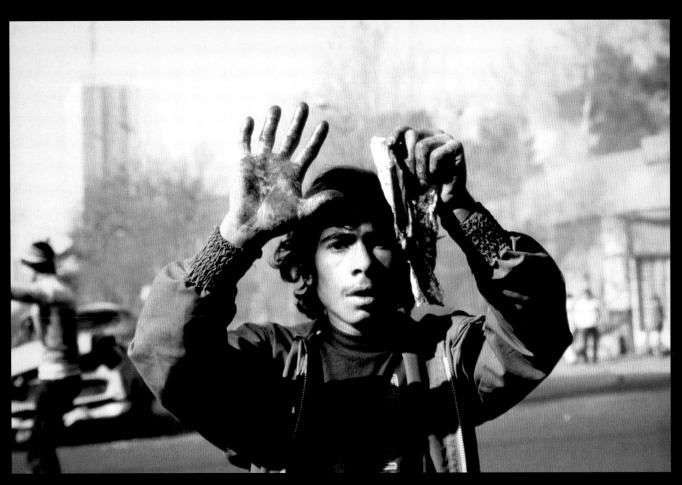

Above: 31 December 1978, Tehran, Persia (now Iran). A protester displays a bloody hand and cloth as the riots escalate into violence. Patrick Chauvel

Above: 24 August 1980, Lenin Shipyard, Gdansk, Poland. Striking workers attend Mass. It was this strike that led to the creation that year of Poland's first trade union, Solidarnosc (Solidarity), despite the Communist government. One of the union's founders, Lech Walesa, went on to serve as Poland's first post-Communist president in 1990–95.
Jean Louis Atlan

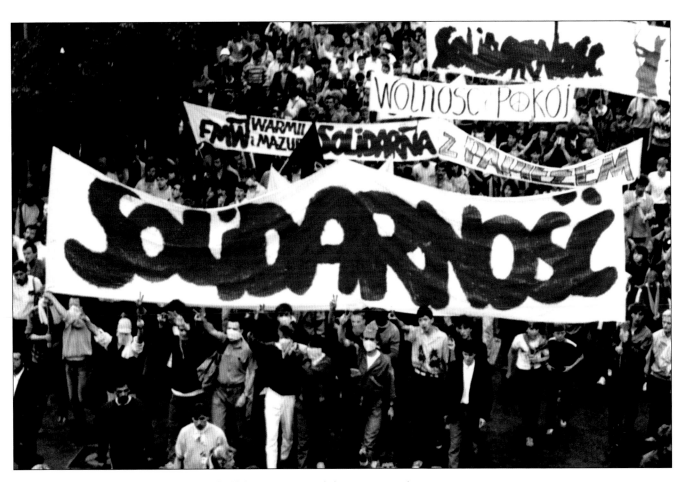

Above: 1987, Poland. During a visit from Pope John Paul II, demonstrators march down a street carrying banners reading "Solidarnosc". The trade union became a national movement backed even by the Roman Catholic Church although it was banned by the Polish government from 1981 to 1989. Peter Turnley

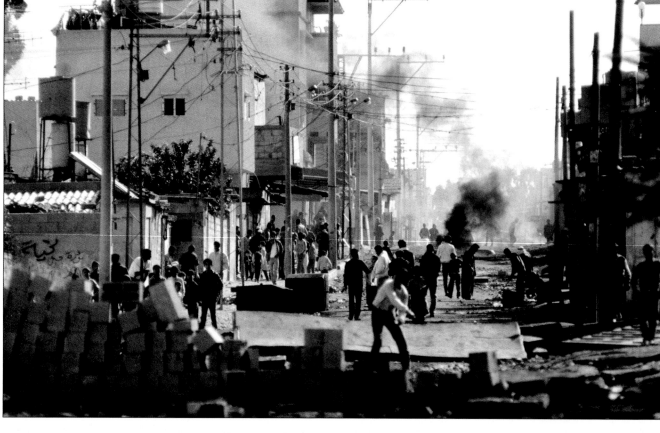

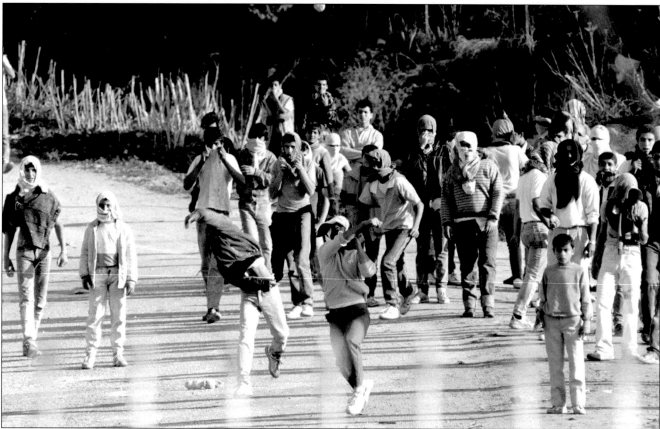

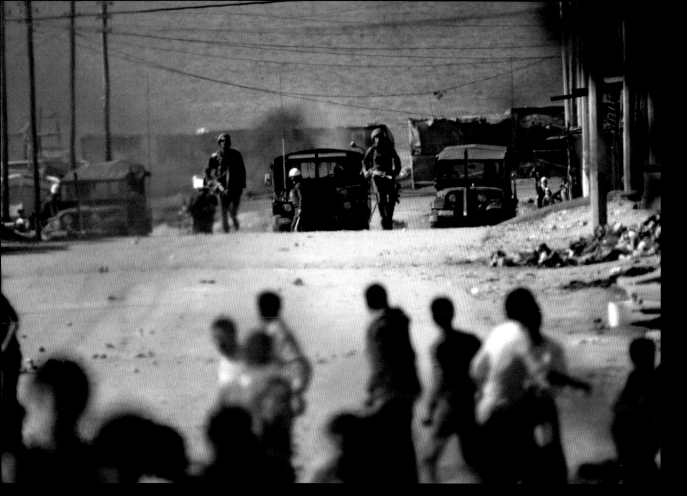

Left, above: c.1990, Gaza City, Israeli-occupied. During the
First Intifada or uprising (1987–93), Palestinian men and
boys survey the destruction resulting from the struggle
between Israeli occupying forces and Palestinian inhabitants
for control over the Gaza Strip territory. Micha Bar Am

Left: c.1990, Umm El Fahm, northern Israel. In Israel itself,
Arab youths throw projectiles at Israeli forces as they block
the main road leading north from this Arab-inhabited town
near Nazareth, just outside the West Bank area.
Micha Bar Am

Above: 10 February 1988, Gaza, Israeli-occupied. Rebel
Israeli and Palestinian fighters protest in the occupied
territory of Gaza during the First Intifada uprising. The Israeli
administrative custody camp was closed and declared a
military zone after violence broke out. Patrick Robert

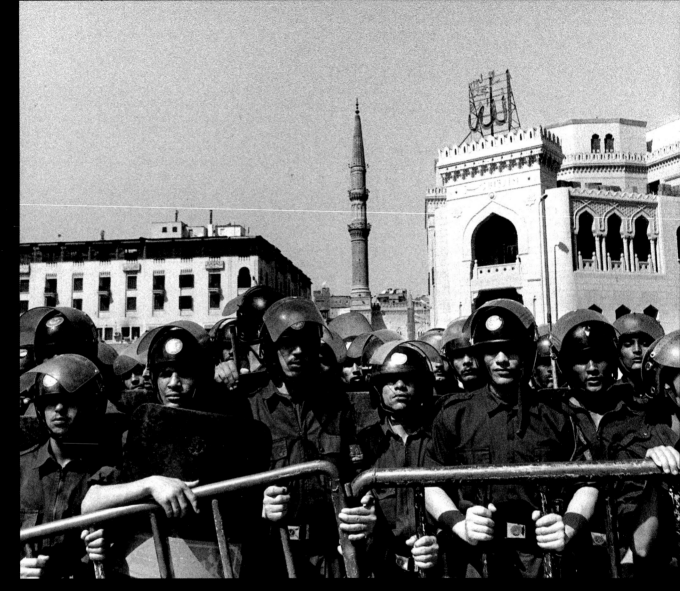

Above: 12 April 2002, Al-Azhar Mosque, Cairo Islamico, Egypt. Policemen and security officers contain a demonstration in solidarity with the Palestinians against Israeli occupation of the West Bank. Karim Ben Khelifa

Above right: 20 June 2004, Az-Zawiya, West Bank. An Israeli border policeman fires a tear-gas canister during a protest by Palestinians against construction of the controversial Israeli security barrier. Goran Tomasevic

Above far right: 20 March 2005, Bethlehem, West Bank. A protester waves an olive branch in front of an Israeli border policeman during a protest at Gilo checkpoint at the entrance to the city. Goran Tomasevic

Right: 28 January 2005, Iskaka, West Bank. Palestinians pray in front of Israeli soldiers during a protest at the construction site of the security barrier. Goran Tomasevic

Overleaf: 12 April 2002, Al-Azhar Mosque, Cairo Islamico, Egypt. A woman displays the Palestinian flag while others voice their opposition to US foreign policy, President Bush and Israeli occupation of the West Bank. Karim Ben Khelifa

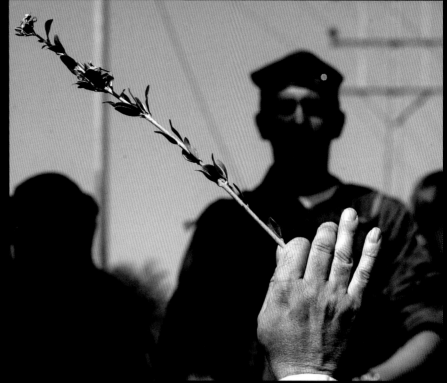
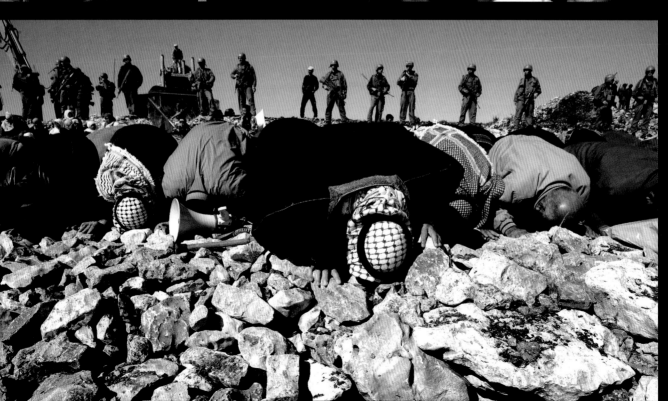

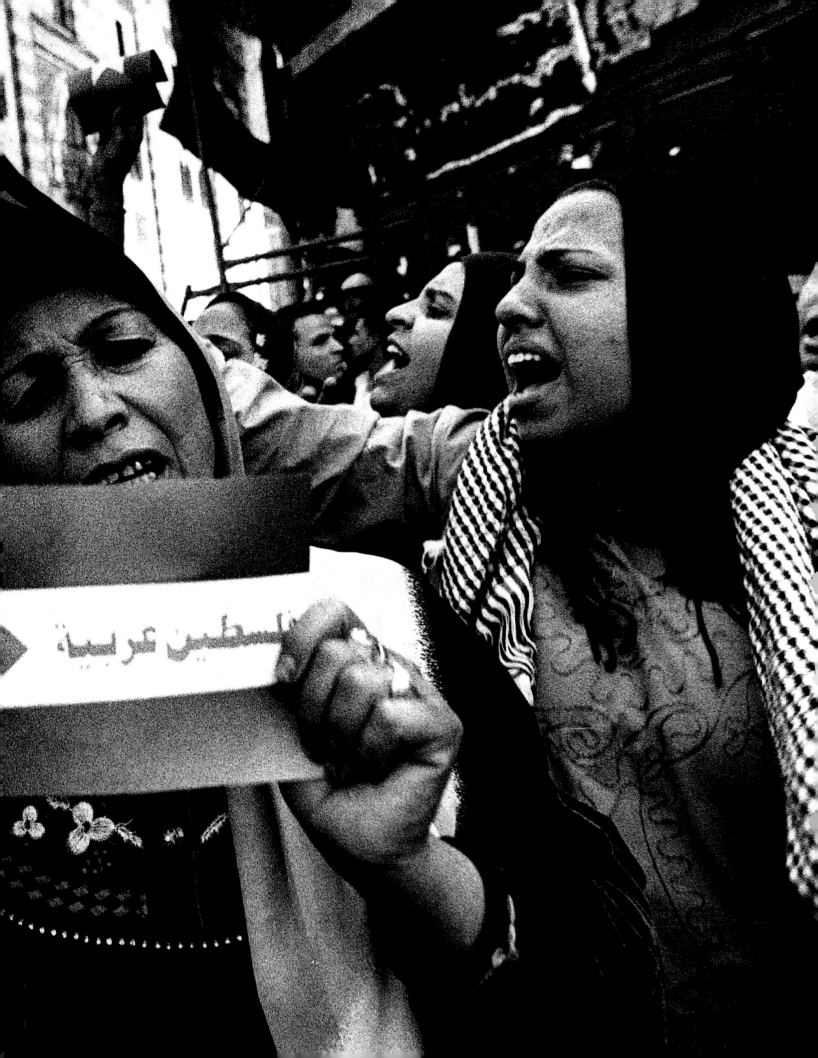

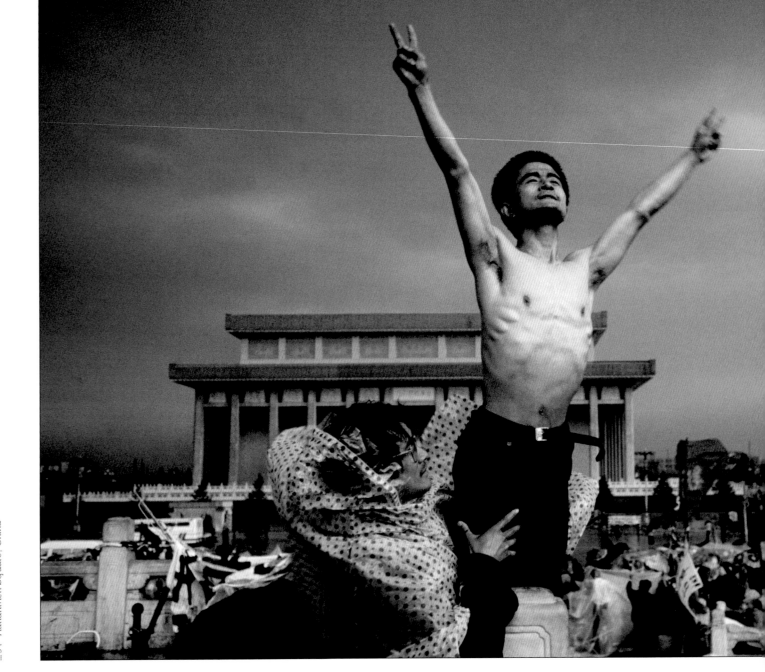

_34 Tiananmen Square, China

Left: 26 May 1989, Tiananmen Square, Beijing, China. Students on hunger strike. The protest began on 15 April, when thousands of students from Beijing University, mourning the death of the liberalizing Communist Party General Secretary Hu Yaobang, began chanting democratic slogans, making political demands and setting up a peaceful protest camp in the square. After some weeks, the lack of favourable government response led growing numbers to embark on hunger strikes. Stuart Franklin

Below: 17–20 April 1989, Tiananmen Square, Beijing, China. The optimistic early days of the student protest, which would culminate on 4 June when the vast square was cleared by People's Liberation Army tanks. Rene Burri

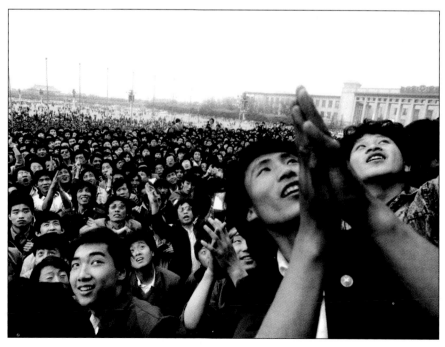

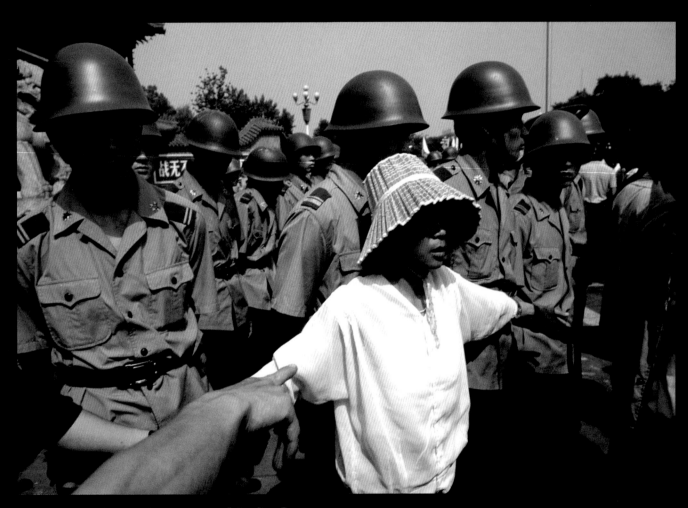

Above: 2 June 1989, Communist Party headquarters. Beijing, China. The army
arrests civilians and students as the government crackdown begins. Stuart Franklin

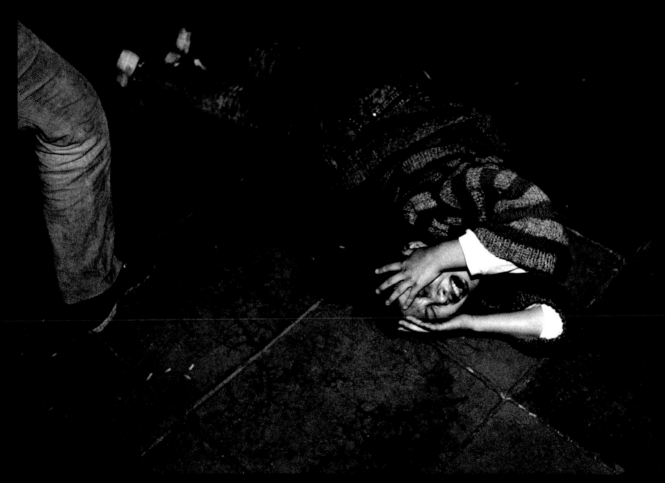

Above: 17 May 1989, Tiananmen Square, Beijing, China. A group of students act out scenes imitating government officials in front of the crowd. A girl from the school of drama mimes the suffering of the Chinese people. Stuart Franklin

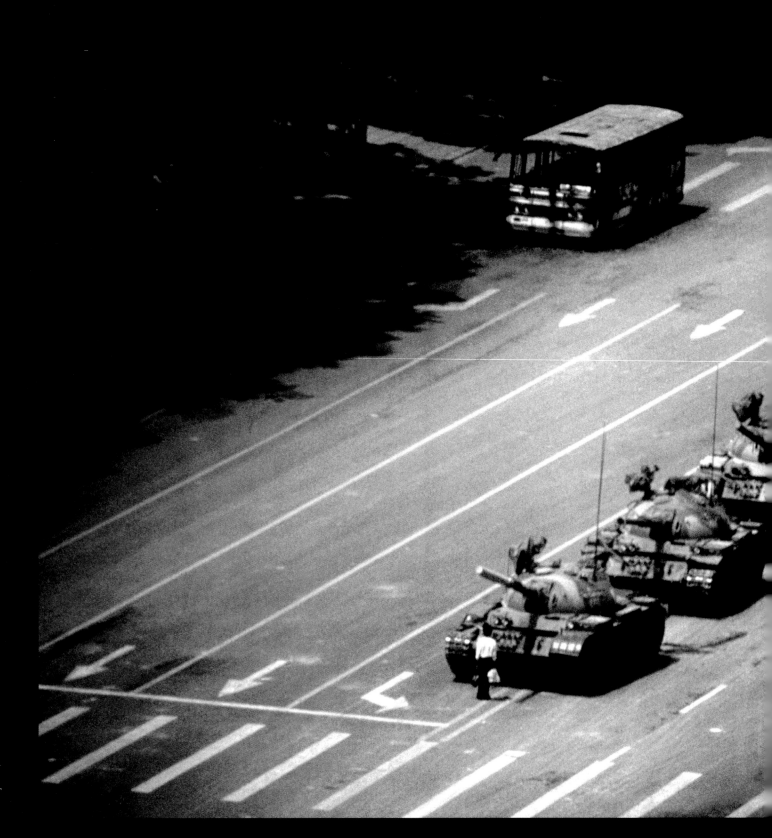

_38 Tiananmen Square, China

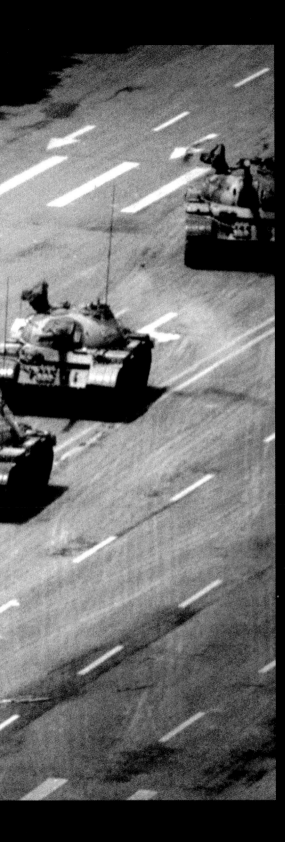

It was odd: at the beginning, the Tiananmen Square demonstrations had an upbeat, almost rock festival feel. But then as the army moved in, it turned ugly. So the following morning, I was on the balcony in my hotel room on Chang'an Avenue in Beijing, about 150 metres from Tiananmen Square. I couldn't leave the hotel, as Chinese security had occupied the lobby. It was a bit frustrating: having grown up with the Magnum ethos that if a picture isn't good enough, you're not close enough, I found myself looking on with quite a long lens.

I remember seeing a row of soldiers and a row of students facing each other at the entrance to the square. Then the tanks rolled forward, and this guy jumped out of the crowd and just did this whole dance in front of them. He jumped on and off the tank, and I was just photographing away.

To be honest, I was thinking that this wasn't terribly interesting. But this guy from *Vanity Fair* was saying it was an iconic moment – a moment that history would remember. And I was going, "Really?" I didn't get it. Photographically, it didn't seem terribly interesting: the guy was really small. But I do think there is an energy to it – there is smoke coming out of one tank, as if they're revving up to run him over. I saw two or three people in civilian clothes scoop him up and take him back into the crowd, which swallowed him up. He has not been seen or heard of since.

It was only after speaking to the Magnum office in Paris a couple of days later that I realized how important it was. They were saying: "This is amazing! You've got the tank man!" It's always nice when you're in the field and the office sound happy, which is rare.

Then *Time* magazine ran it big, and *Life* magazine ran it as a double page. It became an Amnesty International poster, up on every student wall. I was proud that it became so important to people. I'm not the only person who photographed the scene, so I wouldn't say that mine was unique. But I'm not at all bored of talking about it.

Stuart Franklin

Right: 4 June 1989, Tiananmen Square, Beijing, China. The "tank man" survived his daring challenge, as did most people in the square itself when the army rolled in. However, many were killed nearby and across the city – estimates vary from several hundred to many thousands. Stuart Franklin

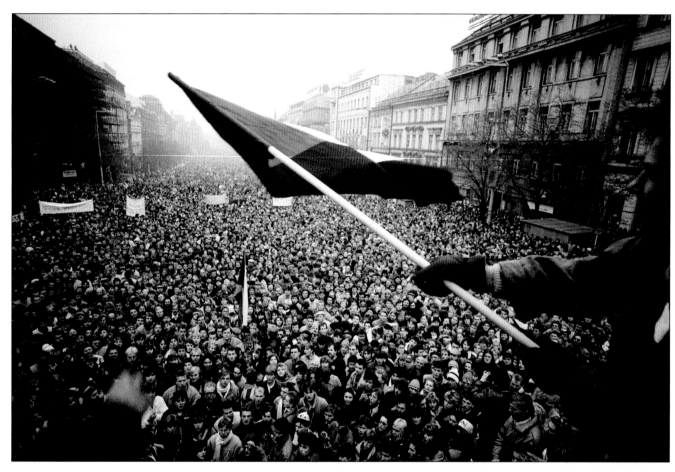

Above: 23 November– 10 December 1989, Prague, Czechoslovakia. Czechs turn out by the thousands to protest against the Communist regime, which had ruled with an iron hand since 1948 (with the brief exception of the soon-suppressed "Prague Spring" of 1968). Similar protests were occurring in other Communist-bloc countries, as the whole of Eastern Europe was transformed. By mid-December, Czechoslovakia's non-violent "Velvet Revolution" had peacefully toppled the regime, and by the end of the year the dissident poet/playwright Vaclav Havel had been elected the country's first democratic president. Czechoslovakia held its first democratic elections for over 40 years in June 1990. David Turnley

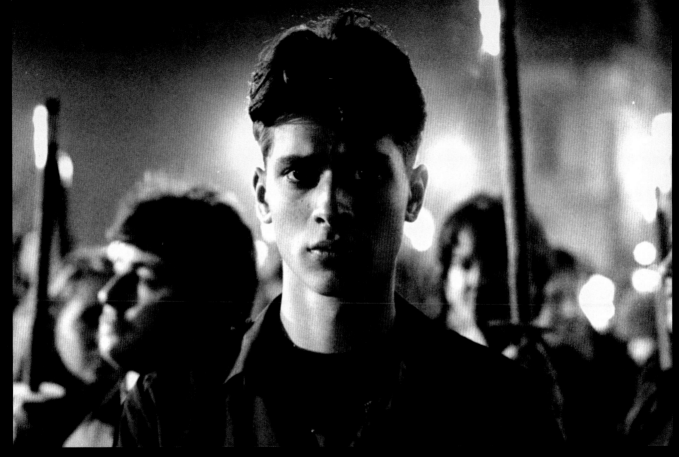

Above: 6 October 1989, Unter Den Linden, East Berlin, Germany. As the Communist state unravels, its offical socialist youth movement, the Free German Youth (FDJ), holds a torchlight procession to celebrate the nation's fortieth anniversary. Chris Niedenthal

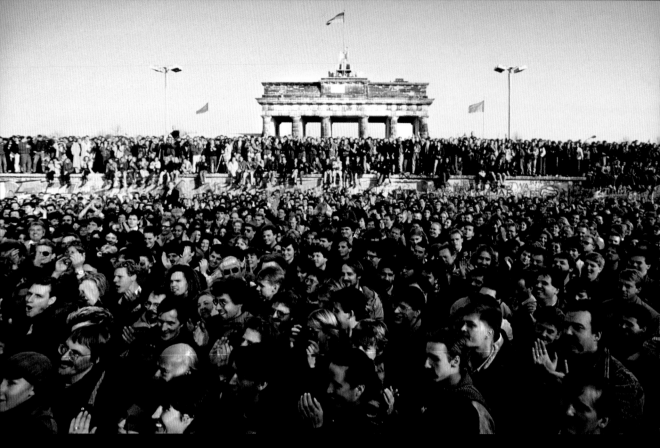

Above: November 1989, West Berlin, Germany.
Crowds gather at, and on top of, the Berlin Wall
in the days after it was opened and the public
allowed through on 9 November. The Wall, built by
Communist East Germany in 1961 as a barrier
between East and West Berlin, was eventually opened
and then demolished in 1989 after prolonged popular
pressure. Seen here is the Brandenburg Gate,
accessible again after nearly 30 years in no man's
land east of the Wall.
Robert Wallis

Right: 4 November 1989, Alexanderplatz, East Berlin,
Germany. Nearly a million people gather to demand
political change; this was the peak of the movement,
and dramatic progress would follow within a few days.
Eberhard Klöppel

Opposite: November 1989, West Berlin, Germany.
A Westerner contributes to the fall of communism,
taking a pickaxe to the Berlin Wall, the symbolic
barrier between capitalist West and Communist East.
Paul Lowe

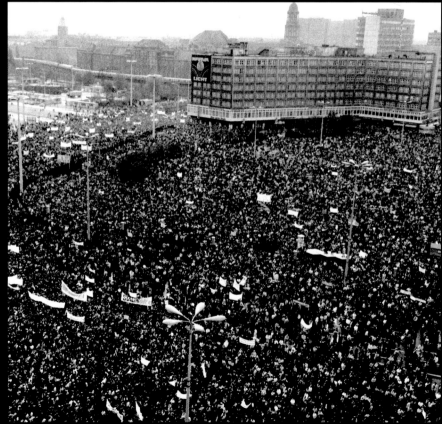

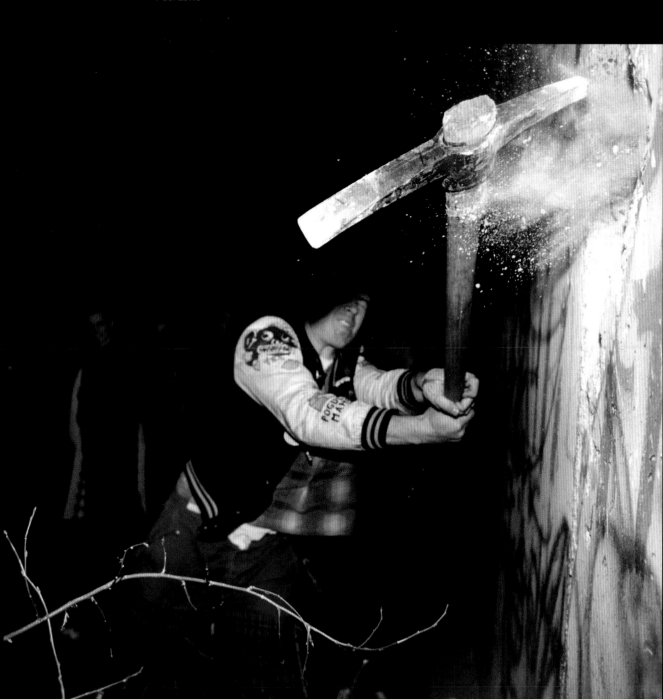

This was an amazing night: to be there at the fall of the Berlin Wall so early in my career really felt like witnessing history first hand. The exuberance and joy of the East Germans who poured over the Wall into West Berlin was infectious, but the reality soon dawned that this was not the start of the end of conflicts and division but rather more the beginning of a series of devastating events that made the world a far more dangerous place. The history of Germany post reunification could be summed up by one piece of graffiti that appeared soon after 11 November on the Wall – "They Came, They Saw, They did a little Shopping".

Paul Lowe

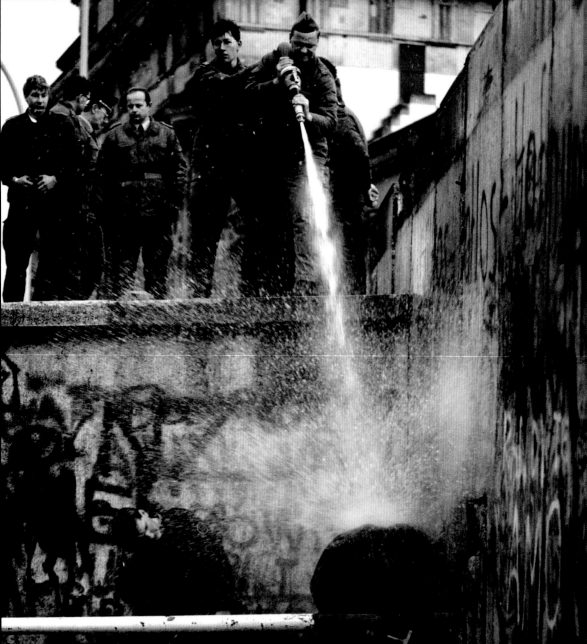

"

I had been working in East Berlin about ten days before this photo was taken, shooting the demonstrations, and came back to London with a feeling something was about to happen but I didn't know what so bought a ticket and got a plane back on 9 November 1989. I met another journalist on the plane, we had a couple of drinks, and decided to head straight to Checkpoint Charlie to head East from West before the border closed that evening. We got in a cab and a few minutes in there was a radio announcement and the driver stiffened and said it was amazing, they were going to open Checkpoint Charlie. There was no one there, it was really odd. We got through on the West Berlin side and then there were people coming towards me and I photographed the very first people who came through from the East. I was working in the no man's land between the walls. Then there were hundreds and later thousands of people as the word spread through Berlin. I worked all night documenting the scenes, people were in tears, kissing the ground as they came through to the West, it was a huge party. Then the East Germans closed their side again and the exodus stopped. The next morning, all along the wall, along the Western side, there were people congregating and people were climbing onto the wall and sitting on top of it and then people began to chip away with hammers at the graffiti and then I found the area we see here in the picture.

In the background of the photo is the Brandenburg Gate, behind the East German border guards. The guards were lined up along the wall trying to stop people climbing on it. At this point a group of young people started to bang away at one of the sections of the wall and this is the beginning of the fall of the section that is so famous now having been shown again and again on television and used in advertising – a symbol of freedom. This was the beginning of the fall of the wall. Someone then picked up a metal pole (seen here) and started using it as a battering ram and the border guards started soaking them with this hose for quite a while and then someone produced a sledgehammer and as each person became tired someone else took over and it was just constant banging until the slab fell. It was caught on television and became the defining moment of the fall of the wall.

There were not really too many crowds, mainly young people, teasing the border guards, exchanging banter, "it's the end", that sort of thing. As the section fell there was a whole sea of hands pushing against it, the first section of the Berlin Wall was pushed down by crowds. After the border guards surrounded the hole trying to stop people streaming through. This was more symbolic than anything else. Later in the week a real gate was opened so people could move freely.

"

Tom Stoddart

Left: 10 November 1989, West Berlin, Germany. East German guards try to halt destruction of the Berlin Wall. Tom Stoddart

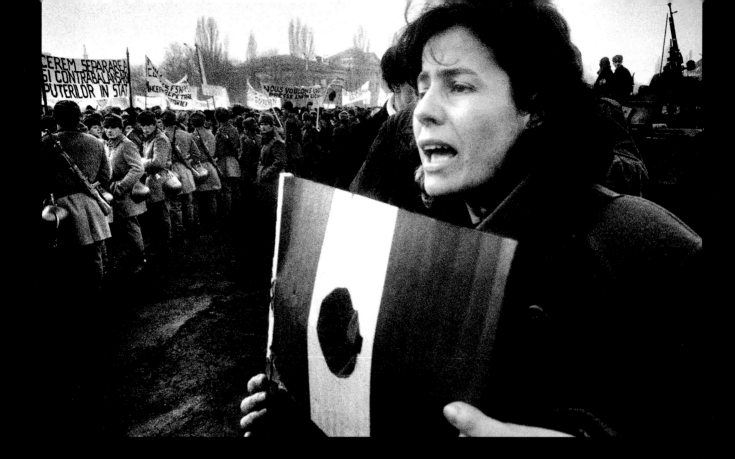

Above: 21–22 December 1989, Bucharest, Romania. Mass protest against the tyrannical rule of President Nicolae Ceaușescu, triggered by the killing of demonstrators by his forces on 17 December in the town of Timisoara. In this photo, the Communist coat of arms has been removed from the centre of the Romanian flag. Romano Cagnoni

Opposite: 21–22 December 1989, Palace Square, Bucharest, Romania. A young soldier who has changed sides to join the public protest. Tom Stoddart

Overleaf: December 1989, Romania. Tanks menace city streets during the revolution, the most violent of those in Eastern Europe that year. President Ceaușescu and his wife were executed on 25 December, but violence continued between workers and intellectuals, and it was some years before the country truly embarked on a path towards democracy. Dod Miller

" I was at home, ready to celebrate Christmas with my parents, and we were watching these amazing scenes on television with the Ceaușescus on the balcony in Piata Palaltuli (Palace Square, later renamed Revolution Square) addressing a crowd of about 100,000 people, condemning the protests and riots in Timisoara, giving the usual rambling speech. It became clear no one was applauding at every sentence as was usual, and then the crowd began to jeer. The Ceaușescus looked like rabbits caught in the headlights. Elena Ceaușescu whispered to her husband, "talk to them, talk to them". Far from quelling the mood, it exploded into a riot situation. I left to get to Bucharest as soon as possible. Driving across the border in a hire car marked PRESS with another journalist, people lined the streets and threw flowers at us like we were a liberating force. When we arrived in the centre of Bucharest there was lots of shooting going on by the *securitate* (the secret police) and units of the army. There was lots of sniping from rooftops, lots of people were being killed. Over 1,000 people died. The civilians protesting were largely unarmed.

This photo was taken in what had been a scene of heavy fighting and this soldier, along with many others, had eventually changed sides and allied with the civilian anti-government protesters. He has *libertate* (freedom) scratched on the side of his helmet.

The revolution was an incredible thing to see. It takes a lot of courage to stand in front of people who are going to kill you. I witnessed the incredible courage of people desperate for freedom. "

Tom Stoddart

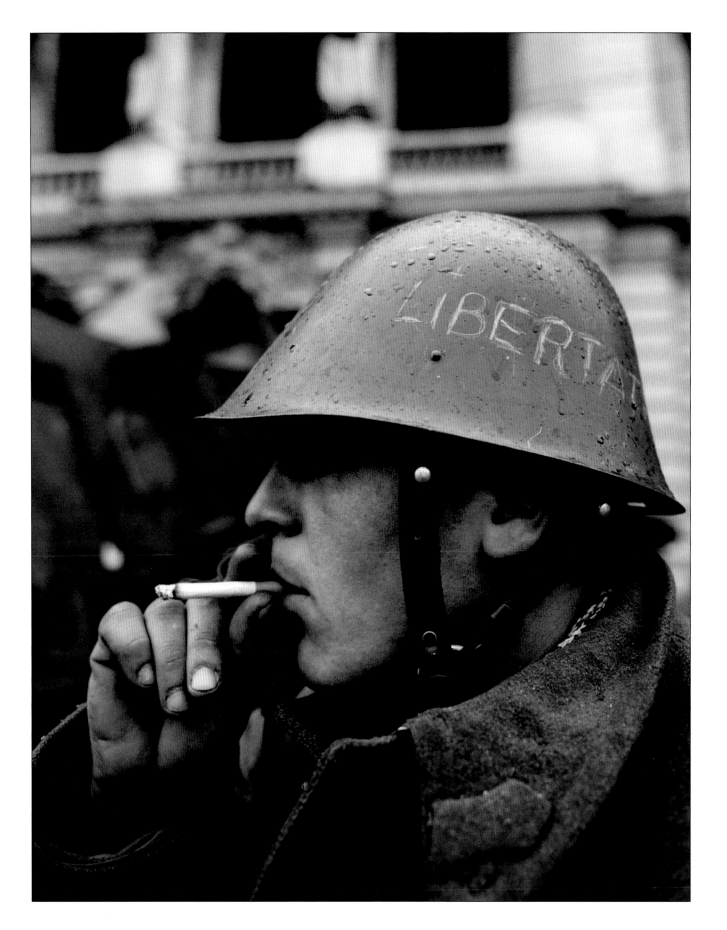

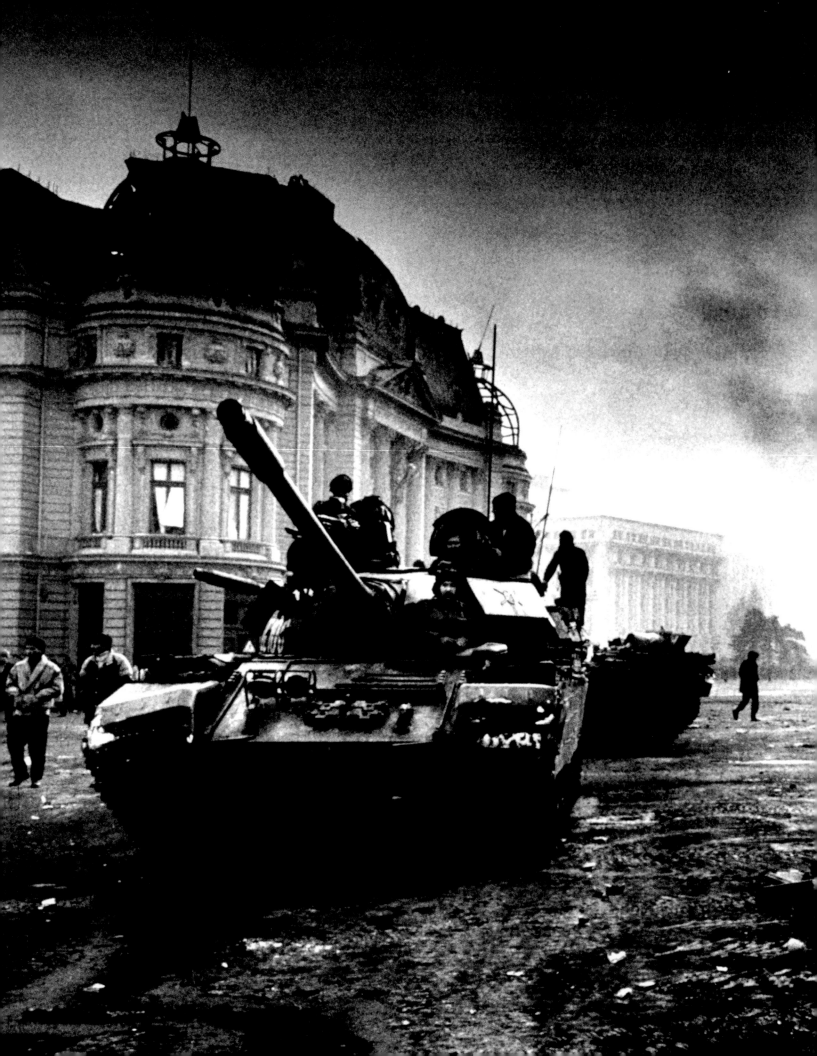

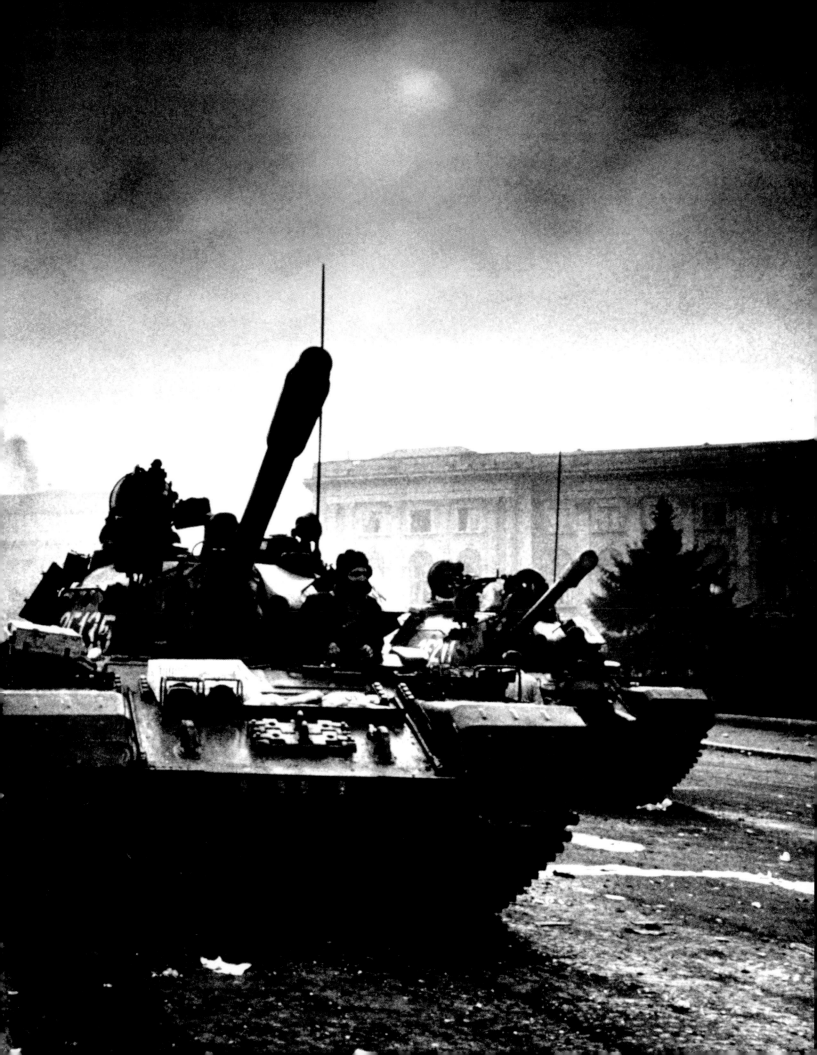

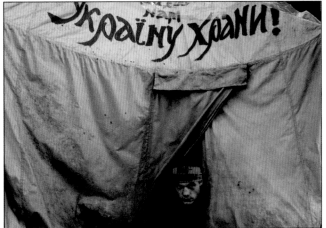

Left, above: 22 November 2004, Independence Square, Kiev, Ukraine. Democracy takes hold in the former Soviet Union, with a protest rally during Ukraine's presidential election. The opposition candidate, Viktor Yushchenko, was defeated by allegedly fraudulent means in the second round, but the peaceful "Orange Revolution", which saw thousands of people take to the streets, led to a re-vote and Yushchenko's victory. Oleg Klimov

Left: 3 December 2004, Kiev, Ukraine. A man peers out of his tent outside the prime minister's office, where he is camping in support of Yushchenko. Carlos Cazalis

Right: 3 December 2004, Kiev, Ukraine. The Orange Revolution lives up to its name, with displays of orange pro-Yushchenko banners and balloons to confront forces guarding the presidential office. Although Ukraine had become independent from the Soviet Union in 1991, it was only with the Orange Revolution that it fully moved on from its past. Carlos Cazalis

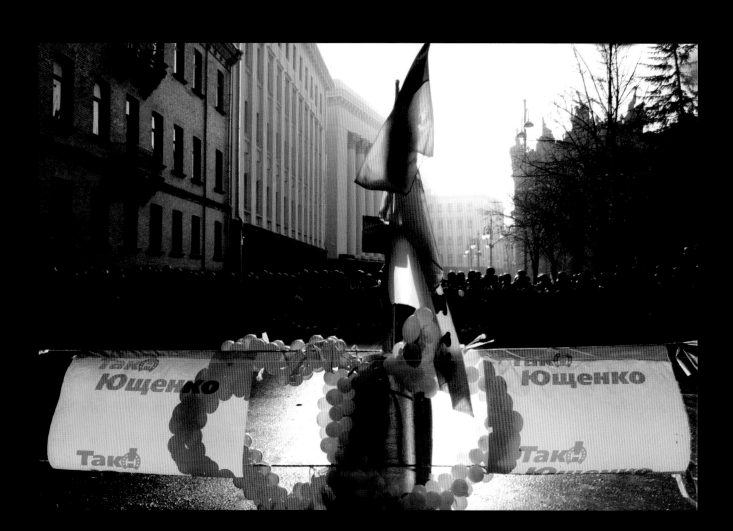

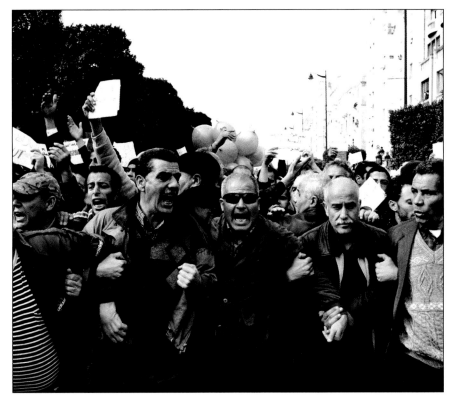

Left: 21 January 2011, Tunis, Tunisia. In the first of the uprisings comprising the "Arab Spring", thought to have been largely triggered by economic factors combined with access to online media, Tunisian demonstrators demand the resignation of the government. Public uprising had forced President Ben Ali to flee the country on 14 January after 23 years at its head, but demonstrations continued against remaining members of the establishment. Alex Majoli

Below: 21 January 2011, Tunis, Tunisia. Protesters scale a lamppost to make their point against the ruling regime. Alex Majoli

Right: April 2011, Tunis, Tunisia. Young men sing verses from the Koran in front of the National Theatre after a demonstration. Alfredo D'Amato

Overleaf: 20 January 2011, Tunis, Tunisia. A boy squeezes through to watch as protesters demand removal of the Constitutional Democratic Assembly Party (RDC) logo from its headquarters. Alex Majoli

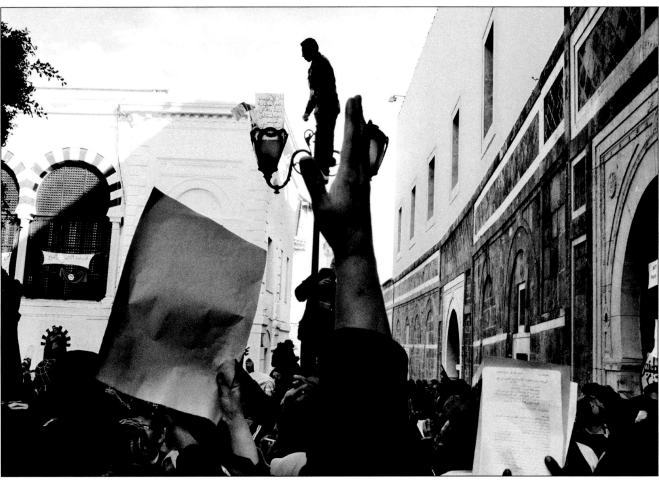

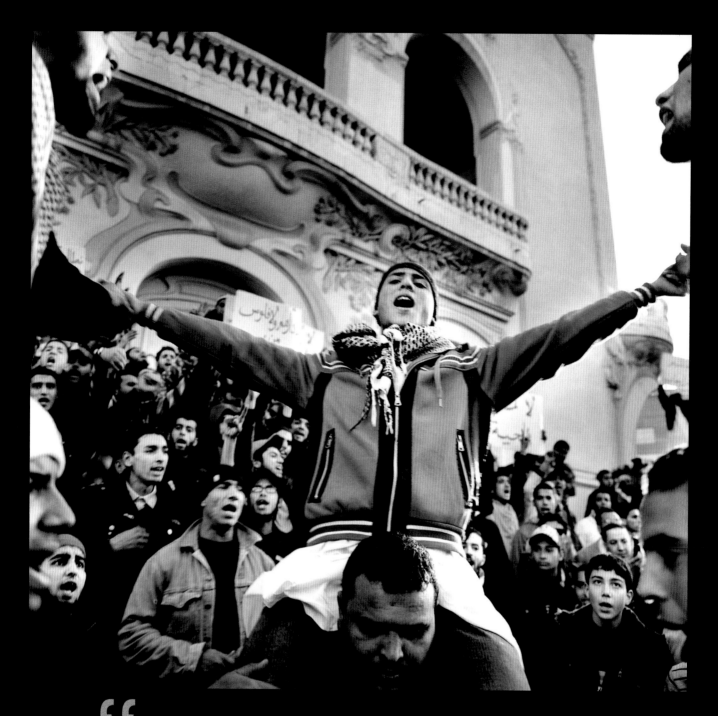

“ Weeks after the fall of President Zine El-Abidine Ben Ali, protesters from all around the country arrive in the capital to join the sit-in at the Kasbah outside the parliament building, hundreds of people with slogans, chanting a demand for the resignation of the prime minister, Mohamed Ghannouchi, unhappy that many members of the RCD, the ex-president's political party, were among the group of politicians, left to rebuild the government and organize new democratic elections after the deposition of Ben Ali. The protesters, united and well organized, resisted there for more than a month till 27 February when the police arrived in the square and tried to evacuate the crowd and the clashes started. After a day of violent fighting that left five protesters dead, Prime Minister Ghannouchi resigned. Tunisians used to meet in the evening at the National Theatre after any demonstration to celebrate and discuss politics; that day, as always during the "Jasmine Revolution", people meet at the same place, happy and proud of achieving the latest step forward. ”

Alfredo D'Amato

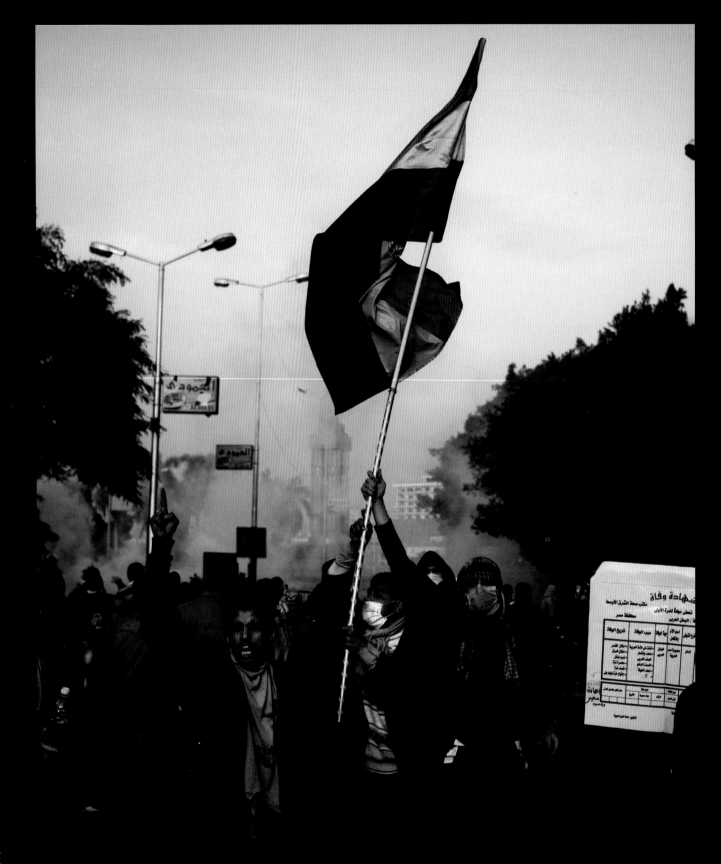

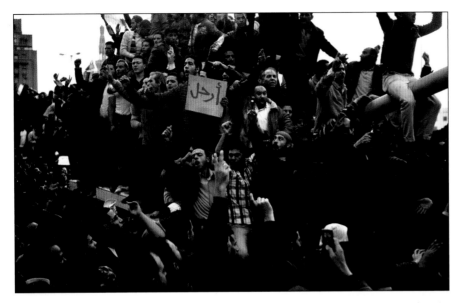

Opposite: 29 January 2011, Cairo, Egypt. A group of protesters holding an Egyptian flag cheer each other on towards Tahrir Square amid tear-gas and pellet bullets during demonstrations against the government of President Hosni Mubarak, in power since 1981. The country had been under an Emergency Law throughout this period: corruption was rife, constitutional rights were constrained, and the economy was suffering. With increasing access to the modern world, the population had had enough. The uprising began on 25 January. Dominic Nahr

Left: 30 January 2011, Tahrir Square, Cairo, Egypt. Protestors clamber all over an army tank, chanting and singing, during another day of protest. Dominic Nahr

Below: 6 February 2011, Cairo, Egypt. Graffiti about the twitter social networking site is seen on the shutters of a closed store as protesting Egyptians gather on the Day of Martyrs to honour those killed in clashes in Tahrir Square. Ron Haviv

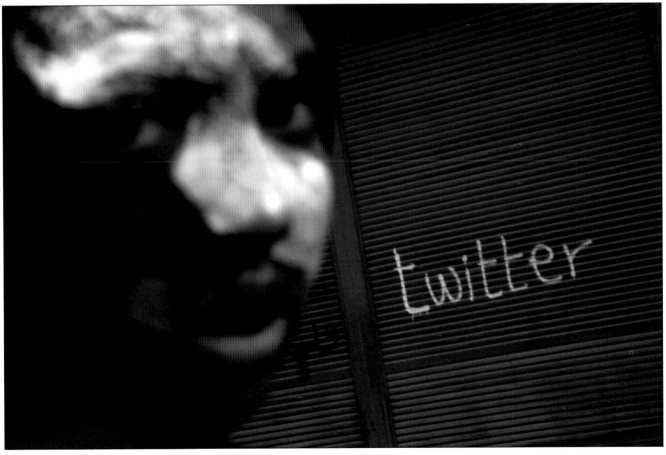

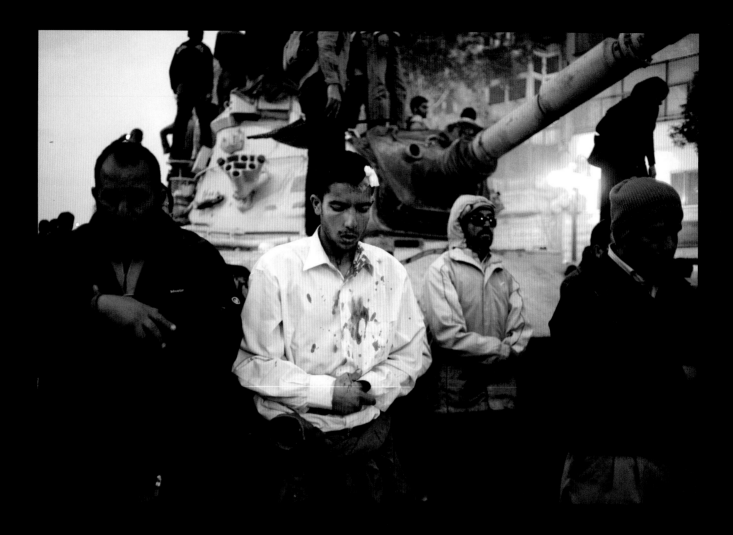

"

I had been in Egypt covering the revolution since Friday 28 January. It was the first time I had ever covered something like this as a photographer.

This picture was taken on Wednesday 2 February at the end of a very long day in Tahrir Square when apparent supporters of President Mubarak marched to the square and clashed with the thousands of anti-government protesters who had been peacefully camped there for several days. The two groups started a stone-throwing battle around lunchtime, which raged all through the night and continued for the next two days.

It was late evening and the call to prayer sounded. A group of men began praying in front of an Egyptian army tank that had been abandoned in the midst of the fighting. As I moved closer I saw the young man, who had clearly been injured during the clashes, join the group. I guess it is a good picture, not just because of the visual impact of a bloodied young man in a white shirt, praying in front of a tank, but also because of the metaphor behind it. His attitude seemed to sum up that of the protesters. That no matter what Mubarak threw at them they would hold their ground until he stood down. And that's what they did.

"

Ivor Prickett

Above: 2 February 2011, Tahrir Square, Cairo, Egypt. Evening prayers during the protest. Ivor Prickett

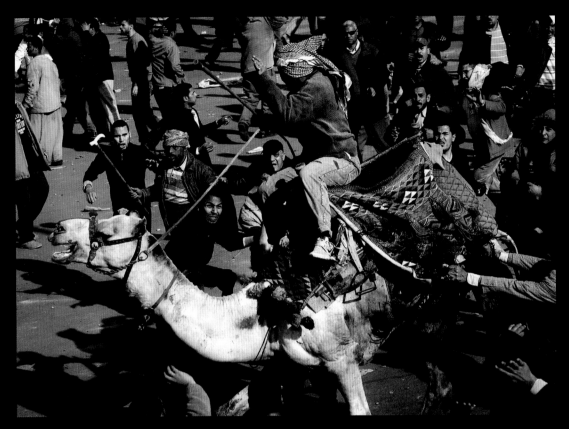

Above: 2 February 2011, Tahrir Square, Cairo, Egypt. A supporter of President Mubarak rides a camel through the melee as pro-Mubarak and anti-government demonstrators clash. Chris Hondros (killed in April 2011 while photographing the civil war in Libya)

Below: 7 February 2011, Tahrir Square, Cairo, Egypt. Egyptians gather to protest against the Mubarak government; four days later, Mubarak capitulated and resigned. Ron Haviv

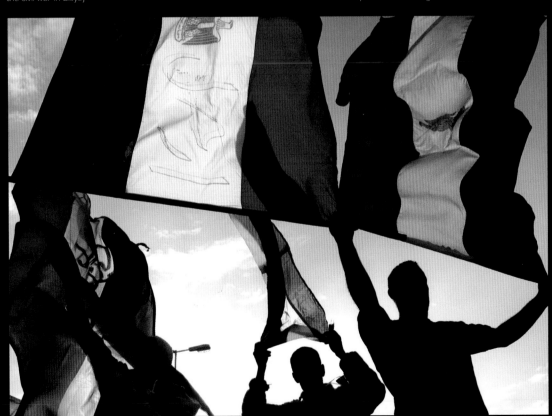

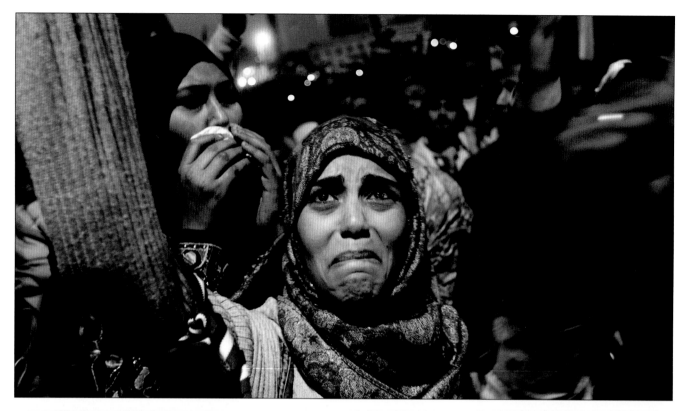

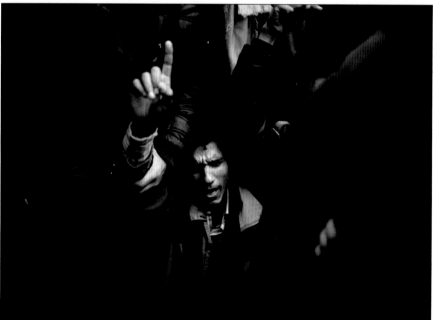

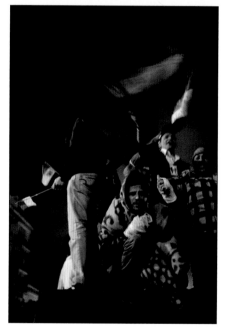

Top: 11 February 2011, Tahrir Square, Cairo, Egypt. Crowds are moved to tears by the announcement that President Mubarak is to resign, after 18 days of protests. Women played an active, independent and visible role in the uprising, a phenomenon previously unknown in Egyptian society. Chris Hondros

Above left: 9 February 2011, Cairo, Egypt. Demonstrators speak out against the Mubarak regime in front of the entrance to the Egyptian Parliament. Moises Saman

Above right: 11 February 2011, Cario, Egypt. Although cold and in some cases wounded, Egyptians celebrate the announcement that President Mubarak has stepped down as president. Moises Saman

Opposite: 12 February 2011, Tahrir Square, Cairo, Egypt. The jubilant reaction to Mubarak's resignation. One of the striking features of the uprising was that it included protesters from a wide variety of social backgrounds, who in normal life might have had very little contact with each other. Dominic Nahr

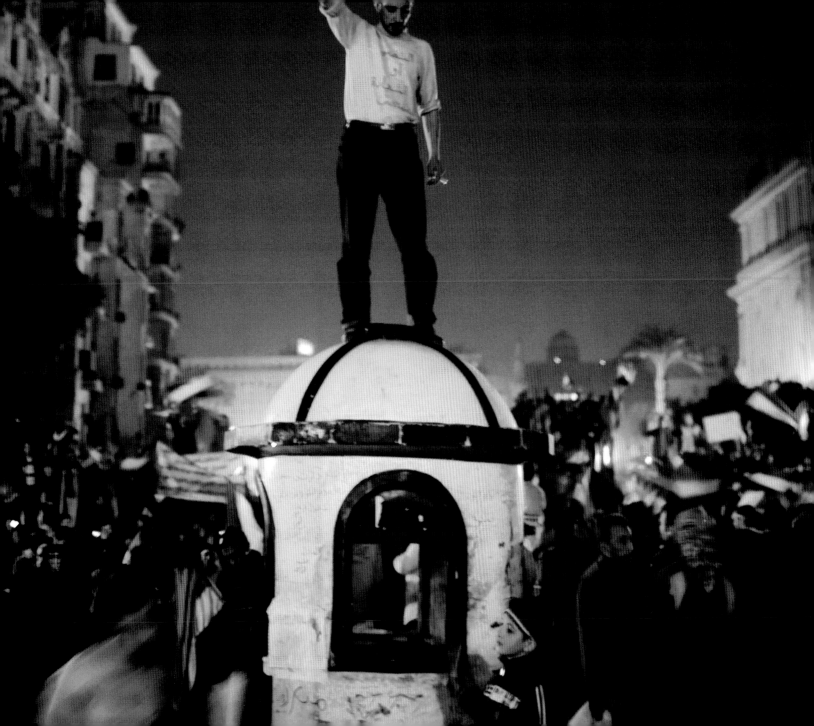

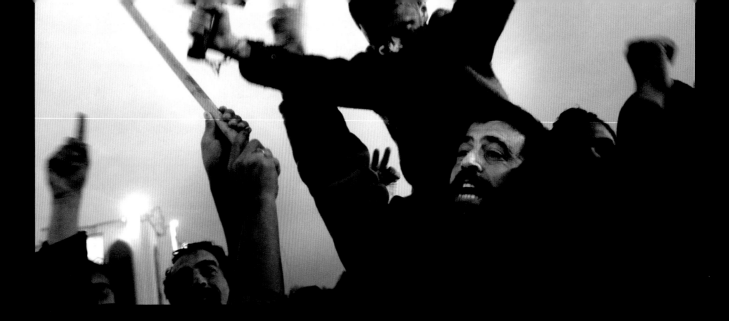

"

Only a week had gone by since the outbreak of the Libyan revolution. When I crossed the border from Egypt into Libya, it was hard to know really what to expect. During the 42-year rule of Gadaffi the country had been rather isolated and as the other Arab revolutions, the Libyan revolution seemed to take everyone by a huge surprise – and maybe most of all the Libyans themselves. The city's main square (where these pictures were taken) was home to the headquarter of the newly formed protesters, as well as the mosque and a burned-out police station that had just been overrun, leaving five people dead.

The Friday prayers started calm and peaceful, but soon that mood changed completely. The main square in front of the mosque was packed with people. The flag of the new rebellion was painted on the cheeks of children and blowing quietly in the wind from rooftops across the square. Seconds after the imam said his last words the crowd got up on their feet and gathered as one big organism facing the mosque. Screaming, shouting and almost crying. From the bottom of their lungs.

It seemed to me as if, from a place hidden deep inside them, a feeling that for so long had been restrained and hidden away from the ever-watching ear and eye of the Gadaffi regime was finally let loose into the open.

Mads Nissen

"

Opposite: 24 February 2011, Tobruk, Libya. A couple of hundred people gather in the central square, shouting anti-Gaddafi slogans while destroying a portrait of him. The uprising against the despotic regime had begun on 17 February. Mads Nissen

Below left: 25 February 2011, Tobruk, Libya. Protesters gather after Friday prayers at Tobruk's central mosque, shouting anti-Gaddafi slogans before marching through the streets. Mads Nissen

Below: 24 February 2011, Tobruk, Libya. Women young and old join the crowd protesting in the central square. Mads Nissen

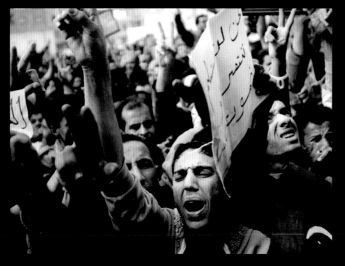

Below: 24 February 2011, Tobruk, Libya. A portrait of Libya's ruler, Muammar Muhammad al-Gaddafi, thoroughly defaced by protesters, with graffiti of swastikas and a star of David (symbol of Jewishness), and shoes thrown disrespectfully onto it. Mads Nissen

Right: 9 February 2011, Zawiyah, Libya. A Gaddafi supporter holds a portrait of the Libyan leader as fireworks go up in the background on a soccer field where government minders took a group of foreign journalists to attend a staged celebration. Moises Saman

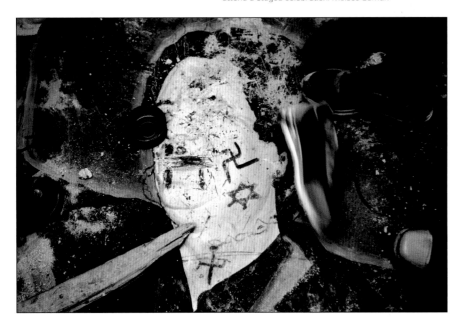

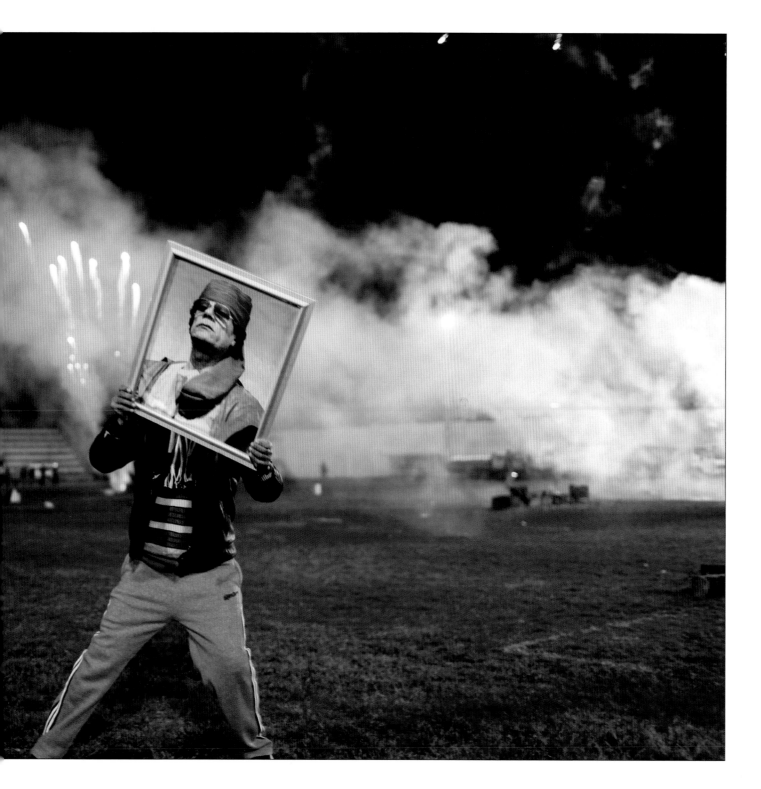

_65 Libya

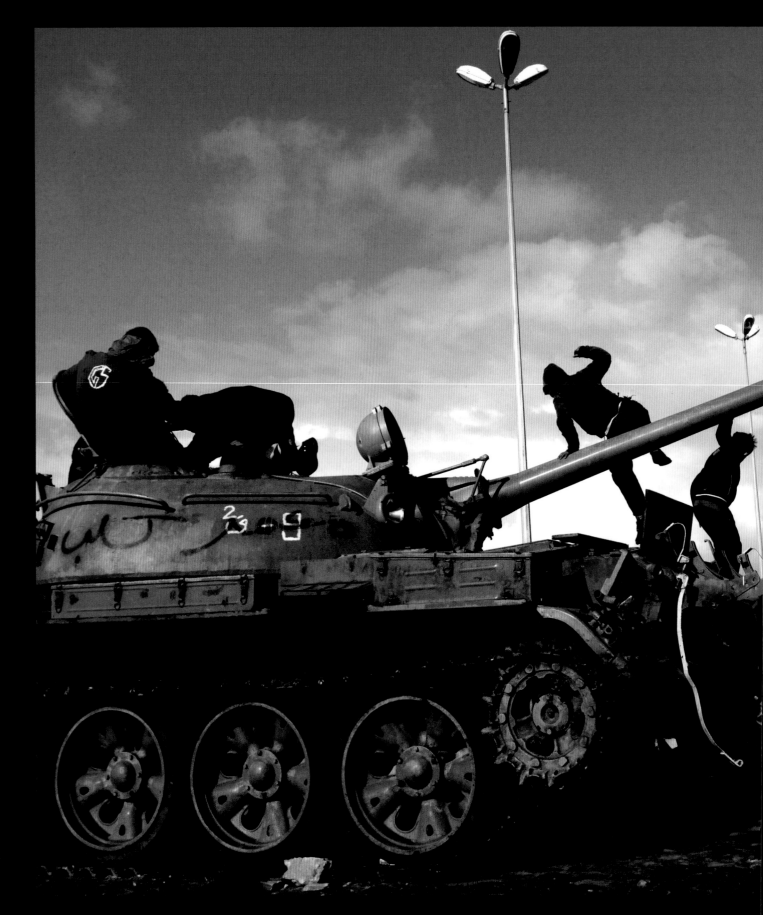

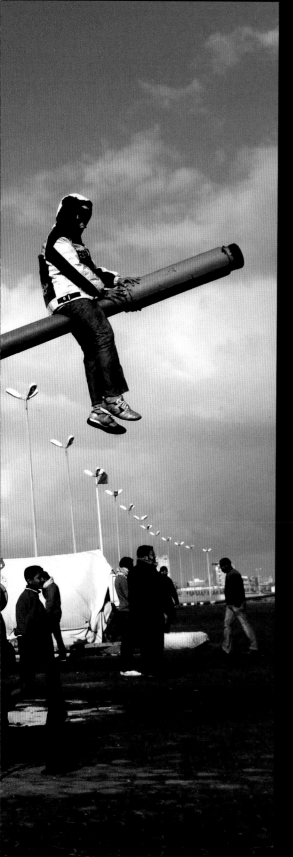

There was a small window of time in the Libyan war, after the initial liberation of Benghazi but before the lethal battles that were to come, where I spent my days photographing protests along the shores of the Mediterranean. In some ways like the revolutionary protests in Egypt weeks before, this demonstration was a combination of celebration of what had been accomplished and outrage over what was still yet to be done. The man in the centre, his face painted with the Libyan national colours, looked about to explode. As media, I was totally welcome, as the rebels knew that press coverage of their plight was key if they were ever to get international support.

John Moore

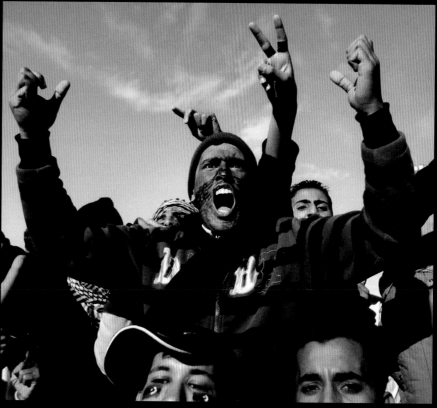

When I first crossed into Libya, the initial fighting for Benghazi had already taken place, and almost completely out of the gaze of the international media. The main battles for eastern Libya were over, so Benghazi was a safe rebel-held city when I arrived. The populace had driven out Gaddafi's forces in a populist revolution that had cost them dearly in blood, but had gained them considerable hardware in terms of weapons, including tanks. These would soon be used by their newly formed militia when they began to push government forces west. This tranquil scene, as civilians relax atop a captured government tank in Benghazi's main square, was a brief pause before the next violent stage of the conflict.

John Moore

—chapter 2

Protest
and
Insurgency

Protest and Insurgency

In August 1965, the Watts district of Los Angeles was ripped apart by six days of rioting and looting. Almost 3,500 were arrested, and the death toll was 34, while damage to property was estimated at $40 million. These were by no means the first urban riots in America and they were certainly not the last. The death of Martin Luther King in 1968, for example, sparked riots in over 100 US cities. Further rioting in Los Angeles in April 1992 saw 54 dead. But nothing on this scale had ever been seen before. The causes were a familiar litany of urban deprivation and racial tension, exacerbated by brutal policing and sweltering summer temperatures. The grievances may have been legitimate but the apparent course of any such protests was a rapid descent into looting and larceny. The urban riot and its accompanying scenes of bloodied protestors, battered police, burning cars and smashed buildings had soon become an uncomfortably settled feature of twentieth- and twenty-first-century life.

Almost exactly this volatile mixture was behind the sudden outbreak of rioting in Brixton in south London in April 1981. If smaller in scale, it lacked nothing in nastiness. Much the same happened again in Brixton four years later. Cities across France were rent by similar outbreaks of violence in the autumn of 2005, the only difference being that a religious dimension entered the equation: the rioting youths were predominantly North African Muslims in origin who felt themselves yet further dislocated from mainstream society. Religion was at least nominally the cause of the

rioting between Christian and Muslim gangs in the Nigerian city of Jos in the early part of 2010, which left almost 1,000 dead.

Urban unrest of a very different kind happened in Paris in May 1968 when, for a moment, a radical student intelligentsia seemed about to sweep all before it. Superficially, the Parisian *évènements* (simply, "events") were a continuation of the French tradition of "direct action", violent social upheavals that can be traced to the French Revolution itself. Nineteenth-century France saw a succession of bloody insurgencies, notably in 1830, 1848 and, most frighteningly, in 1871 – the Commune – when in one week the French army in effect declared war on rioting Paris, slaughtering perhaps 20,000.

But there were two obviously different aspects to the student protests of May 1968. The first was that they were exactly that, student protests. All of a sudden, a heady sense of newly liberated youthful idealism that would smash the complacent and backward-looking old order to usher in a euphoric epoch of progressive liberalism was created. No less significant, it prompted a wave of strikes. By mid-May, 10 million workers had downed tools. The government came close to falling.

The other key point was an underlying sense of anarchy. It was certainly the case that the protests had been seized on by a variety of fringe groupings to exploit them for their own revolutionary ends. But what was striking was the extent to which the majority of the protestors embraced this destructiveness,

building barricades, burning cars and hurling paving stones and Molotov cocktails. That these startling events galvanized world opinion and – as important – decisively reinforced a belief in a youth-led counter-culture across the Western world is indisputable.

Whatever its idealism, Paris in the spring of 1968 bred the notion that violence in pursuit of ideals was legitimate. The Poll Tax riots in central London in March 1990, for example, were marked only by the violence of the Paris *évènements* rather than by their youthful drive. In the same way, there was an unmistakeable sense of threat in Seattle in November 1999, when at least 40,000 gathered to protest against globalization and what they asserted was the deliberate marginalization of the world's poorest and most vulnerable in the interests of big business. The same criticism can be levelled against the so-called "Carnival against Capitalism" in London in June 1999, when the City of London was effectively closed down by gangs revelling in their nihilistic violence. It was the mob at its most pointlessly destructive in the cause of fashionable agitprop. The same deliberate thuggishness pervaded the student riots in London in the autumn of 2010. It is hard to see any essential difference between this kind of looting and the mayhem occasionally created by rioting sports fans. Not even the rioting in Montreal in 1993 after the final of the Stanley Cup, when 47 police cars were destroyed, was more senselessly destructive. If there is a difference, it is that such riots are spontaneous whereas those in Seattle and London and

elsewhere had always been intended to cause maximum destruction.

That said, there is nothing inherently violent about mass protest. In September 2002, the Countryside Alliance organized a march in London in which 400,000 took part. It was entirely peaceful. What was different was that it was a law-abiding middle class taking to the streets, protesting against the disparaging treatment of rural areas, including the poorly thought-out ban on blood sports introduced by the governing Labour Party. Put briefly, it was a demonstration in favour of precisely the conventional values the left dismissed as reactionary. Similarly, demonstrations in America organized by the libertarian Tea Party after its foundation in 2009 have always been peaceful, despite a tendency by commentators to paint this reflection of a swathe of conservative middle-American opinion as a sinister far-right organization. Perhaps most tellingly of all, the Paris *évènements* of 1968 came to a sudden halt after a month of chaos when a crowd of 100,000 gathered on the Champs-Elysées in response to an impassioned televised appeal by President de Gaulle for an end to the violence. The solemnity of the new demonstrators shocked France back to normality.

However, volatility remains a hallmark of much political protest, never more so than when generated by economic hardship. Egypt in 1977 was gripped by riots protesting against rising food prices, the so-called "bread riots". It took the army and 79 deaths to restore order. Much the same was true of the food riots in

West Bengal in 2007. In Argentina in 2001, it was predominantly the middle class that rose in protest against the government's attempts to overcome the country's chronic debts. Efforts by the beleaguered government of Fernando de la Rúa to impose a news blackout on the unfolding crisis led to the leader's enforced flight from Buenos Aires, as he was humiliatingly airlifted from the roof of the presidential palace in front of vast jeering crowds. The riots in Karachi in May 2007, which left 43 dead and parts of the city gutted, were purely political. As rival political parties resorted to gunfire, the government responded by issuing a shoot-to-kill policy. More recently, the Euro-zone crisis of 2010–11 brought huge numbers onto the streets of Portugal, Spain and, above all, Greece. The prospect of impoverishment in the service of an anonymous entity's greater political goal has never been likely to placate anyone.

There is a difference, however, between national unrest and union activity. By any measure, social justice demands fair treatment for all, and in the face of employer intransigence, organized labour has self-evidently struggled to raise the status of the potentially exploited. The goal achieved, it has no less consistently sought to embed its new status. More especially, it has sought to make strike action an agent of social change. In the West, at least since the end of the Second World War, union muscle-flexing in pursuit of wider political goals has been a potent source of disruption. (In the Soviet-dominated East, any such actions would have been dismissed as "counter-revolutionary" and their supporters

given ample opportunity to contemplate their "false consciousness" in Siberia.)

Post-war Britain provided a textbook case of union power at its most damaging. A faltering economy found itself a ready victim of unions making the most of weak labour legislation. The two-year Grunwick dispute in north London saw thousands of activists picketing against a handful of non-union workers at a photo-processing laboratory. The same tactics were deployed by the print unions at Wapping in east London in 1986–87 as they attempted to close the newly opened News International newspaper plant there. Both disputes ended in defeat for the unions, but union power generally remained a force to be reckoned with, in political as well as practical arenas. The miners' strike of 1984–85, however, became a direct clash with the Thatcher government, which – all too aware of the miners' strikes of 1972 and 1974 that had led to the collapse of an earlier Conservative government after more or less paralyzing the country – eventually broke the strike power of the unions. Traditionally the most powerful union in Britain, the National Union of Mineworkers was left an emasculated shadow of itself, and former coal-mining areas suffered severe unemployment and hardship.

In France, on the other hand, union power has generally been more astutely deployed. Over two months at the end of 1995, what amounted to a general strike in protest at raising retirement ages saw the country almost grind to a halt. Importantly, at no stage did the unions lose public support. The French government was forced into a humiliating climb-down.

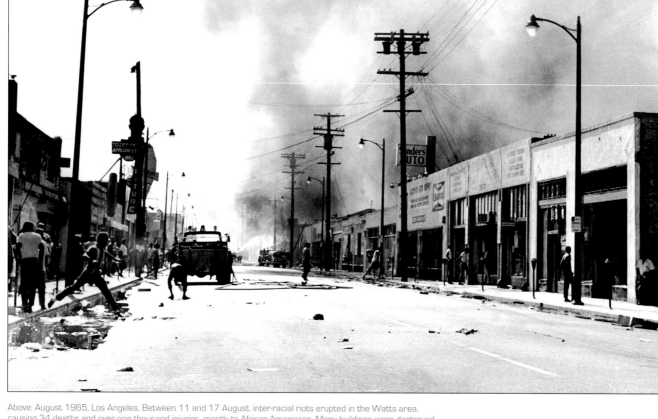

Above: August 1965, Los Angeles. Between 11 and 17 August, inter-racial riots erupted in the Watts area, causing 34 deaths and over one thousand injuries, mostly to African-Americans. Many buildings were destroyed.
Photographer unknown

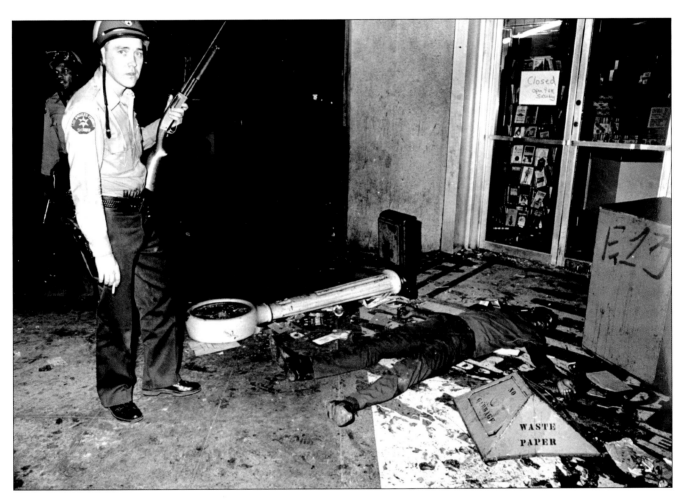

Above: Summer 1965, Los Angeles. An armed policeman stands beside the body of a black American protester during the riots in the Watts district. Harry Benson

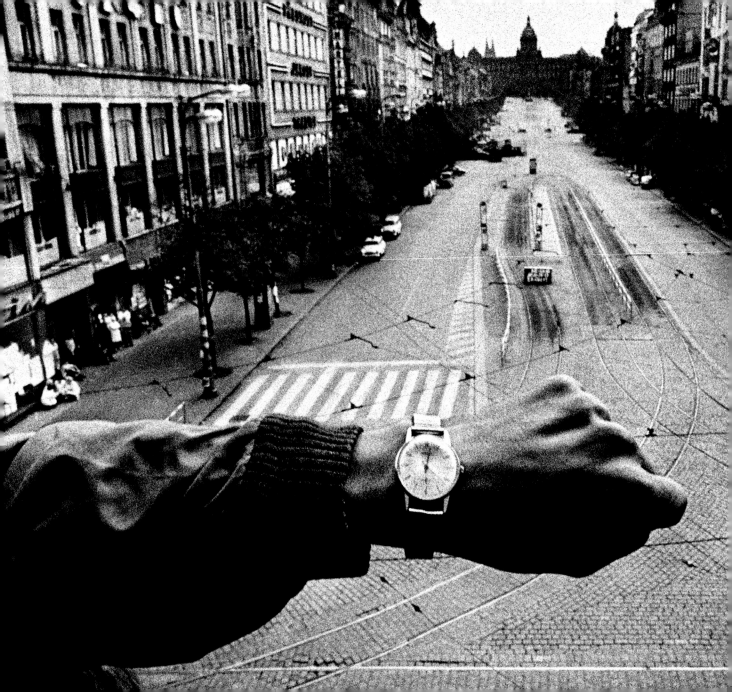

" The Russian invasion of Czechoslovakia in August 1968 concerned my life directly. It was my country. I took these photographs for myself, not for a magazine. It was only by chance that they were published. I wasn't a reporter. I had never photographed anything that you might call "news". Suddenly, for the first time in my life, I was confronted with that kind of situation. I responded to it. I knew it was important to photograph, so I photographed. I didn't think much about what I was doing. Later, some people told me that I could have been killed, but I hadn't considered that at the time.

I think the series of my photographs of the Russian invasion are important as an historical document, it shows what really happened in Czechoslovakia in 1968. But perhaps a few of the photographs – the best ones – are something more. They are the ones where it's not important who's Czech and who's Russian, the ones where the important thing is that one person has a gun and the other hasn't. And the one who hasn't is, in fact, the stronger. "

Josef Koudelka

Left: August 1968, Prague, Czechoslovakia. Soviet forces appear on the streets. Josef Koudelka

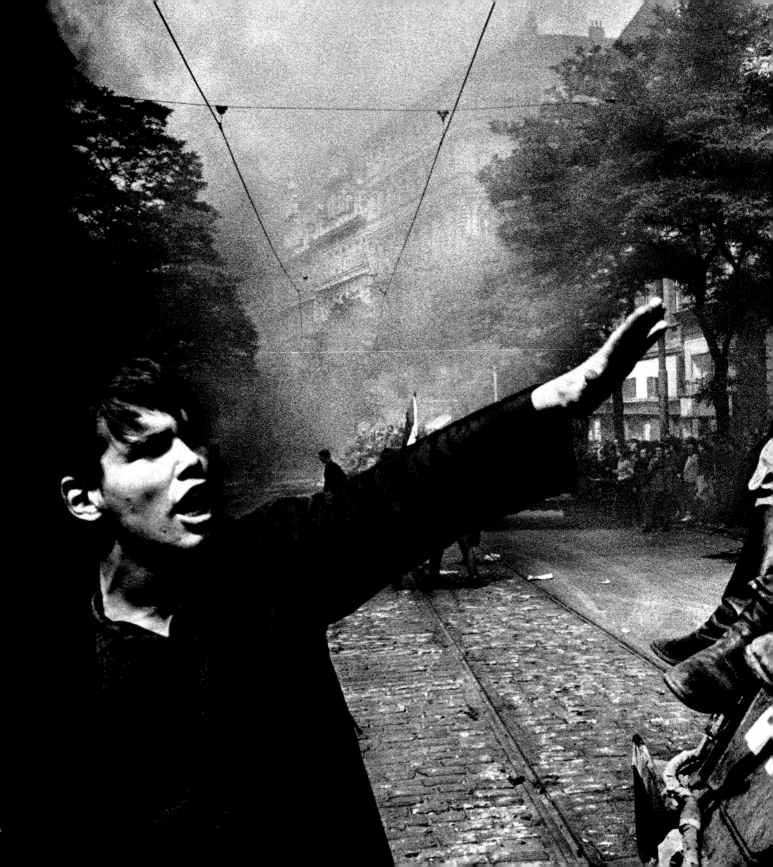

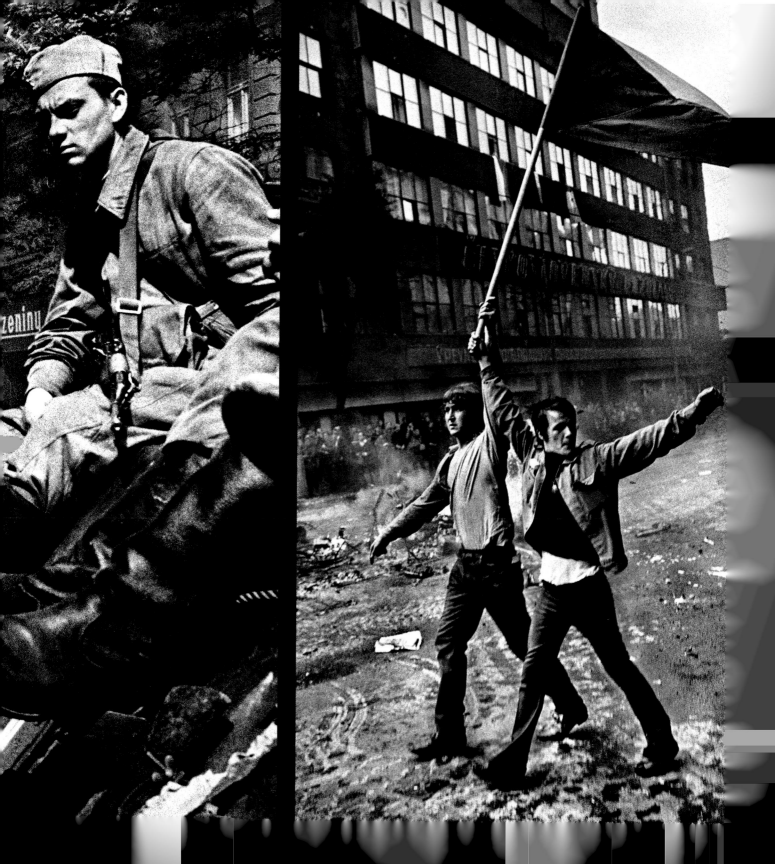

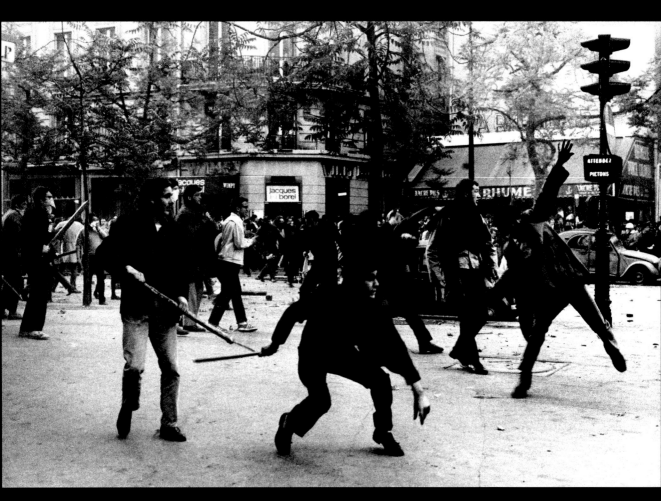

Above: 6 May 1968, Boulevard Saint-Germain, Paris.
Students hurling projectiles at the police. Bruno Barbey

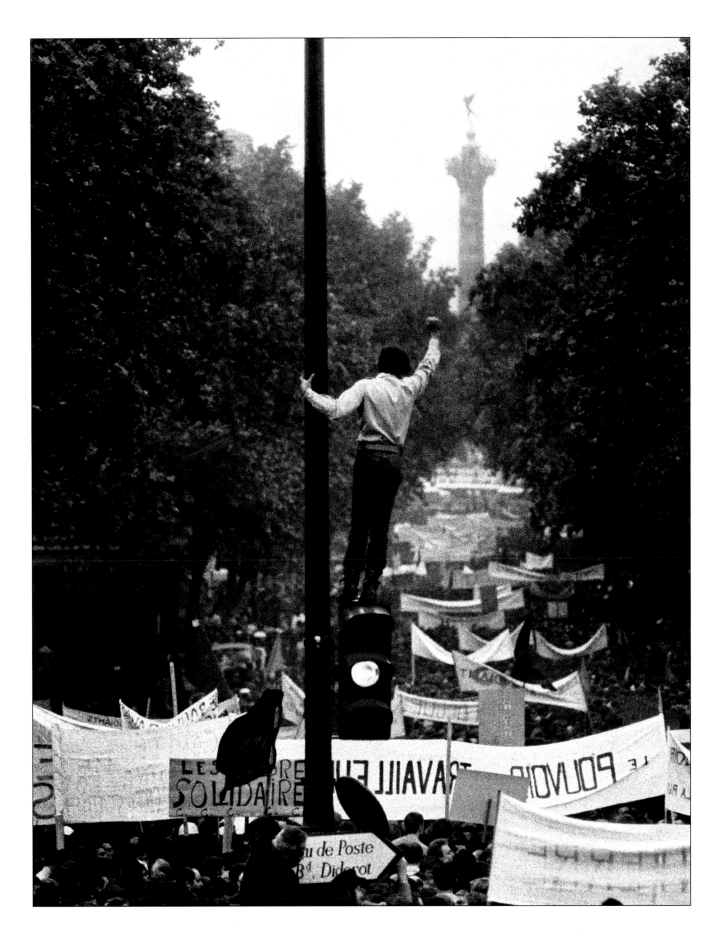

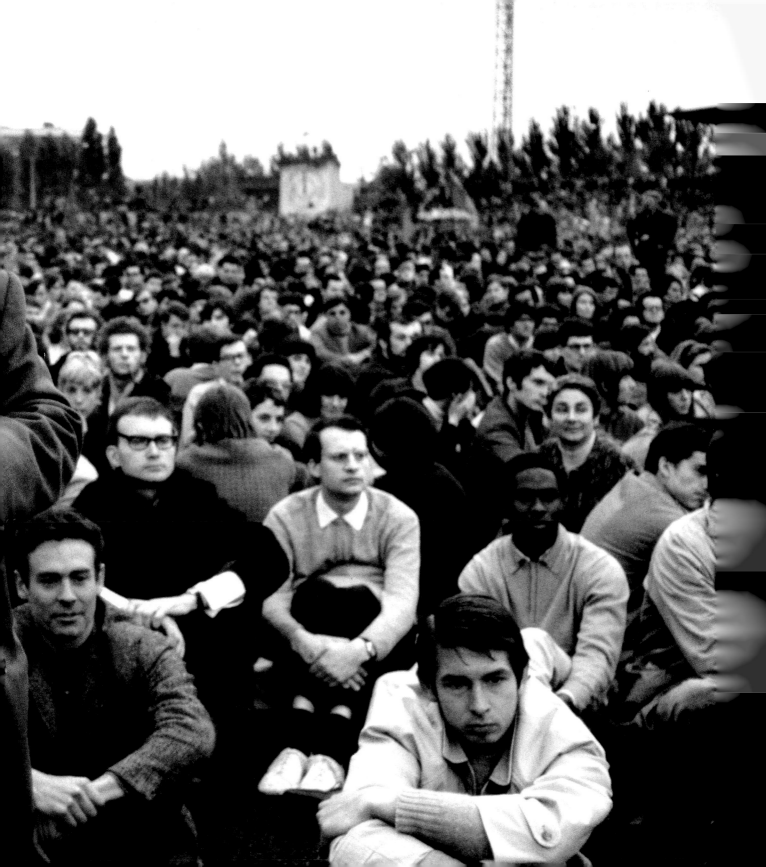

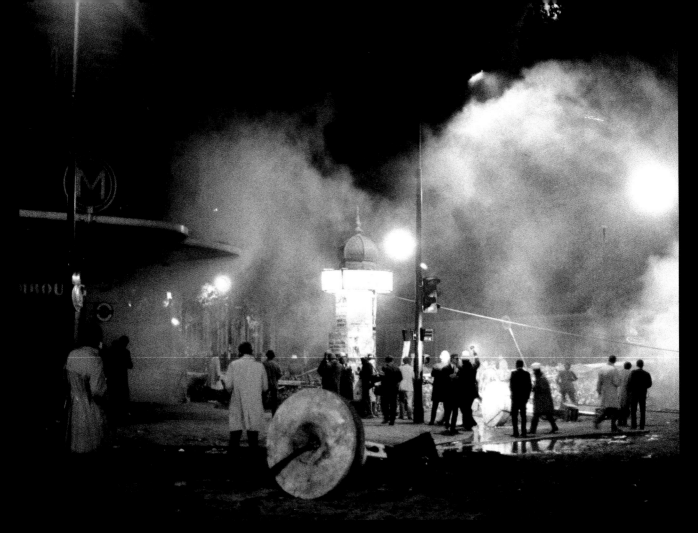

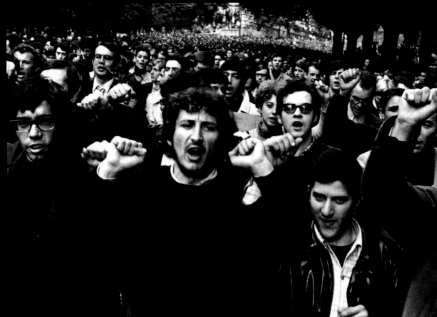

Above: 10 June 1968, Luxembourg metro station, Paris. A burning barricade. Bruno Barbey

Left: May 1968, Paris. Workers and students marching to the Charléty stadium.
Henri Cartier-Bresson

Right: 30 May 1968, Champs-Elysées, Paris. A march in support of President Charles de Gaulle against the student/worker uprising. Although de Gaulle was re-elected the next month, he suffered from an authoritarian, old-fashioned image and resigned in 1969. Bruno Barbey

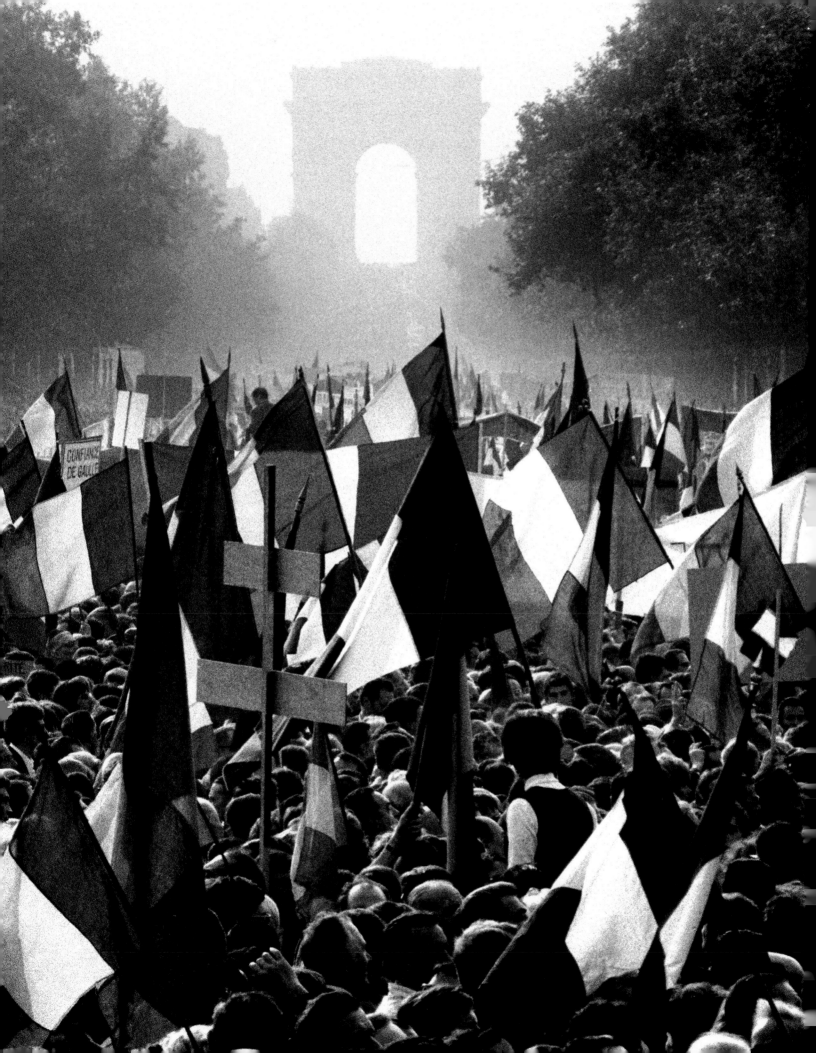

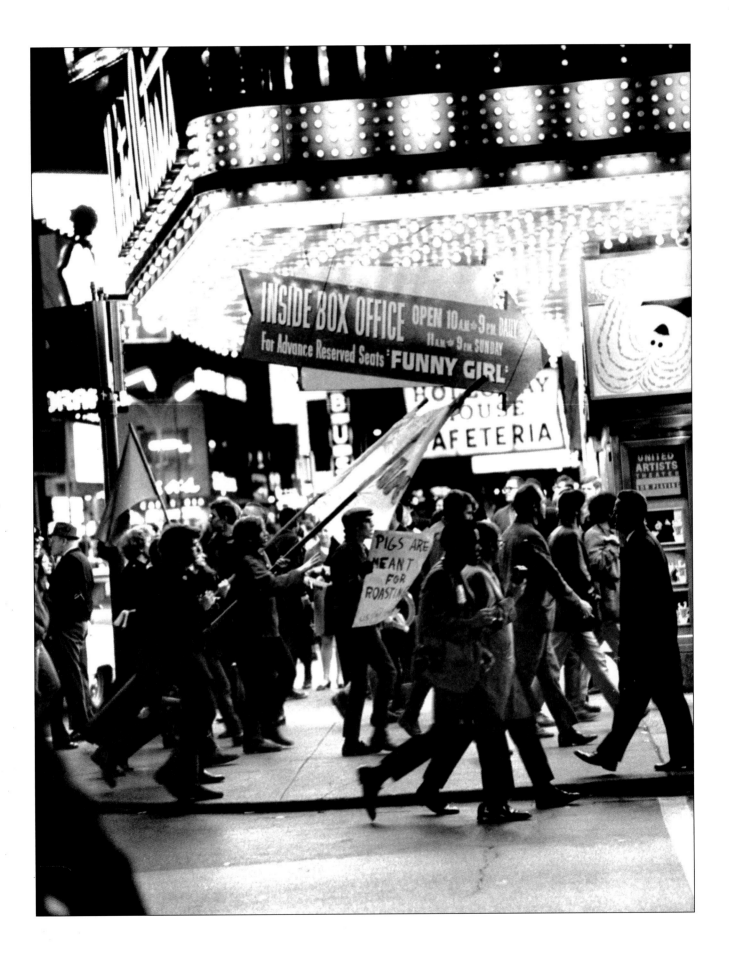

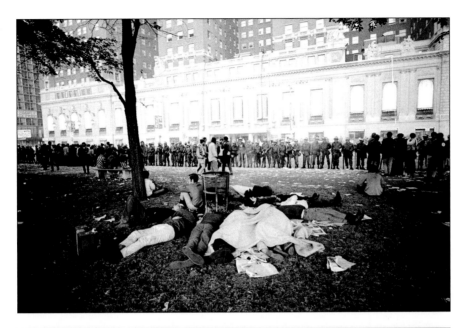

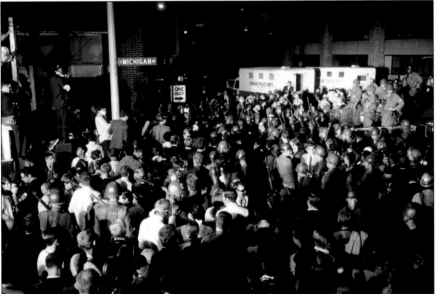

Left: 6 November 1968, Chicago. Students marching at night carrying protest signs as part of their anti-election demonstrations. Their objective was to challenge establishment ways. Michael Mauney

Top: 28 August 1968, Grant Park, Chicago. A group of Yippies – members of the Youth International Party, known for anarchistic street-theatre pranks – sleeping under the watchful eye of the National Guard in front of the Hilton Hotel. Photographer unknown

Above: August 1968, Chicago. Contained by the National Guard, Yippies demonstrate in front of the Hilton Hotel, where many delegates to the Democratic National Convention were staying. The Yippies' aim was to distract public attention from politics and show people how little control they had over political process. Julian Wasser

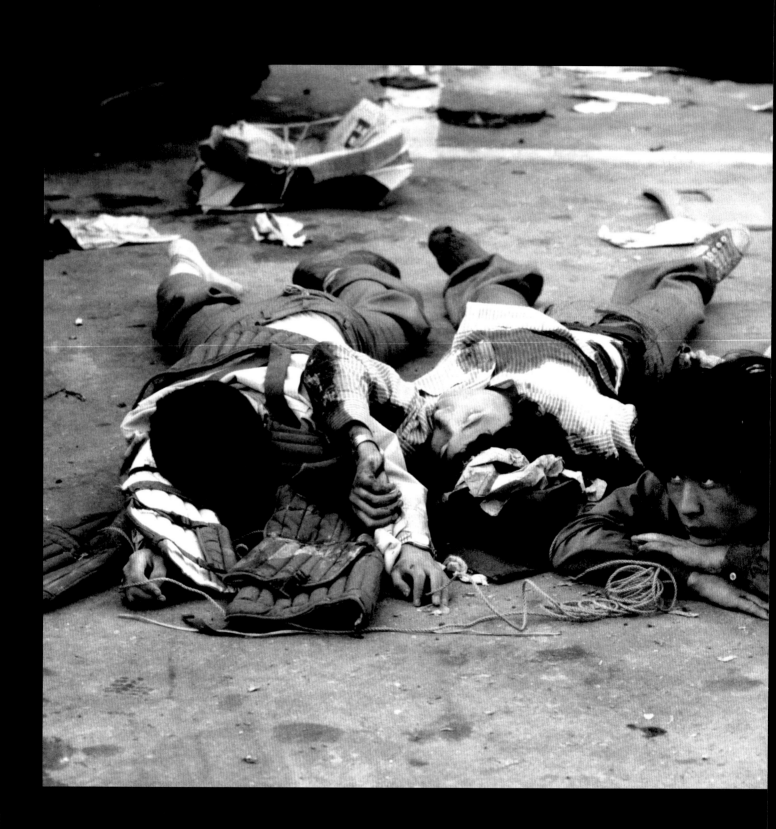

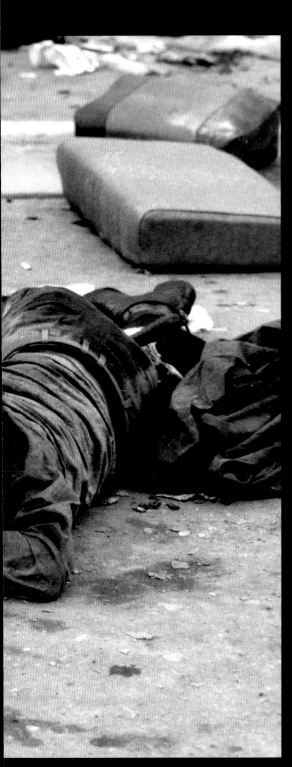

Left: May 1980, Kwangju, South Korea. The massacre of students and other pro-democracy demonstrators challenging the martial law imposed by Major General Chun Doo-hwan. François Lochon

Below: May 1980, Kwangju, South Korea. The massacre in Kwangju, in which hundreds of students were killed and many more injured, tortured or imprisoned by the South Korean military. Chun's military regime survived, despite ongoing demands for greater democracy, until 1987. François Lochon

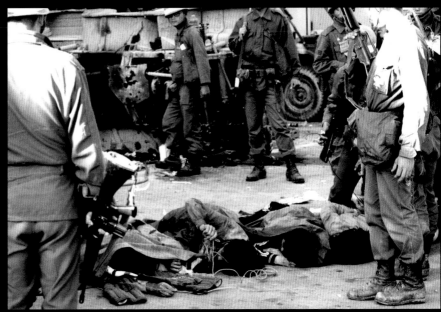

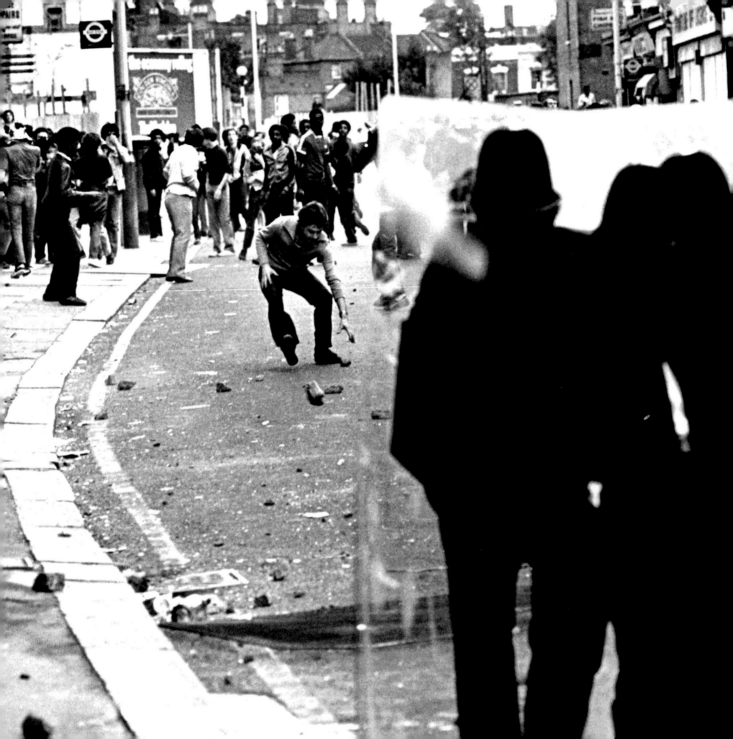

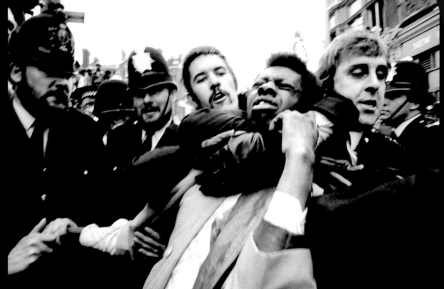

Brixton, spring/summer 1981. The Thatcher government had really got into its stride, attacking the unions, workers, the poor and the vulnerable. Tension had been rising as the police were increasingly being seen as a political tool for the Conservative Party. The oppressive and racist police presence that had sparked the April uprising with the deliberately oppressive Swamp 81 operation had been strengthened and they were acting in an increasingly provocative manner. When the resentment finally boiled over it was quickly followed by further rioting across the whole country.

The April uprising in Brixton was my first experience of rioting. It was also the first time that I'd seen police in retreat from an infuriated community. Over the April weekend that began the riots I was repeatedly attacked by both police and rioters. It was a rapid education in photography under pressure and self-preservation.

David Hoffman

Left: Spring/summer 1981, Brixton, south London. Stones and other projectiles are thrown at police as racial tension boils over, exacerbated by recession and high unemployment. David Hoffman

Above: 1977, Lewisham, south London. Police make an arrest during race riots. The neo-Nazi National Front had tried to stage a march through the area, clashing with anti-fascists. The police used riot shields for the first time. Peter Marlow

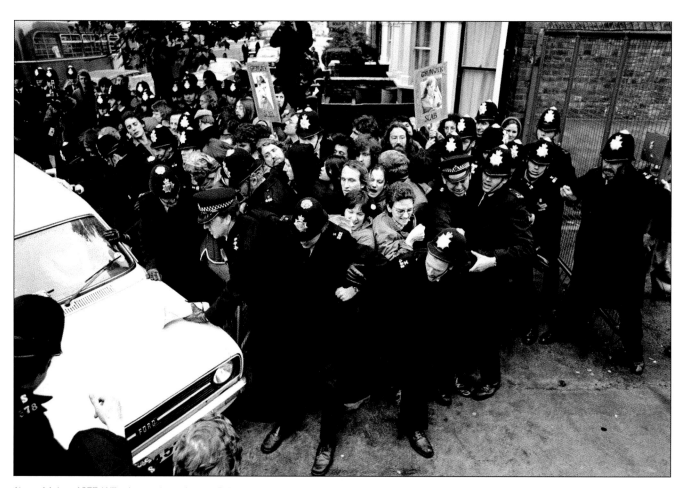

Above: 14 June 1977, Willesden, northwest London. Police struggle to hold back pickets as a van enters the main gate of the troubled Grunwick film-processing firm where a strike ran for two years, 1976–78. The latter half of the 1970s was a period of huge industrial unrest in the UK, and the Grunwick strike was one of many across all sectors. Photographer unknown

No

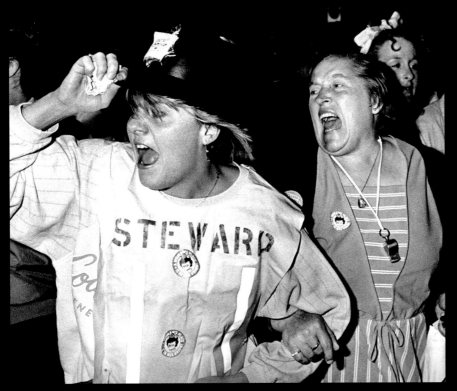

Left: 1986, Wapping, east London. Pickets at the newspaper workers' strike. News International had moved its newspaper printing from traditional labour-intensive methods in Fleet Street to electronic methods in Wapping. After a year of protests, the employers triumphed and the strike collapsed.
David Hoffman

Below: 1986, Wapping, east London. Police with riot shields at the News International strike.
David Hoffman

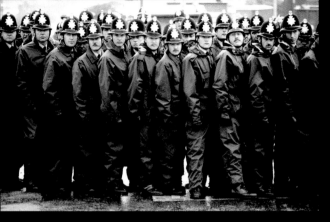

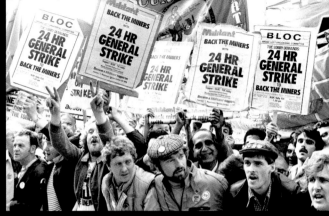

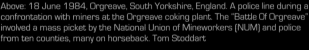

Above: 18 June 1984, Orgreave, South Yorkshire, England. A police line during a confrontation with miners at the Orgreave coking plant. The "Battle Of Orgreave" involved a mass picket by the National Union of Mineworkers (NUM) and police from ten counties, many on horseback. Tom Stoddart

Above right: 3 September 1984, Brighton, England. A crowd gathers outside the Trades Union Congress (TUC) conference hall, demanding a general strike to show support for the ongoing miners' strike. The strike had commenced on 12 March, and would continue until March 1985. Peter Skingley

Right: 1984–85, northern England. Miners' families join the demonstrations. Here a protester wears a mask caricaturing Prime Minister Margaret Thatcher and a badge declaring "coal not dole". The miners were ultimately defeated, the vast majority of mines closed, and the grip of the trades unions broken; many former mining towns, especially in the north of England, suffered great hardship for decades. Thomas Haley

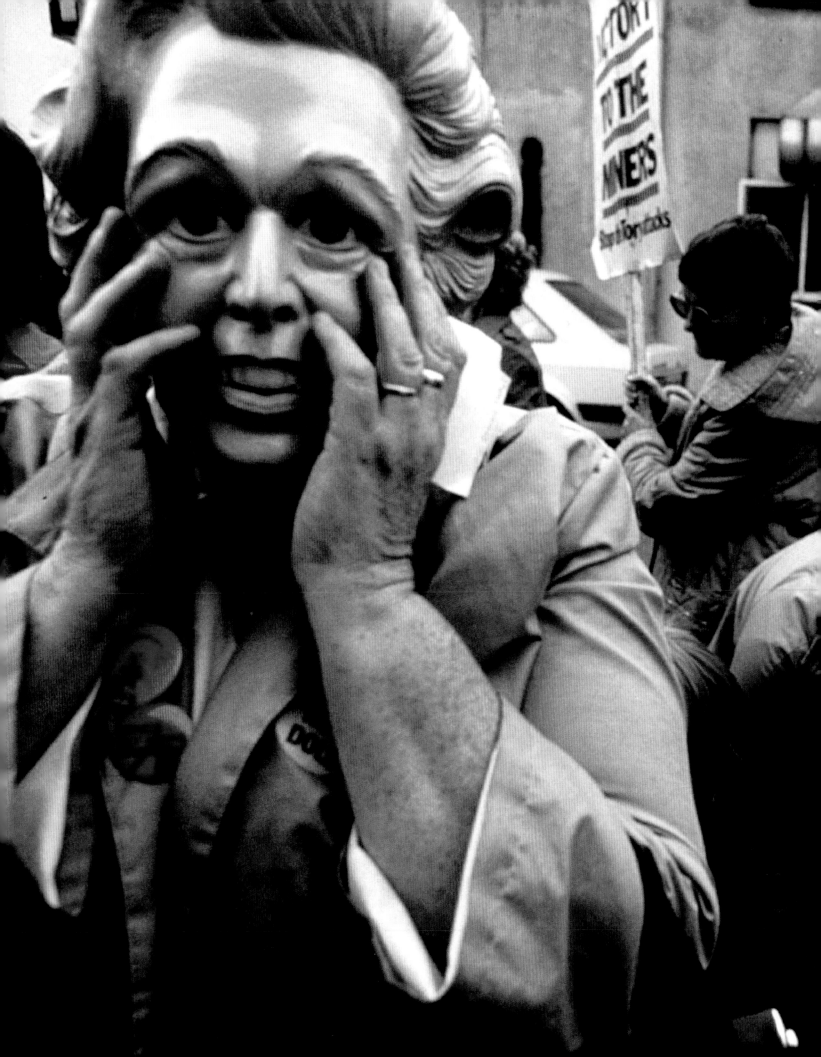

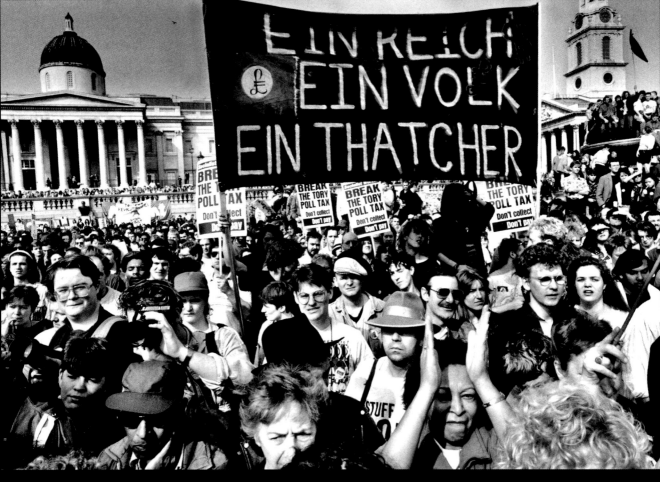

EIN REICH
EIN VOLK
EIN THATCHER

BREAK THE TORY POLL TAX Don't collect Don't pay

"

This was one of the best days I have ever spent taking pictures. I had been flattened a couple of times by "testerical" coppers but was nonetheless motoring well by mid-afternoon when Grand Buildings was torched by the anarchists, the flames adding to the festive atmosphere.

The Poll Tax had been a festering sore for what felt like an age and after a few earlier demos that had been crushed by police action this one had really kicked off. I found it quite hard work, before I even reached Trafalgar Square I'd had a police shield driven edge-on into my throat by a cop who left the Downing Street cordon and ran across Whitehall at me just for the privilege.

The air was crackling with energy. Random truncheonings, police vans driven into the crowd and mass charges by riot plod had only reinforced people's determination to force some democracy down Thatcher's throat.

I was watching in the square as the cops lost it early on. Just before this shot I'd been trying to shelter with three cops behind a pole. They were more scared than I was and the pole wasn't entirely adequate as protection.

When this scene unrolled in front of me I sprinted out in front of it, grabbing four frames before making my excuses and running away. By this time I'd had the hair on one side of my head burnt off by an exploding motor bike, my knee mashed by a scaff clamp hurled from the top of the burning offices and had been tumbled a dozen times by cops, horses, rioters and vans. I'd never been happier.

"

David Hoffman

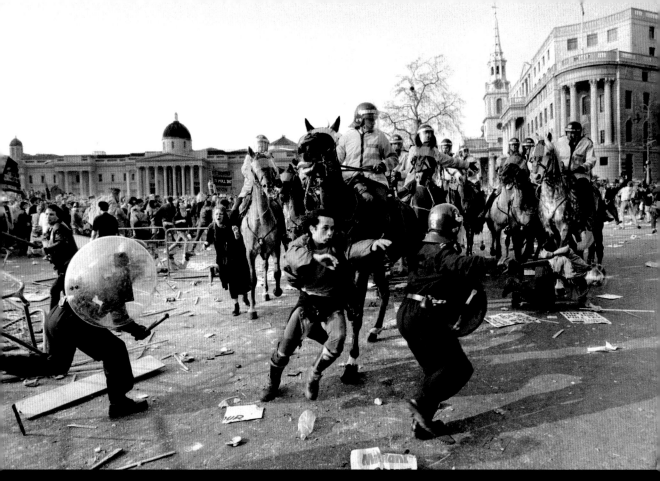

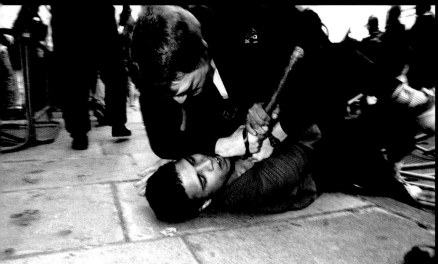

Opposite: 31 March 1990, Trafalgar Square, London.
The poll tax riot: an outpouring of public protest
against the Community Charge, known as "poll tax",
a flat-rate tax on all adults which was seen as placing
an unfair burden on the poor. The tax was introduced
in Britain in 1989/90, under Margaret Thatcher,
and replaced in 1993. The banner implies parallels
between Thatcher and Hitler. David Hoffman

Above: 31 March 1990, Trafalgar Square, London.
Protesters clash with riot police on horseback and on
foot. David Hoffman

Left: 31 March 1990, London. A protester is
arrested. David Hoffman

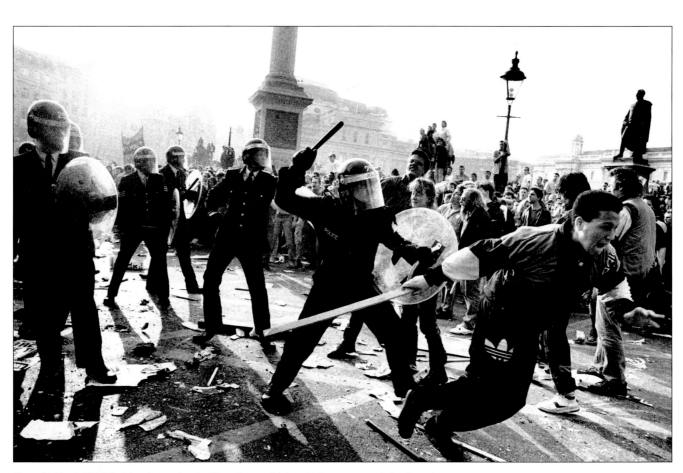

Above: 31 March 1990, Trafalgar Square, London. Riot policemen fighting with demonstrators during the anti-poll-tax demonstrations. Paul Mattsson

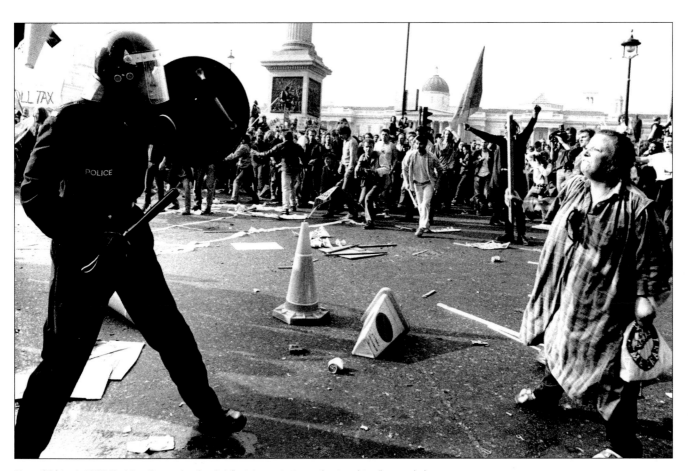

Above: 31 March 1990, Trafalgar Square, London. A defiant demonstrator confronts a riot policeman during the anti-poll-tax protest. Paul Mattsson

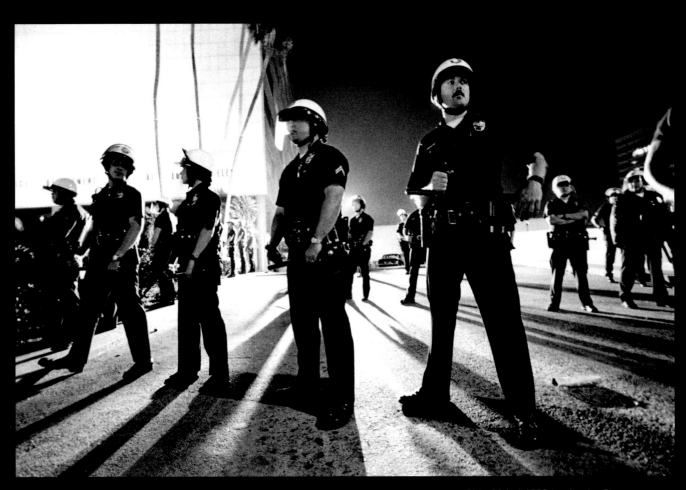

Right: 29 April 1992, Los Angeles. Rioters overturn a
parking-attendant booth at the LAPD Parker Center.
Ted Soqui

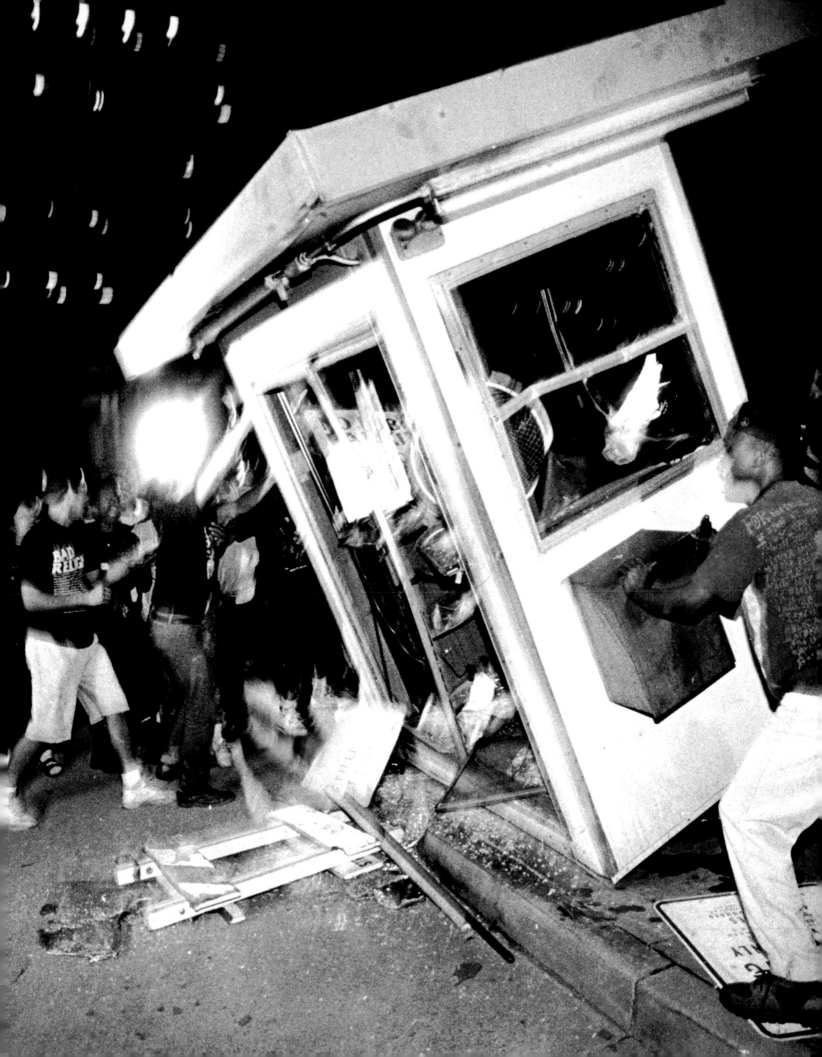

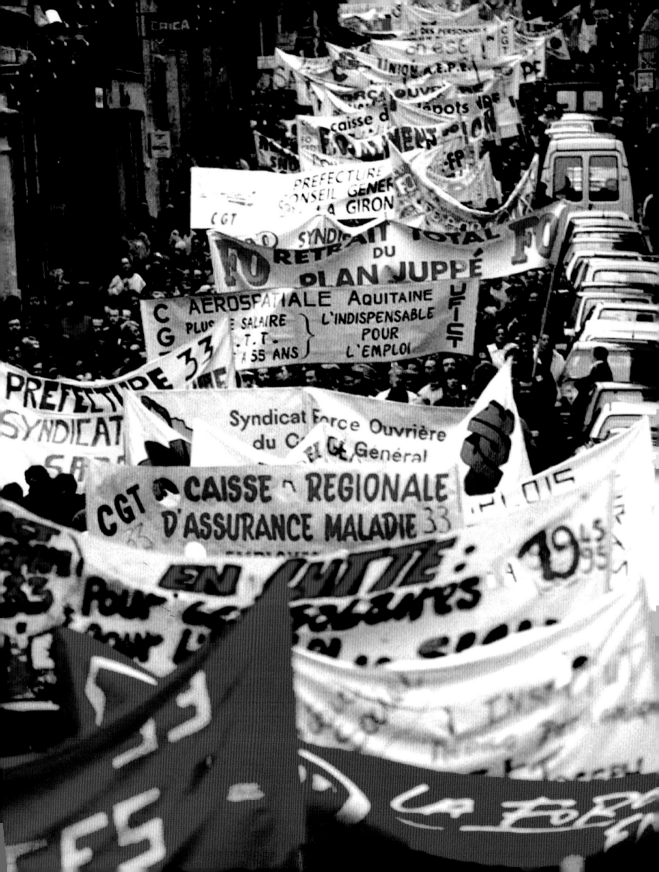

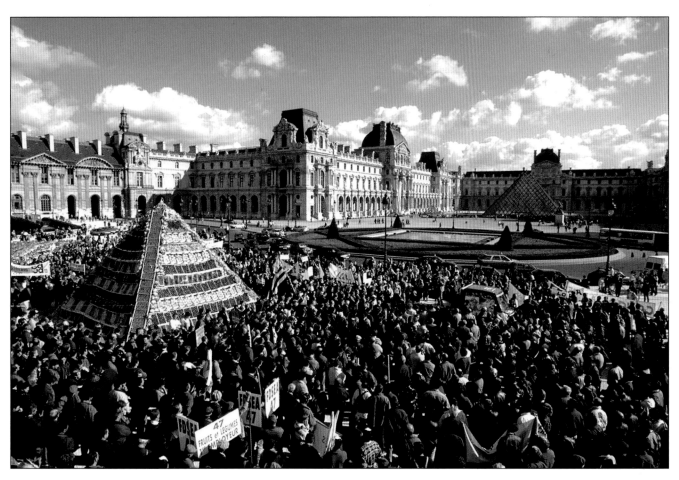

Left: 12 December 1995, Bordeaux, France. Brandishing a sea of banners, 35,000 demonstrators take to the streets to oppose French Prime Minister Alain Juppe's plans to reform the welfare system and health service. Derrick Ceyrac

Above: 25 October 1995, Paris. A demonstration by market gardeners against tax reforms and unfair competition from supermarket chains. Alain Nogues

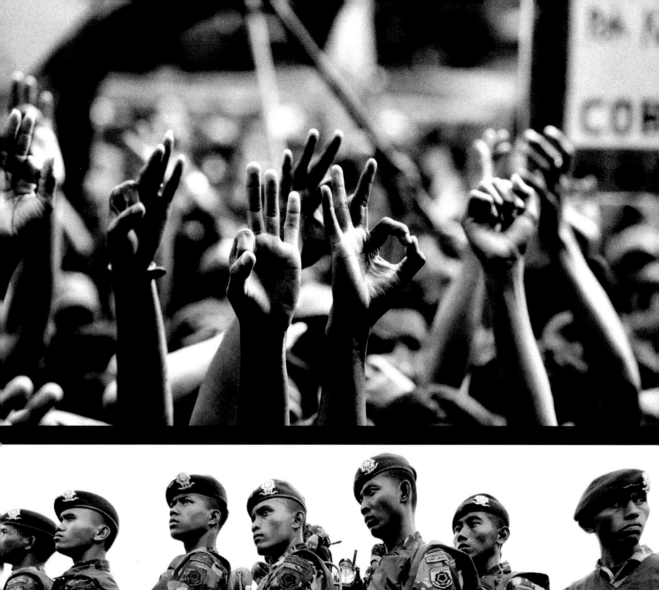
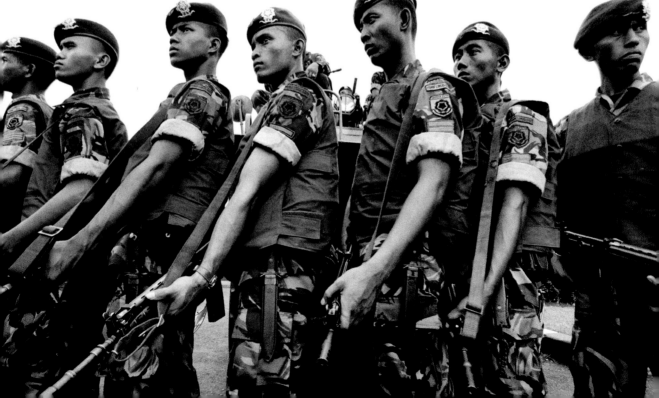

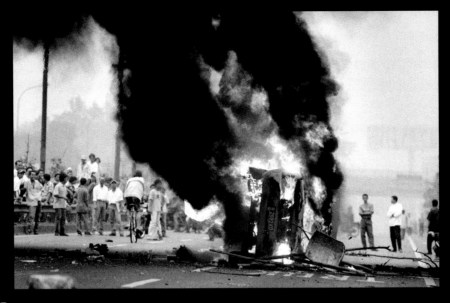

" I arrived in Jakarta on one of the biggest days of protest against President Suharto. He had been President of Indonesia for more then 35 years. This was the beginning of the Asian economic crisis and Suharto was losing control. The rupiah had fallen in value more then 300 per cent. From the airplane I could see the fires raging around the city. As soon as we landed I got an official airport taxi. We tried heading toward the city centre but it was impossible as the main toll road was blocked. So the driver and I had to go the long way around the city to get to my hotel where I could drop my belongings and hit the ground to see why the protests were raging so out of control. The roads were such a mess – about a mile from my hotel was a massive sea of people. The people were streaming in and out of a shopping mall. The police were just watching. I couldn't believe my eyes. At one point a teenage kid was carrying a cash register. As I continued toward the city centre I came upon an overpass, under it was a car turned on its side and completely engulfed in flames. Clearly President Suharto wasn't in control of Jakarta any longer. The army had been called in to control the looting and chaos but after 35 years of strong-arm rule these rioters weren't deterred. It was the beginning of the year of living dangerously. Violence gripped Indonesia.

A few days later when the students had massed to march on parliament the army set up to control the crowds. At some points the army would surround the entrance to the buildings but the students had already encamped themselves on the grounds. It was sweltering hot and the humidity was off the charts. The rain would come and go, cooling things off. The grounds of the parliament were so littered with trash that every step was on a water bottle or a newspaper. The students wouldn't leave until their political demands were met. A few days later President Suharto relented and resigned from office. He was succeeded by Jusuf Habibie. Habibie would serve until the first free elections were held in 1999.

In 1999 Indonesians had embraced democracy and were fervent supporters of the election process. Everywhere you went in Jakarta there were party flags and political advertising. The election field was crowded with candidates. One of the most popular candidates was Megawati. She had the biggest crowds and the most vocal supporters. Her campaign had hand signs, songs and logos. The logos like graffiti were all over, some supporters even body-painted the logo. It was as intense a political manifestation as I had ever experienced. Indonesians were experiencing political freedom for the first time in modern history. "

Andrew Kaufman

Left, top: 1999, Jakarta, Indonesia. Supporters of Megawati, daughter of former President Sukarno, flash her symbol during her election campaign. Andrew Kaufman

Left: Summer 1998, Jakarta, Indonesia. Soldiers guard parliament after street protests had forced the president's resignation. Andrew Kaufman

Above: Summer 1998, Jakarta, Indonesia. A car set on fire by protesters. Andrew Kaufman

"
This man, along with a few thousand others, was on an anti-Habibie demonstration in Jakarta. Tens of thousands were marching through the business district calling for the predecessor of Suharto to also resign. I was walking backwards in the middle of the crowd when suddenly sunlight reflecting off office towers shone right on the protestors. The demonstration turned more violent later in the evening but during the late afternoon it was simply a sea of humanity.
"

John Stanmeyer

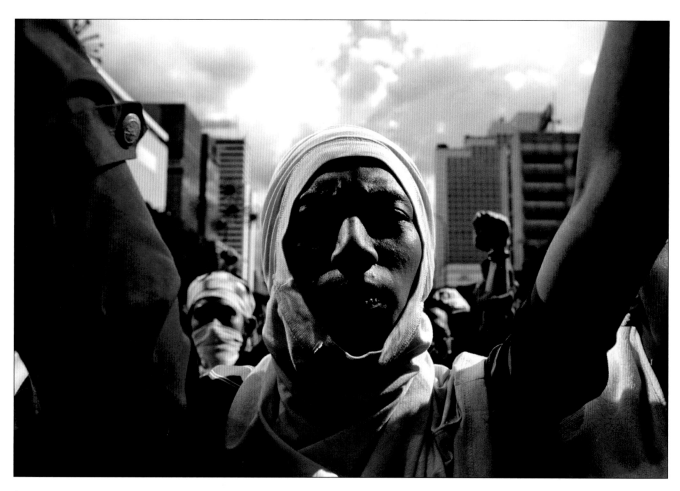

Above: November 1998, Jakarta, Indonesia. Students demonstrating against President Habibie.
John Stanmeyer

Right: 20 December 1999, Jakarta, Indonesia.
Megawati's supporters hear the news.
John Stanmeyer

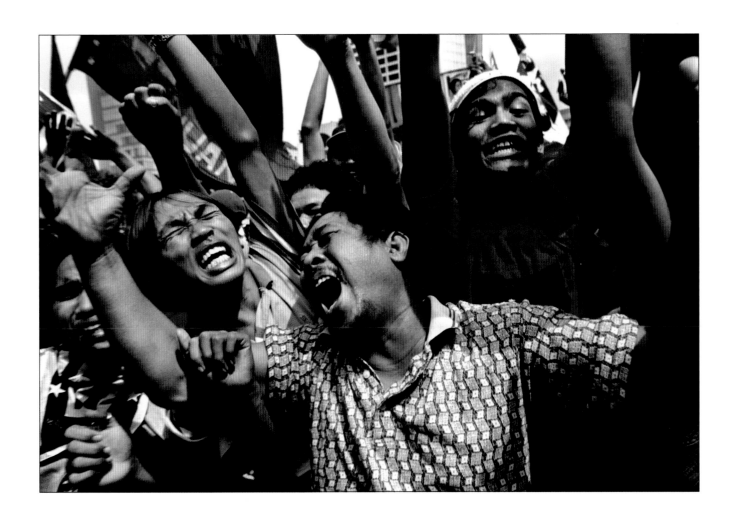

These young men broke out in rage and anger right at the moment they learned the election of their presidential candidate, Megawati Sukarnoputri, was revoked. It took place in downtown Jakarta at the famous Plaza Indonesia roundabout. The event transpired right in front of me. No special positioning. Didn't feel danger though maybe there were elements to be concerned about which I wasn't aware of.

John Stanmeyer

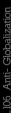

Below: 30 November 1999, Seattle, USA. A protester in front of anti-riot police near the World Trade Organization (WTO) building. Activists demonstrated against globalization and corporate capitalism, demanding better rights for Third World workers.
Karim Ben Khelifa

Right: 1 December 1999, Seattle, USA. Police arrest demonstrators against the WTO meeting.
Karim Ben Khelifa

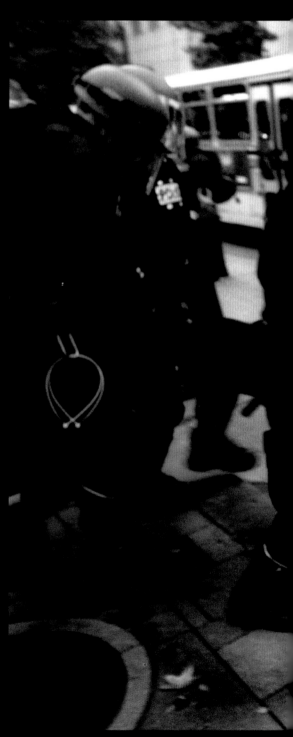

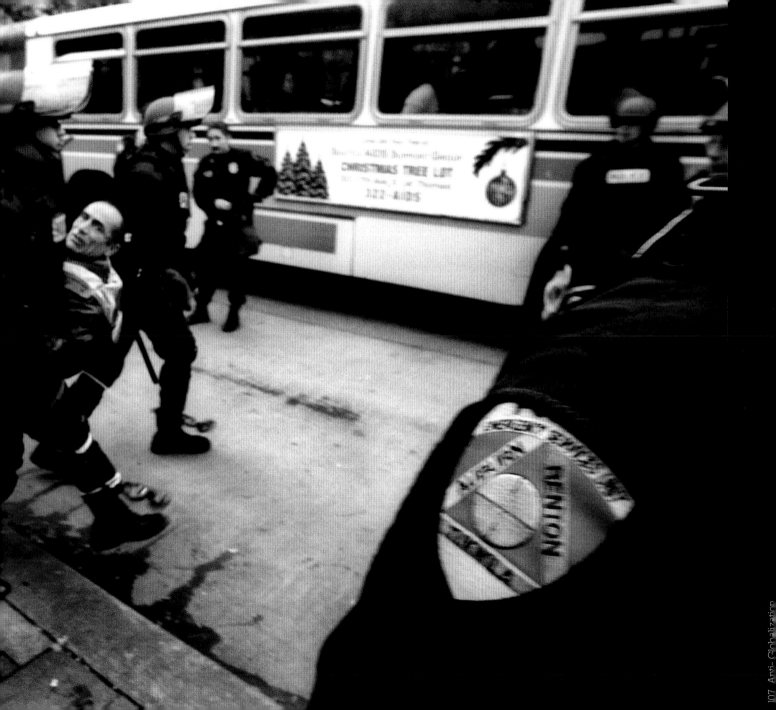

"

I lived in Prague for three years just before the protest against the IMF and World Bank in September of 2000. It was the beginning of my career as a photographer and I learned quickly how important it is to know how to navigate around a city during protests and which narrow, winding streets might get you out of a dangerous situation. While some people visiting for the first time got caught in the middle of the violence, I could easily find quick escapes when it got too violent. I also sensed how important it was to understand the complicated history as it was critical to understanding the mood of the people of Prague. This country and its people had experienced a colossal change as it moved from a Communist to a capitalist state in the decade leading up to the protest and it impacted the mentality of the people living there.

The transition to capitalism began to cause economic problems such as poverty and unemployment and there was disappointment despite the rapid growth of their economy and liberalizing of freedoms such as of speech and a free press. As a result, many disillusioned voters came out to protest against the IMF and World Bank meetings and thousands of activists travelled from all over the world to clash with police in the streets of Prague for several days. Police estimated more than 15,000 protesters were involved.

Police fortified the capital with tanks, tear-gas and water cannons and, in an ironic twist, these same police who may have once worked for the Communists now found themselves guarding multi-national establishments like McDonald's. The Czechs, who were for the most part anxious to move forward with their economy, found themselves in the middle of a heady battle between global anarchists and a young government searching for the right path towards capitalism.

"

Ami Vitale

Opposite and below: 27 September 2000, Prague, Czech Republic. Police in riot gear confront anti-globalization protesters challenging meetings of the International Monetary Fund (IMF) and World Bank. Ami Vitale

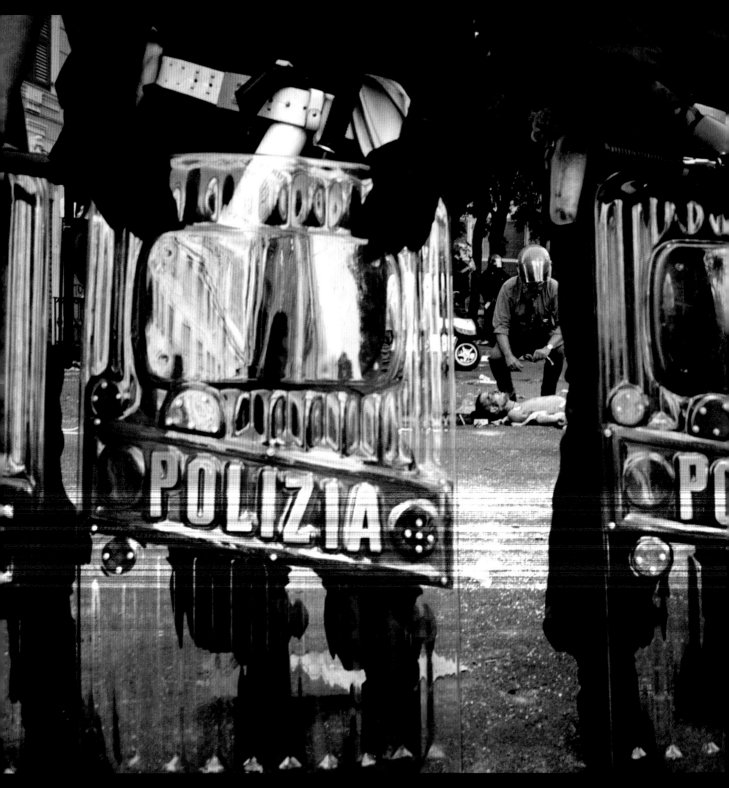

Above: 29 July 2001, Genoa, Italy. Carlo Giuliani was an Italian anti-globalization protester who was shot and killed by police during the demonstrations against the Group of Eight (G8) summit. Antoine Serra

Opposite top: 20 July 2001, Genoa, Italy. Anti-globalization activists throw petrol bombs at police as widespread fighting erupts though the city; some 150,000 protesters took to the streets during the G8 summit. Dylan Martinez

Opposite bottom: 20 April 2001, Quebec City, Canada. A violent anti-globalization protester smashes the window of a Global Television News vehicle during the WTO Summit of the Americas. Larry Towell

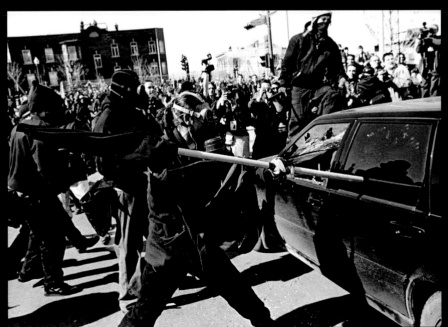

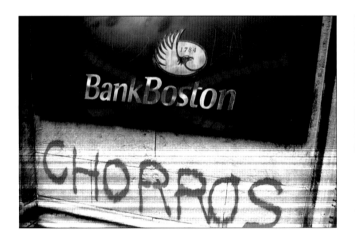

Above left: December 2001, Buenos Aires, Argentina. Graffiti sprayed by angry protesters on the wall of Bank Boston after the Argentinian government had frozen bank accounts. *Chorros* means thieves in the Lunfardo slang used in tango lyrics and in the Argentinian underworld early in the twentieth century. Andrew Kaufman

Above and right: December 2001, Buenos Aires, Argentina. Perónistas hurl rocks at *communistas* during Argentina's economic crisis. Nearly 30 people were killed in violent street protests and food rioting that month. Andrew Kaufman

" It seemed as though the Asian economic crisis had spread. I found myself in Buenos Aires soon after reports of massive crowds of people trying to withdraw their savings from banks all over Argentina. The peso was about to be devalued and Argentinians were desperate. One night during my time in Buenos Aires I was trying to catch up on some office work and I heard outside my windows the neighbours starting to bang pots and pans. Before I knew it there was this cacophony of banging. People started to pour into the streets and they were headed for the Casa Rosada, the president's residence. Before long the Plaza De Mayo was filled with thousands of people banging pots and pans demanding the government fix the banking crisis. Unfortunately things digressed, rocks were thrown, tear-gas was fired and ultimately the police had to disperse the thousands of protesters who late at night had called upon the government to step up and confront these dire circumstances. Argentina was going to default on its IMF loans.

There were street protests every day. Argentina had three new presidents in as many days. The protests were pitting political ideology and party against one another. Before long these political parties were settling their differences with violence in the streets. I was at a rally in the Plaza Jusiticia and some of the supporters had broken off and were milling about on a side street. Then all of the sudden from opposite ends of the streets rocks were being thrown: the *communistas* had confronted the Perónistas. The Perónistas, whose roots are with Eva Perón, weren't going to be manhandled by these political ideologues. I was up close to the rock throwing. Maybe too close as all of the sudden the Perónistas turned and cornered me. I was roughed up but somehow managed to escape. I was rattled – these guys were big like soccer hooligans and they thought I was the soccer ball. Immediately I returned to the plaza and found some respite with colleagues. Moral of the story: don't be alone when two political parties square off and start throwing rocks. Argentina's problems weren't solved that day. "

Andrew Kaufman

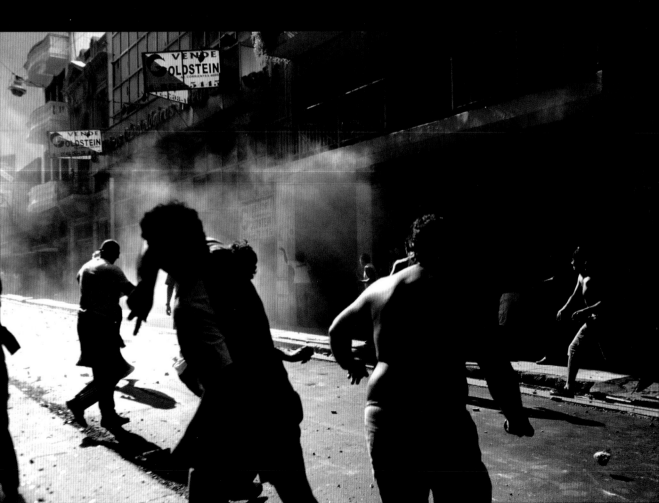

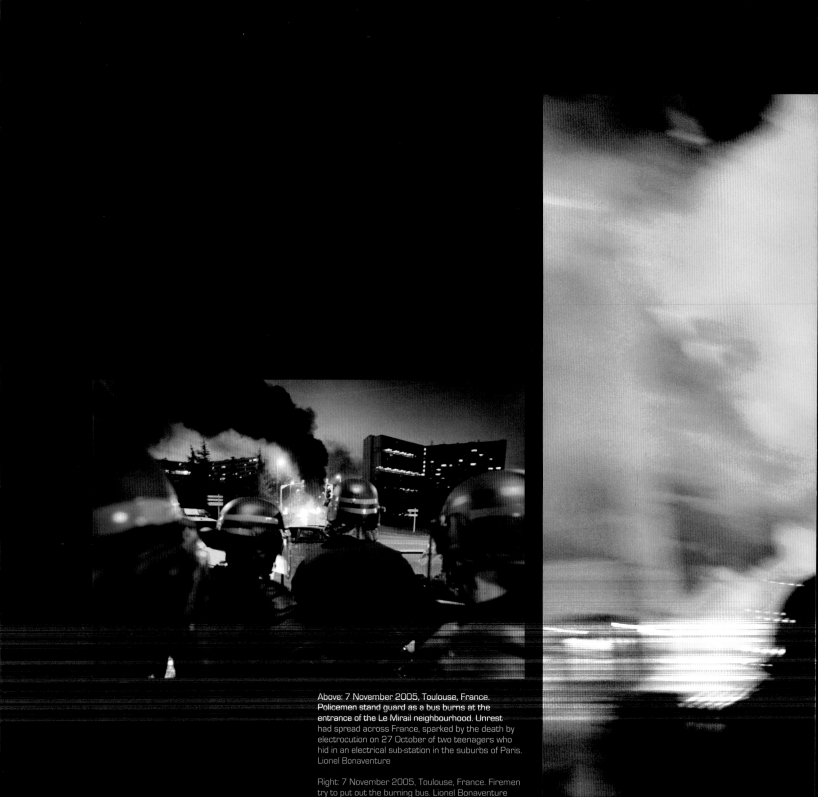

Above: 7 November 2005, Toulouse, France.
Policemen stand guard as a bus burns at the
entrance of the Le Mirail neighbourhood. Unrest
had spread across France, sparked by the death by
electrocution on 27 October of two teenagers who
hid in an electrical sub-station in the suburbs of Paris.
Lionel Bonaventure

Right: 7 November 2005, Toulouse, France. Firemen
try to put out the burning bus. Lionel Bonaventure

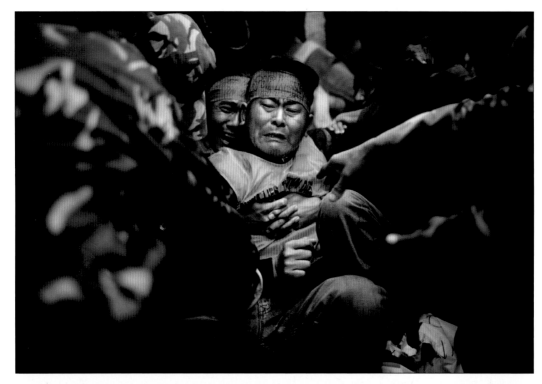

Top: 15 March 2008, Kathmandu, Nepal. Tibetan protesters are removed by Nepalese police from the UN building, where they were demonstrating against Chinese rule in neighbouring Tibet and especially the 2008 Chinese military crackdown. Their headbands demand "stop killings in Tibet". Brian Sokol

Above: March 2008, Dharamsala, Himachal Pradesh, India. In the northern Indian town that houses the Tibetan government in exile, a young Tibetan monk takes part in a candlelit protest against China's rule in Tibet. Atul Loke

Right: 15 March 2008, Kathmandu, Nepal. An elderly Tibetan wails after the protest at the UN building, during which Nepalese police arrested around 20 people and baton-charged protesters. Brian Sokol

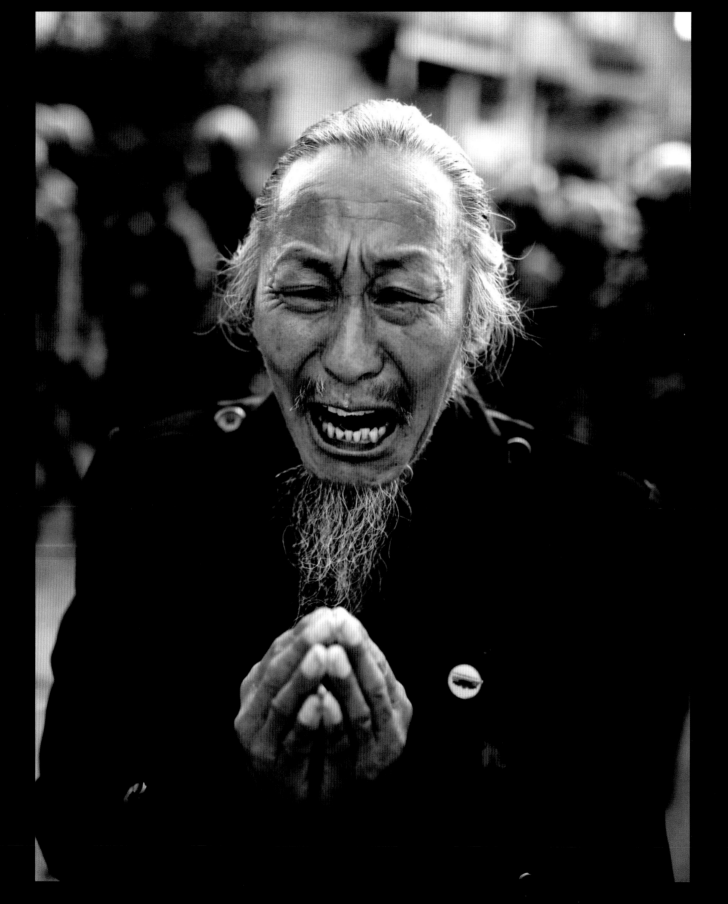

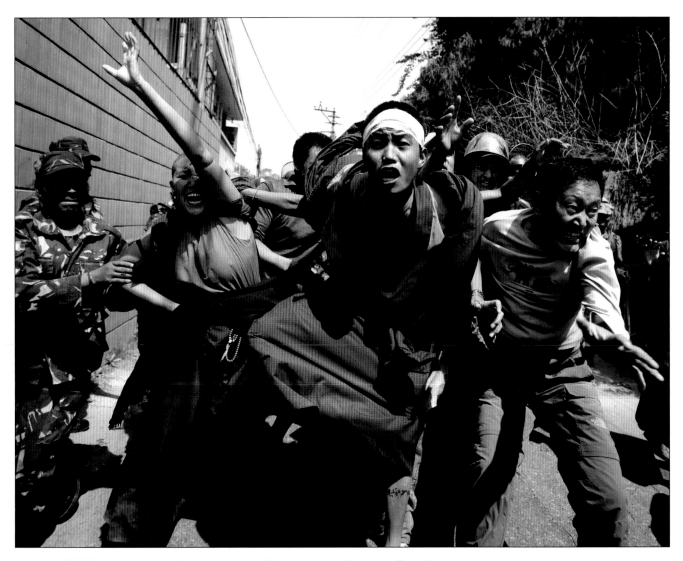

Left: March 2008, Dharamsala, Himachal Pradesh, India. A young Tibetan has painted his face as a Tibetan flag, adding the words "free Tibet" and "kill me", in protest at Chinese rule in Tibet. Atul Loke

Above: 30 March 2008, Kathmandu, Nepal. Tibetan activists are chased by Nepalese riot police while protesting outside the visa section of the Chinese consulate. About a hundred Tibetan monks, nuns, refugees and activists were detained after shouting anti-China slogans and yelling "free Tibet". Adrees Latif

"

The day after Iranian President Mahmoud Ahmadinejad was re-elected, opposition protesters took to the streets to protest at the result but were beaten and arrested by plain-clothed and uniformed security forces, often brutally, and the media swiftly became persona non grata. As a response and show of force, a pro-Ahmadinejad rally was organized in Vali Asr Square, scene of some of the opposition protests and designed to send a message to the opposition. Media were taken there as tens of thousands of supporters gathered and, despite the fact that the rally was organized and many supporters had been bussed in, it was clear that these people did fervently support their leader and would not cave in to the opposition complaints. We had to squeeze our way through the crowd with cameras in the air to avoid them being crushed and climb over people and metal barriers to get to the front where it would be possible to photograph the crowd head-on. To be at the heart of such a rally as an obvious Westerner – surrounded by security forces and pro-government supporters, who the day before would have beaten me on the street if they had caught me taking photos of the opposition protesters – was a strange feeling.

Ben Curtis

"

Below and right: 14 June 2009, Vali Asr Square, Tehran, Iran. Supporters of President Mahmoud Ahmadinejad at the rally. Ben Curtis

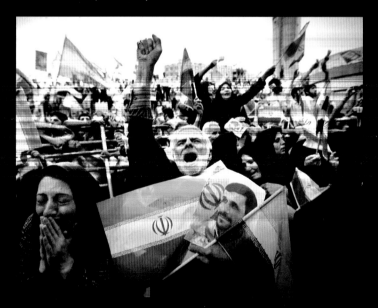

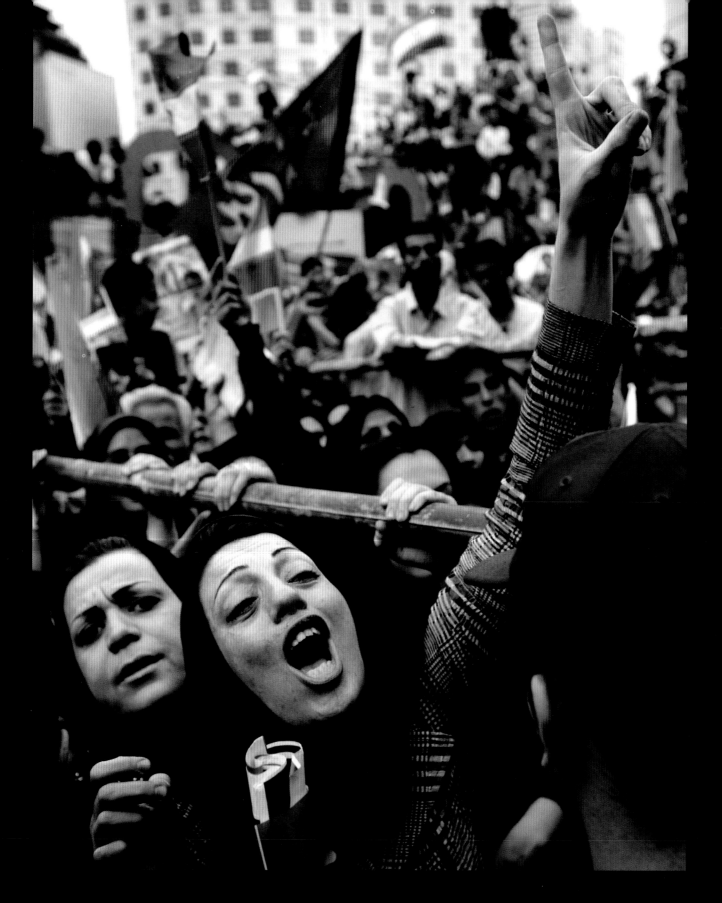

" With all phone networks and internet shut down, we didn't have much of an idea what would happen the day after the pro-government rally, except we'd heard some rumours opposition supporters might try to march to Azadi (Freedom) Square. It seemed unlikely to be big – in the preceding days anyone who had tried anything like this had been either beaten or arrested or both. However, the information had spread across the capital by word of mouth and when we arrived at one of the routes leading to the square, it was clear this demonstration would be unlike anything seen in Iran for decades. All the roads were a heaving mass of opposition supporters in such great numbers and solidarity that security forces were powerless to touch them – or prevent the media from covering it. I followed the march for many kilometres all the way to the square and thought carefully about how to capture the significance of the event. I had already taken many photos of marchers with banners and placards but it struck me that individuals were not the story that day – the story was the statement made when a large group of ordinary people gather en masse to deliver a message in one voice to their rulers. The sheer power of numbers. At the march's destination in the square I looked extensively around to find the best vantage point to show the enormity of the crowd, and determined it was a small raised space of no more than a few feet wide on the edge of an embankment. I was surrounded by the arriving marchers behind me and had to ensure I didn't get accidentally pushed off the side of it, a fall of many metres onto concrete, but people were very kind and held my legs to stabilize me. I stayed put there for over an hour, knowing I was missing other pictures elsewhere but fearful of losing this position. The square filled up and the gaps in the crowd eventually disappeared just as the light was fading, which was when I took this shot. "

Ben Curtis

Below: 15 June 2009, Azadi (Freedom) Square, Tehran, Iran. Hundreds of thousands of opposition supporters join a mass rally in protest against the result of the presidential election. Ben Curtis

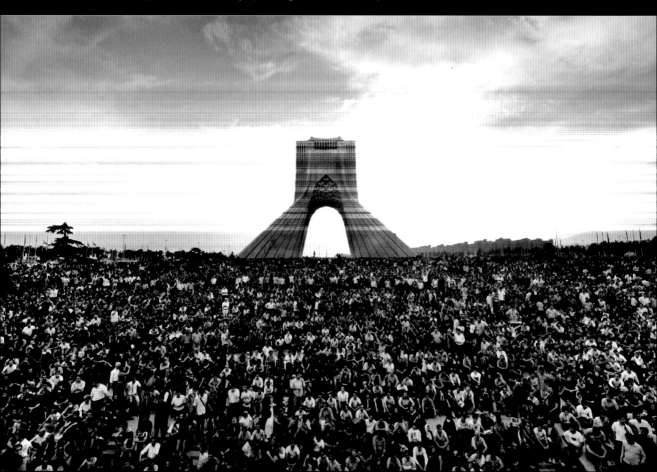

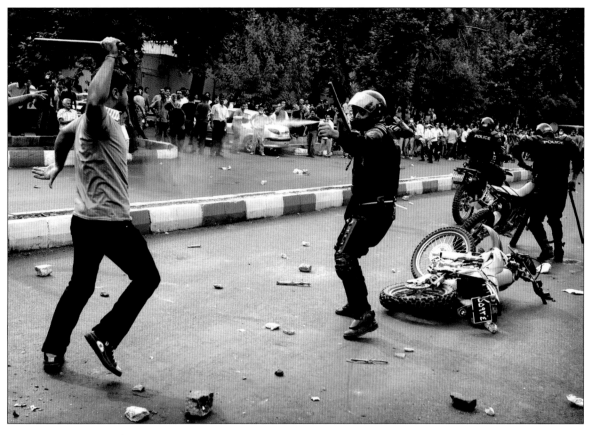

Above: 13 June 2009, Tehran, Iran. A riot-police officer sprays tear-gas at a supporter of defeated presidential candidate Mir Hossein Mousavi during clashes in the city. Olivier Laban-Mattei

Below: 13 June 2009, Tehran, Iran. An injured supporter of the defeated presidential candidate, bleeding heavily, dabs his face with a cloth as cars burn behind him. Olivier Laban-Mattei

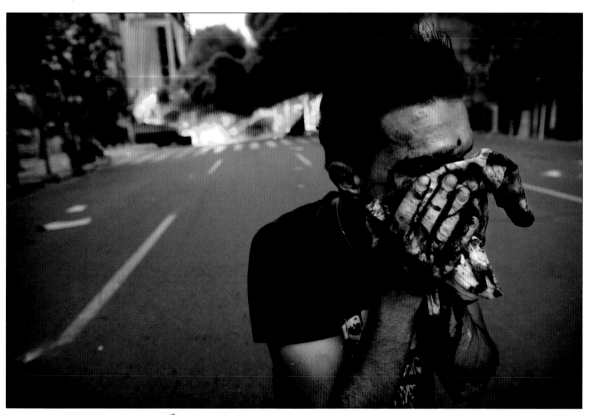

'The fighting between the "Red Shirts" and the Thai army has lasted all day in this street near the fortified camp of the rebels. At nightfall, despite hours of clashes at a distance, the front line has not moved one metre. Thousands of stones, firecrackers and some Molotov cocktails have been sent against the military. In response, bullets, some drawn by snipers located on the building overlooking the intersection. This man, despite dozens of wounded in the day, is still convinced that this fight between David and Goliath is more than symbolic, and therefore continues to fight. But in front of him, the soldiers no longer respond to his gesture.

Corentin Fohlen

Right: 16 May 2010, Bangkok, Thailand. Manning the barricades in the business district. Corentin Fohlen

Overleaf: 16 May 2010, Bangkok, Thailand. A "Red Shirt" anti-government protester throws a tyre onto a burning truck as the violence in central Bangkok continues. Anti-government protesters closed parts of the city for several months, and the state of emergency spread to 17 provinces across the country. Athit Perawongmetha

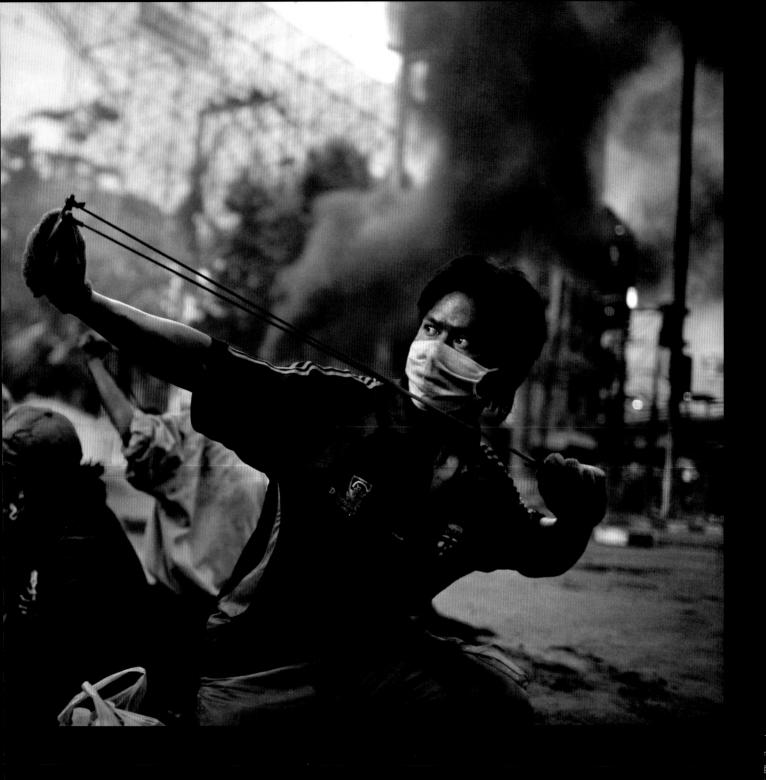

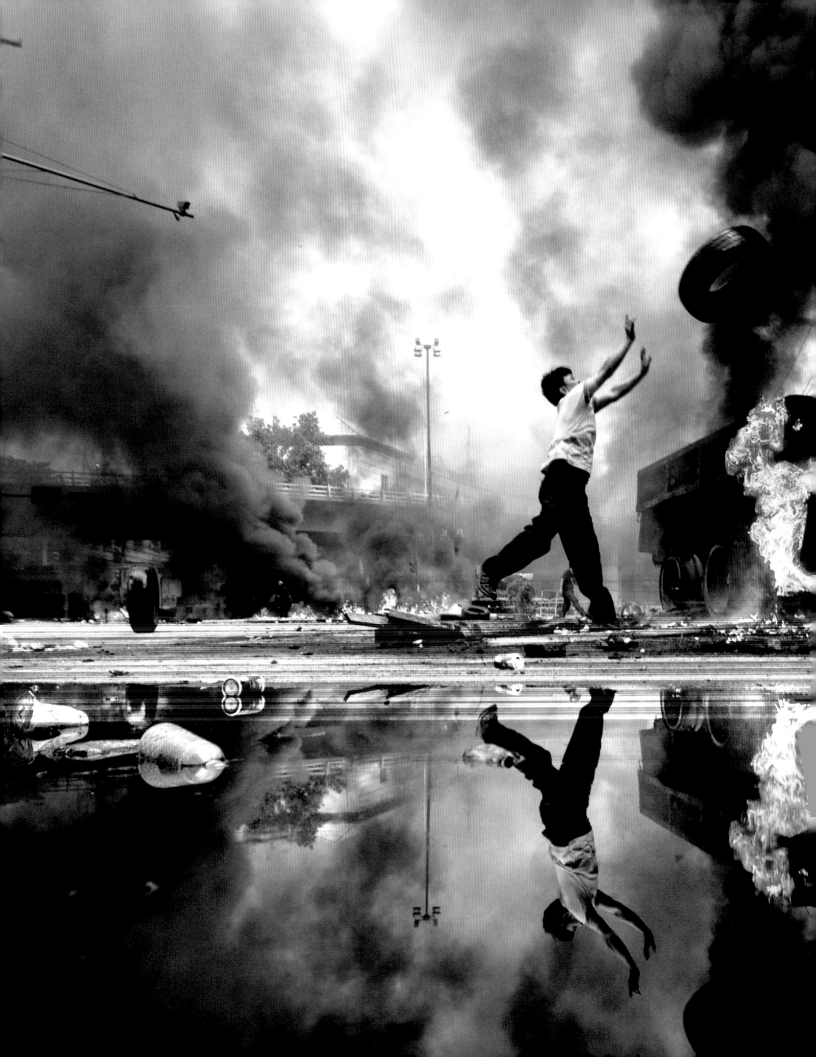

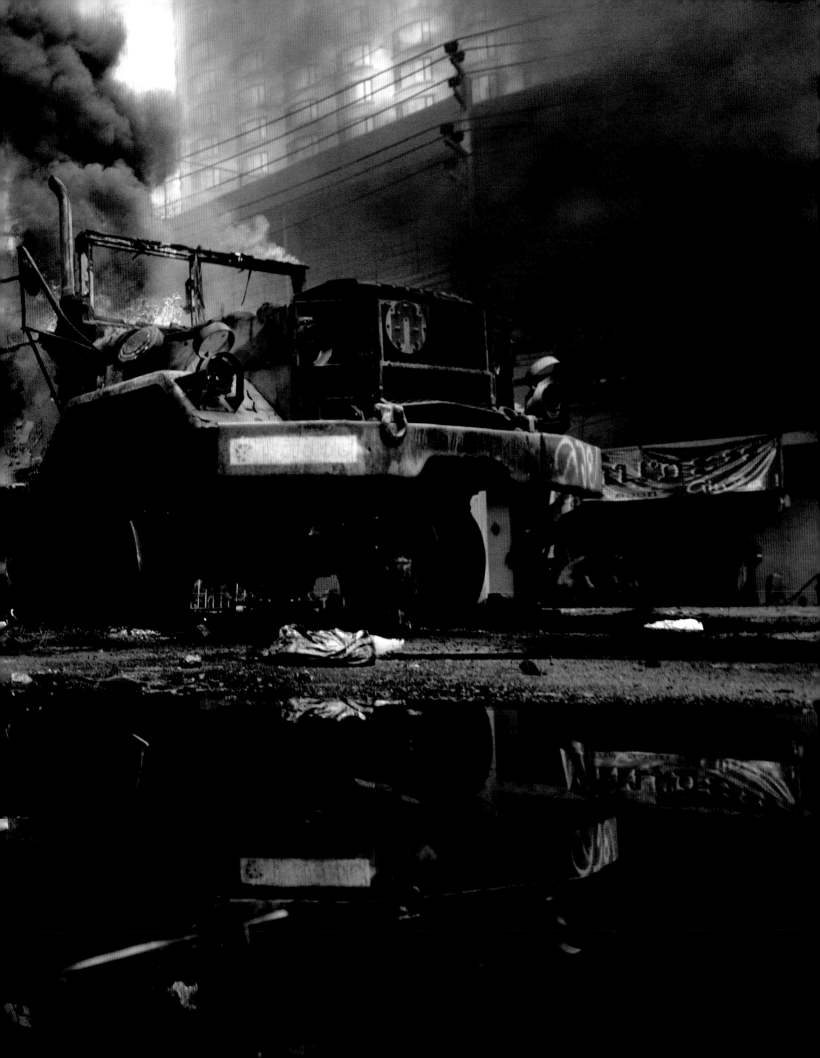

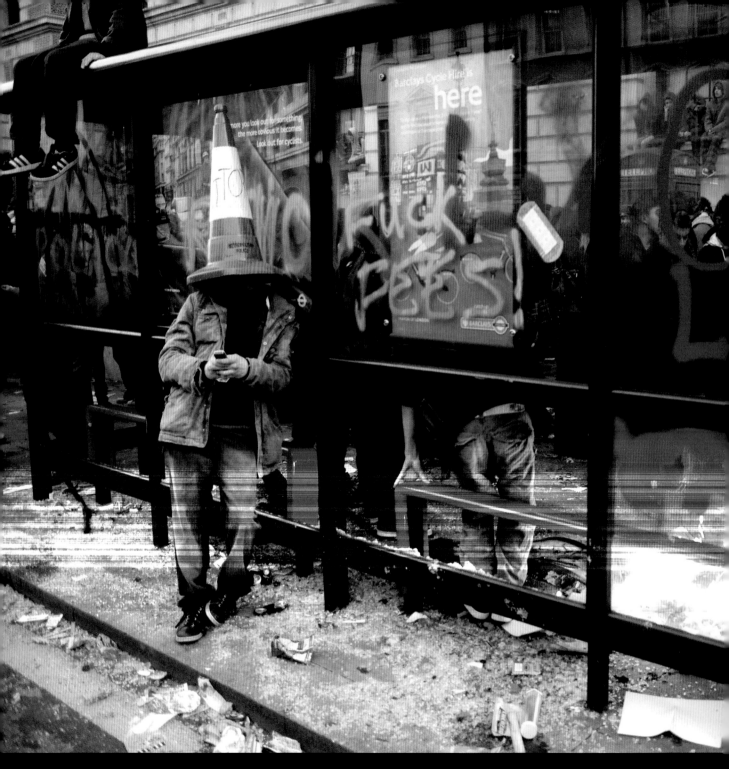

Above: 24 November 2010, Whitehall, central London. A bus stop damaged during a student demonstration against the government's proposed increase in university tuition fees. Andrew Testa

Opposite, top and bottom: 24 November 2010, Whitehall, central London. Students and riot police during the protest against the proposed hike in university fees. Andrew Testa

Overleaf: 11 May 2011, Athens, Greece. Greece was paralysed by a nationwide general strike as hundreds of thousands of workers and civil servants walked out in a 24-hour protest against the socialist government's strict austerity programme. Aristidis Vafeiadakis

Getting drenched in paint, stinking of burning plastic and being bent over wheezing like an old man while trying to keep up with a bunch of teenagers were all features of my coverage of the student protests. Subversive, anarchic, violent, there was a distinct feeling of tension in the air that I had not felt for years at a protest in the UK. Organizing via Facebook and twitter, the students were able to assemble and organize very quickly, always splitting into different groups and moving off at speed in a bid to outrun the police. Keeping up with their movements was difficult, photographers were constantly texting and calling each other to see if it was better elsewhere. It was heady stuff, but once the police had eventually chased them down and the inevitable kettle had been put in place, violence would usually ensue as both sides pushed and niggled at each other. "You kettle, we smash" was the battle cry of the students; the baton charge was the police's usual response.

Andrew Testa

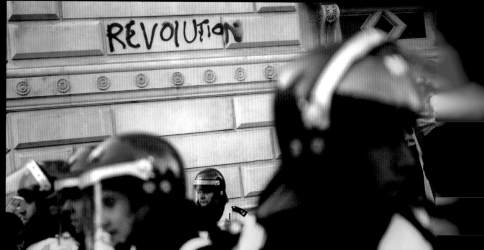

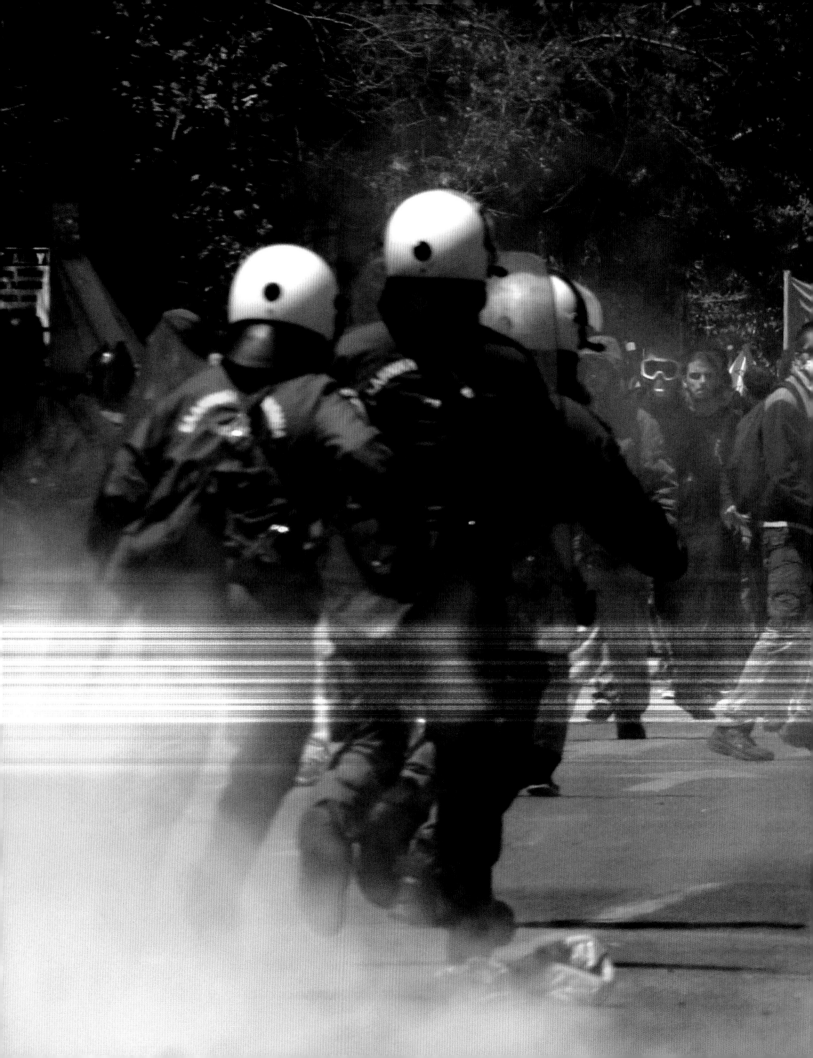

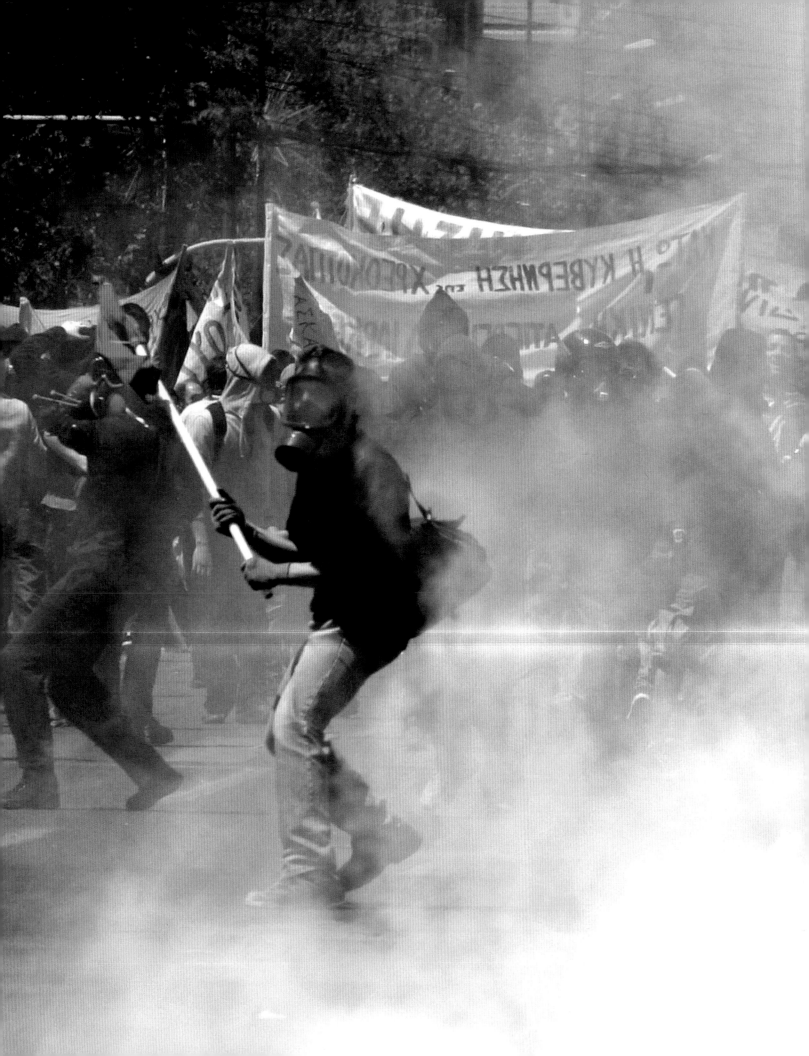

"The people gathering in Change Square in the capital Sanaa came from all over the country, creating the widest possible representation of all levels of society.

Even though 19 people were killed a week before I arrived in Sanaa, the atmosphere on the ground was relaxed and to some extent Change Square looked like a summer festival camp packed with youth in search of a future and formulating their dreams of a brighter tomorrow while lying in their tents. Besides the large attendance and the free-spirited feeling all around, one thing that was absolutely remarkable was the strictly non-violent approach at the gatherings.

Moving around the protesters' camp, working with an iPhone equipped with a Hipstamatic app, I had never felt so invisible. I mean, one could barely know that I was a journalist telling a story with photographs, using a phone to photograph and describe the situation like every other protester in the crowd."

Karim Ben Khelifa

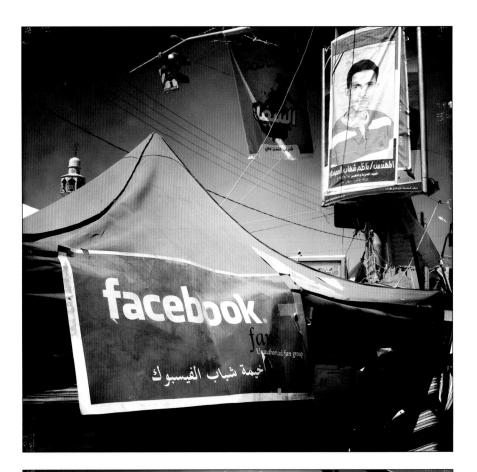

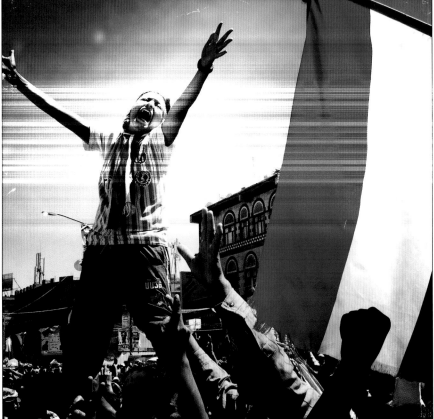

Right, above: 4 April 2011, Sanaa, Yemen. A Facebook tent near Sanaa university during protests against the 32-year rule of President Ali Abdullah Saleh. The protests initially called for reforms to ease the economic conditions causing unemployment and corruption in politics. It was not until later that regmie change was called for. Karim Ben Khelifa

Right: 4 April 2011, Sanaa, Yemen. Protestors against the presidential regime in the university area. Karim Ben Khelifa

Opposite: 1 April 2011, Sanaa, Yemen. A large rally in support of the president, in the centre of the capital. Karim Ben Khelifa

Overleaf, left: 8 April 2011, Sanaa, Yemen. Anti-government protesters in the university area. Karim Ben Khelifa

Overleaf, right: 1 April 2011, Sanaa, Yemen. The pro-government rally. Karim Ben Khelifa

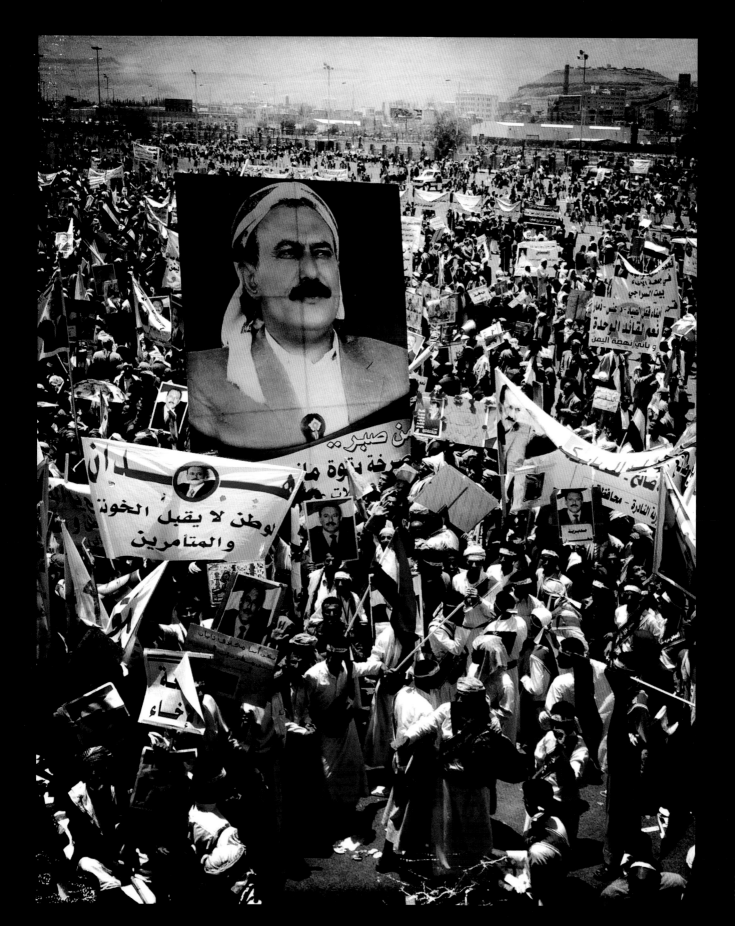

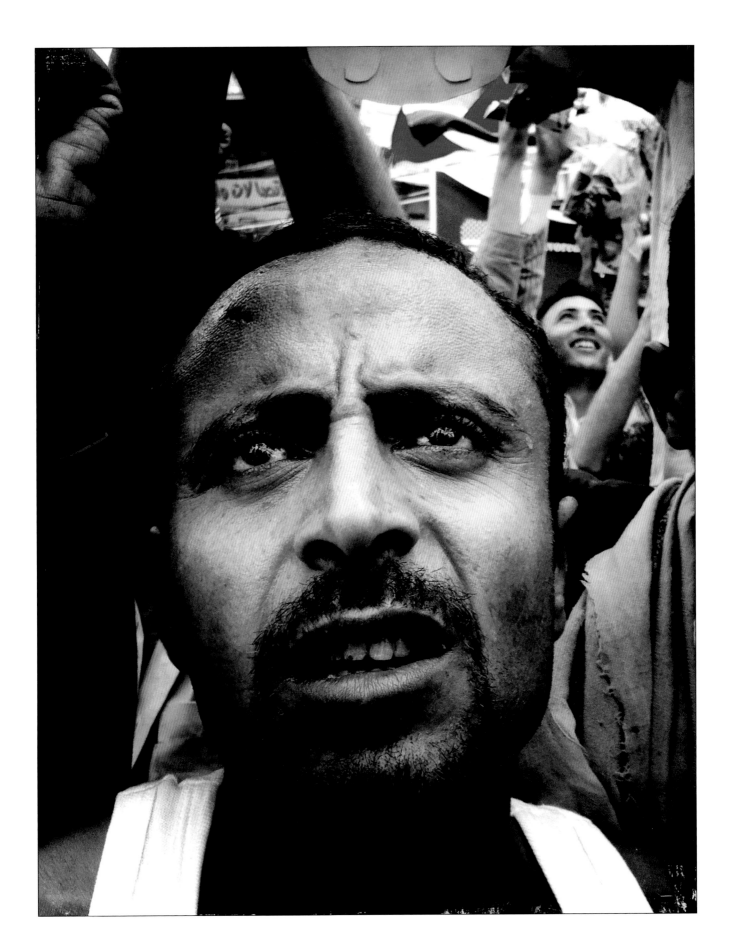

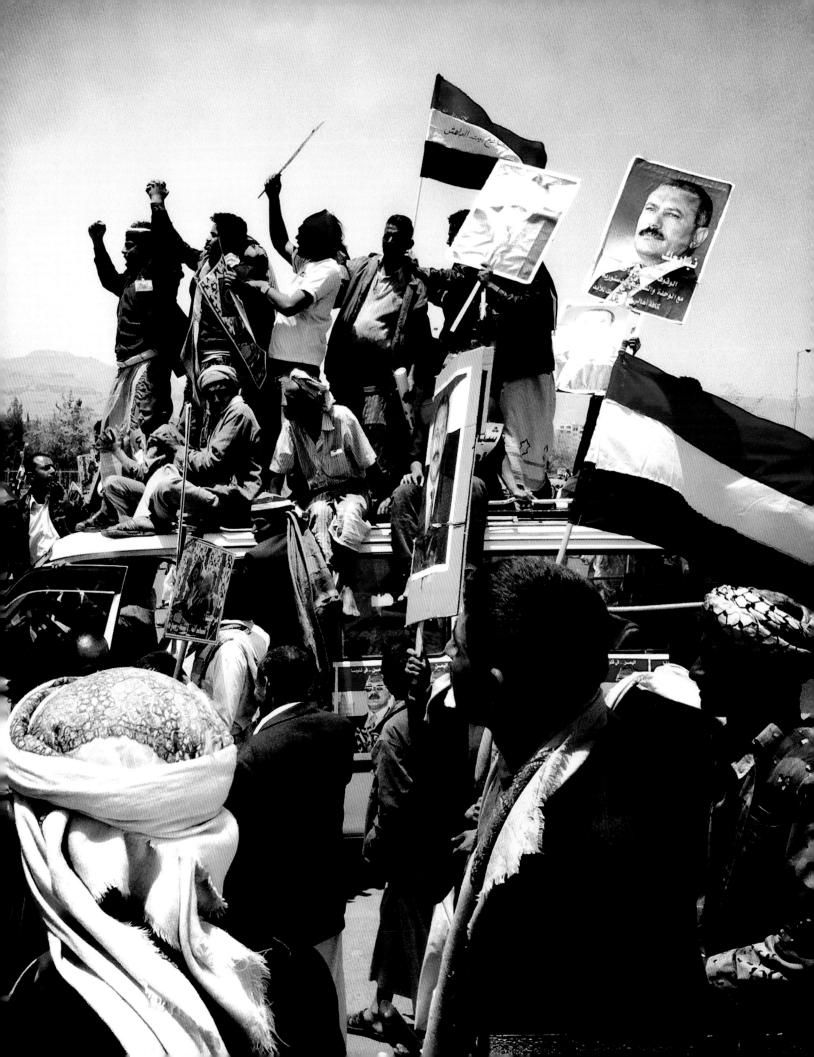

The Struggle for Rights

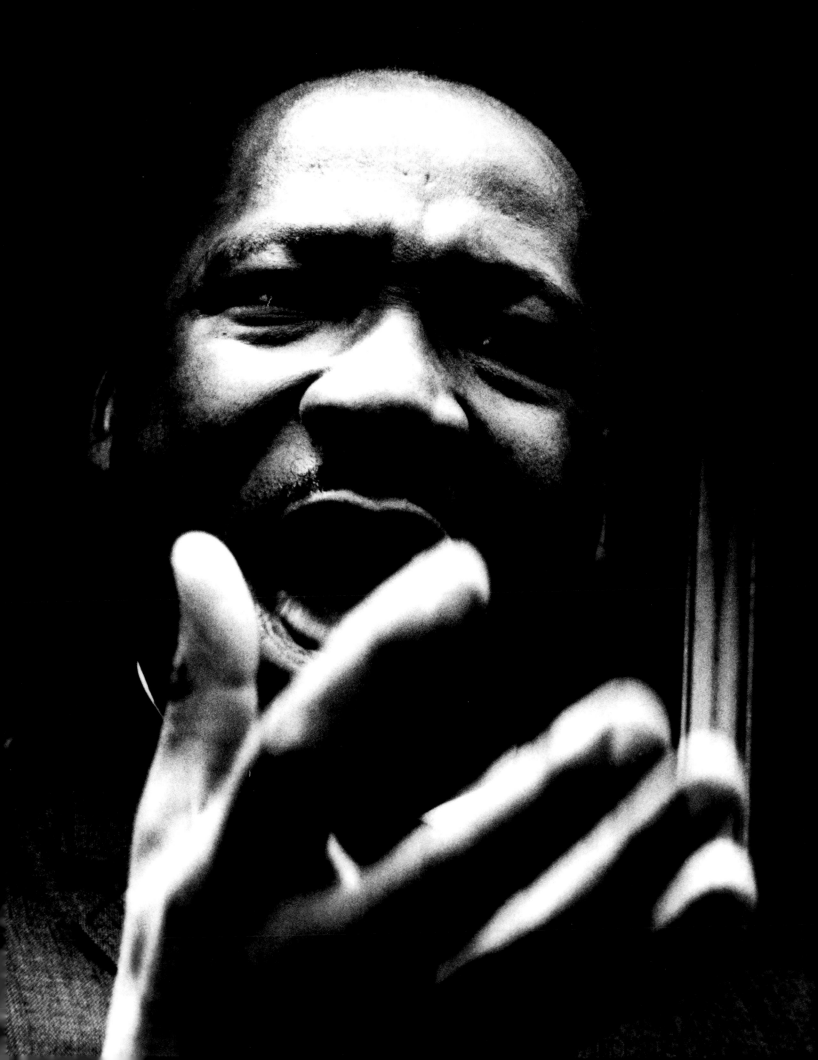

The Struggle for Rights

The adoption of the Universal Declaration of Human Rights by the United Nations in 1948 brought centre stage an idea that had been growing since the eighteenth century: that every individual has the "right" to certain key freedoms. Implementing this noble idea has never proved simple. Inequality and oppression have been constants in human history. Those who profit, in every sense, from the sufferings of others will fight bitterly to retain their special positions. Yet, if tyranny and social injustice can never be eliminated, they can at least be confronted. There have been some notable victories. The single most successful of these struggles was the American Civil Rights Movement of the 1950s and '60s. Its significance was not merely in securing rights for America's black population but in spawning a host of similar campaigning movements across the world, most obviously against apartheid in South Africa. The protest culture it embodied also directly gave rise to women's liberation and gay rights as mass movements as well as a host of other counter-culture ideals.

The American Civil Rights Movement was born in response to the institutionalized racial discrimination that existed in much of America. Although slavery had been abolished in 1865, it had left an inevitable legacy of racial tension. If this was most obvious in the South, it was hardly less of a problem in parts of the North, where areas of many cities were effectively black ghettoes. It was a campaign that aroused bitter opposition and considerable violence not just among obvious hardliners, not least a rejuvenated Ku Klux Klan, but in many apparently moderate elements to whom the supremacy of the white races was a given. Segregation under the legal doctrine of "separate but equal" existed in schools, parks, restaurants, buses, hotels and even churches. Huge numbers of blacks were also disenfranchised through complex voter-registration schemes deliberately designed to exclude them. Blacks in public office and the police were almost unknown.

The most distinctive and effective aspect of the campaign, not least after the formation in 1957 of the Southern Christian Leadership Conference – whose first president was Martin Luther King – was its persistent advocacy of mass non-violent civil disturbance in which the influence of Gandhi was key. It was a tactic that had already proved successful with the Montgomery Bus Boycott of 1955–56, masterminded by King. For over a year the black population refused to use buses in Montgomery, Alabama, after a black woman, Rosa Parks, was arrested for refusing to give up her seat to a white man.

Tensions were similarly high at Little Rock in Arkansas when in 1957 the Little Rock Central High School refused to admit nine black pupils in contravention of a federal court ruling. The pupils eventually had to be escorted to the school by armed troops. From 1960, a further non-violent tactic was devised: sit-ins, where blacks occupied whites-only areas in restaurants, parks and libraries. The numbers arrested across the South threatened to paralyse local courts and prisons. In 1961, following a Supreme Court ruling that segregation on interstate buses was unconstitutional, Freedom Riders put the ruling to the test, taking buses across the South and provoking huge numbers of arrests amid a breakdown in public order. It took presidential intervention before desegregation was finally implemented fully. At much the same time, campaigns were organized to register black voters. This, too, came in the face of fierce, frequently violent white resistance

The highpoint of the movement was the March on Washington for Jobs and Freedom in August 1963. As many as 300,000 assembled to hear King make his ringing declaration "I have a dream". Televised nationwide, it galvanized America. Less than a year later, the Civil Rights Act was passed, albeit only after a concerted attempted by Southern politicians to freeze it out of the legislative programme. Discrimination based on "race, color, religion, sex or national origin" was now legally outlawed. The following year, in 1965, again only after bitter opposition, the Voting Rights Act was passed.

Legislation was one thing; attitudes were another. Ingrained discrimination could not simply be ended by the passing of laws. If now the Civil Rights Movement began to fragment, it was because increasing numbers pressed for a more militant approach in place of the non-violence preached by King. Black Power as it emerged in the mid-1960s espoused not just a positive, increasingly aggressive celebration of black culture but also the use of force to confront continuing racism. The Black Panther Party openly advocated violence in support of black supremacy.

It was telling that the movement began in California, then rapidly emerging as a hotbed

of radical political initiatives, among them feminism. Feminist crusades were not new. The suffragettes had been vocal campaigners for votes for women at the beginning of the twentieth century. But women's liberation, a term coined in the early 1960s, went further, arguing that women were actively oppressed by men in every sphere, their horizons artificially limited, their roles confined to homemakers and sex objects. Hence the disruption, which shocked a watching nation, of the 1968 Miss America competition in New Jersey by a group called New York Radical Women. And hence, too, the Women's Strike for Equality in New York in August 1970, which saw a reported 20,000 women parade through the city. The first feminist demonstration of this new liberation movement in a slightly nonplussed England was in February 1971. Across the Western world, equal-rights legislation followed in swift measure.

Feminism has remained a touchstone of liberal credentials ever since, as have gay and lesbian rights. In New York City in June 1969 there was a running battle between police and gays – the Stonewall riots – following a police raid on the Stonewall Inn, a well-known gay bar in Greenwich Village. By the following summer there were Gay Pride marches in cities across the country. That this was still, for some, an act of radical political defiance, a natural extension of an emerging counter-culture, was underlined by the formation in France in 1971 of the *Front Homosexuel d'Action Révolutionnaire* [Homosexual Front for Revolutionary Action]. Quite rapidly, gay rights became not just a question of seeking tolerance of homosexuality, but also a celebration of

it, the word gay itself deliberately adopted to reinforce a sense of Gay Pride. If the general tide of Western opinion in the 1960s was running towards the acceptance of homosexuality, the struggle was not without its opponents. As late as 2003, same-sex acts were still technically illegal in Texas.

As the West liberated itself sexually, so it increasingly woke up to obvious inequities across the world. None would be more reviled than apartheid. South Africa accordingly found itself a kind of pariah state and the campaign against it took many forms. The most high-profile was against the country's sports teams. A tour of New Zealand by the South African rugby team in 1981 sparked protests that reduced New Zealand to the brink of chaos. These disturbances were nothing compared to those that flared in South Africa itself. The Soweto riots in June 1976 saw the deaths of between 200 and 600 people, many of them school children. Barbarism on this scale guaranteed South Africa's exclusion. It also inevitably led to the collapse of apartheid and, in 1994, the introduction of multi-racial rule.

The struggle for rights similarly embraced the fates of native peoples marginalized by modern societies. Native Americans were one, Australia's Aborigines another. Both saw sustained campaigns to force reluctant governments to acknowledge the wrongs done to them.

Human rights were at the heart of the problems in Northern Ireland after 1969, a minority Catholic population contending with a dominant Protestant majority. Complicating everything was a history of religious hatred that

extended at least from the seventeenth century and in which terrorism had become the norm. When troops were sent to Belfast in 1969, it was to protect the Catholics. Three years later on 30 January 1972, panicking and badly led British soldiers shot dead 26 protesting Catholics taking part in a march organized by the Northern Ireland Civil Rights Association. "Bloody Sunday" instantly became a symbol of heavy handed government oppression. Protests of a very different kind were mounted by imprisoned members of the Irish Republican Army (IRA) in 1978. Demanding they be treated as prisoners of war, they began a "dirty protest", spreading excrement on their cell walls in an attempt to shame the British government into recognizing their status. In 1980, hunger strikes began: 10 IRA men died, including Bobby Sands, who had just been elected an MP. One hundred thousand people attended his funeral.

A very different form of suicide protest, one that shocked the planet, was that of a Buddhist monk in Saigon, South Vietnam in June 1963. Thich Quang Duc burned himself alive in public after dousing himself with petrol. He was protesting against the anti-Buddhist policies of the country's Catholic president, Ngo Dinh Diem. Diem's persecution of the country's Buddhists, who made up almost 90 per cent of the population, was extreme even by his regime's corrupt standards. The so-called Buddhist Crisis it produced ended with Diem's assassination five months later in a military coup. Thich Quang Duc's extraordinary sacrifice was decisive in persuading the United States it could no longer afford to support so nakedly vicious a regime.

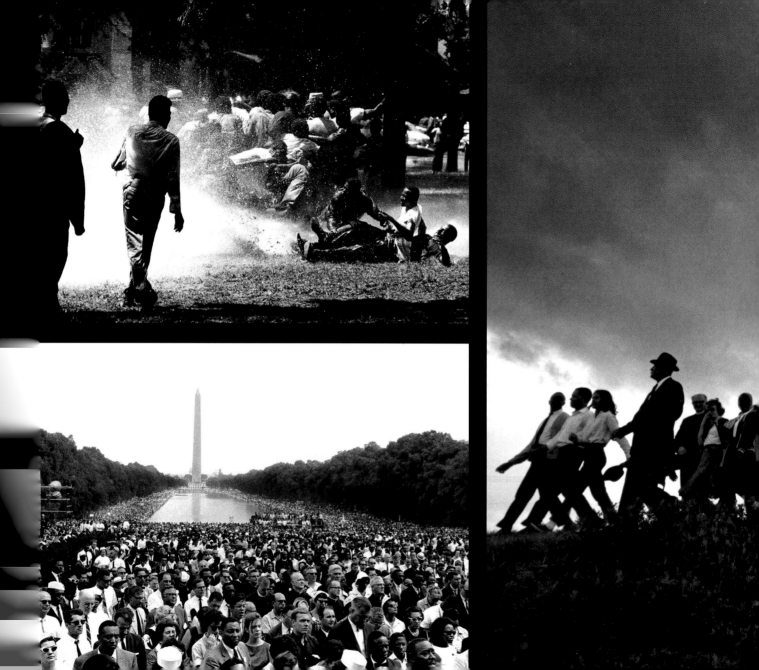

Left, top: 1963, Birmingham, Alabama, USA. Firemen turn high-powered hoses on peaceful demonstrators, who are knocked down and skid across the grass in Kelly Ingram Park. Bob Adelman

Left, bottom: 28 August 1963, Washington, DC. Crowds surrounding the reflecting pool during the March on Washington for jobs and racial equality. The Civil Rights Act, banning discrimination on grounds of race, colour, relgion, sex or national origin, was eventually passed by Congress in 1964. Bruce Davidson

Above: 1965, Civil rights march from Selma to Montgomery, USA. James H Karales

Right: 7 March 1965, Selma, Alabama, USA. The Great Freedom March, led from Selma to Montgomery by Martin Luther King Jr, was confronted by jeering bystanders from the start. Marchers were also attacked by local police. Only the third of the marches that month made it to the capital, Montgomery. Bruce Davidson

Below: March 1965, Selma, Alabama, USA. Led by Martin Luther King Jr, a group of civil rights demonstrators march from Selma to Montgomery to demand black suffrage, which they were being refused despite the Civil Rights Act of 1964. The Voting Rights Act was passed later that year, in August 1965, and finally, unquestionably, outlawed the discriminatory voting practices the marchers were protesting against. Bruce Davidson

Opposite: A man at a civil rights rally holds up a sign for the Black Panther movement. The symbol was first used in 1966, on a protest-vote ballot paper. Flip Schulke

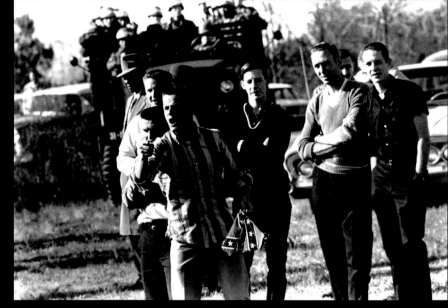

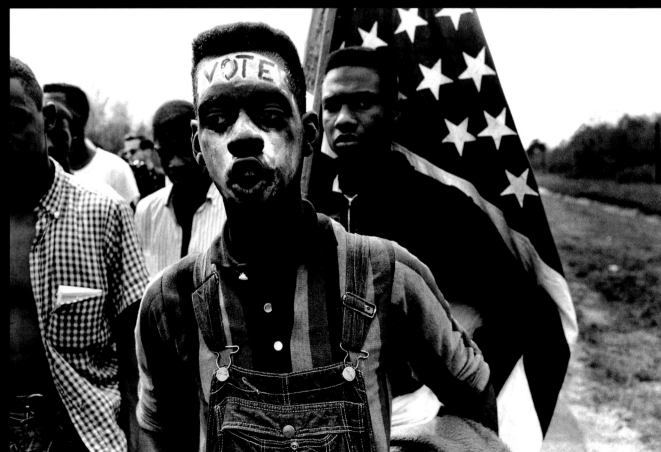

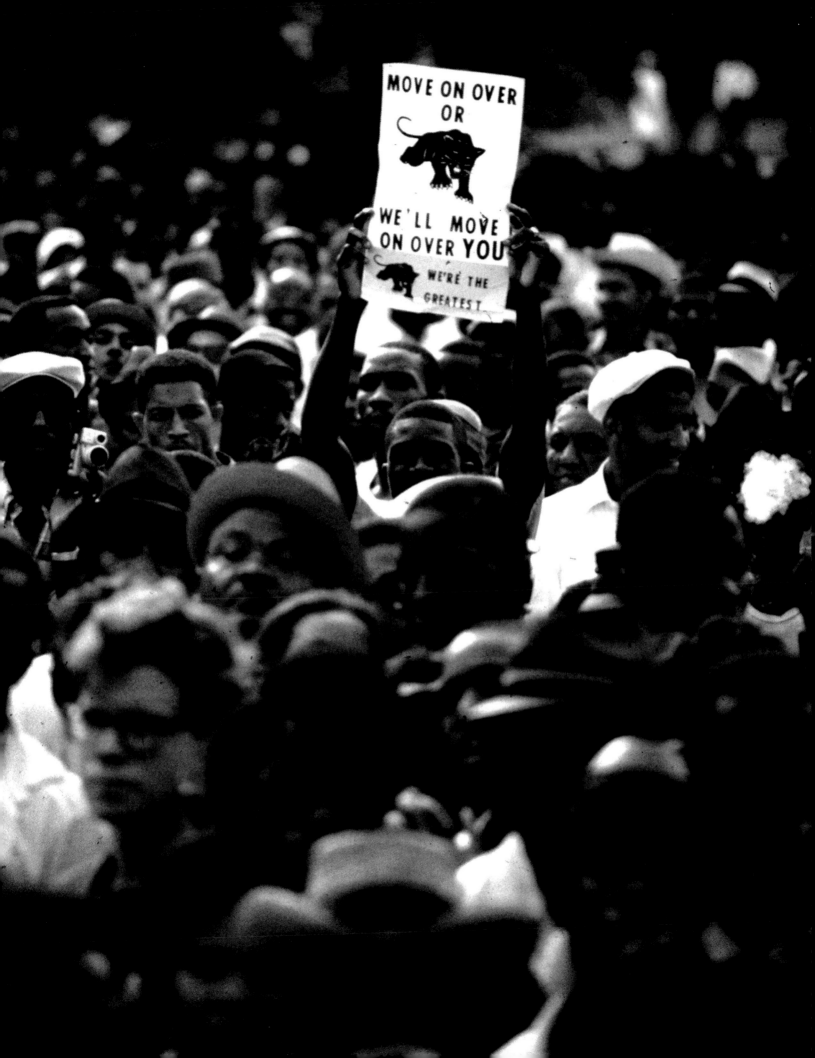

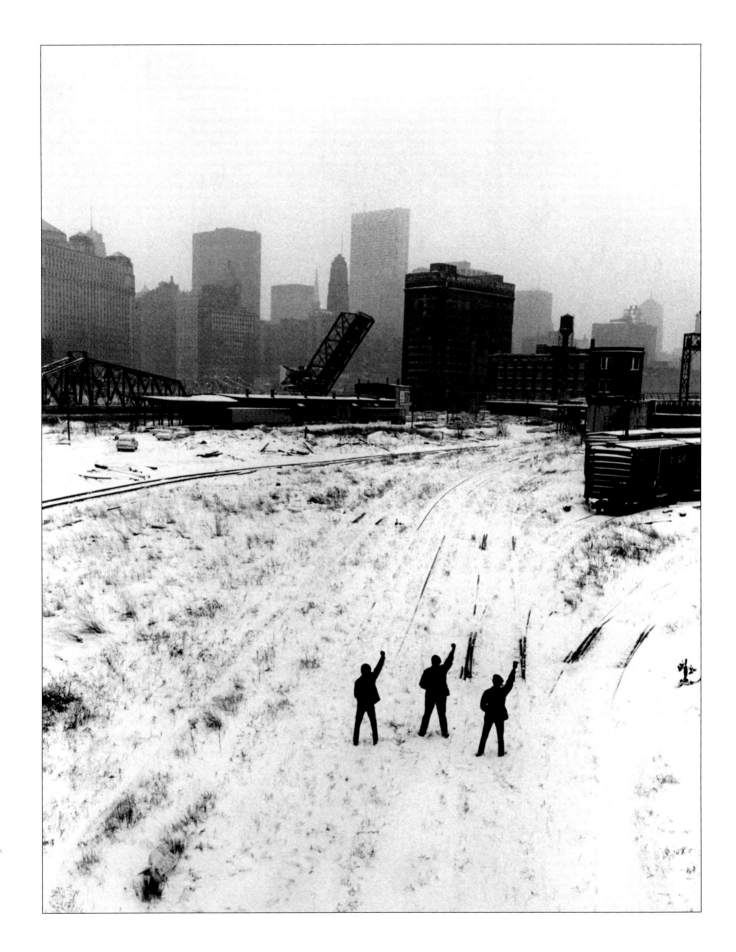

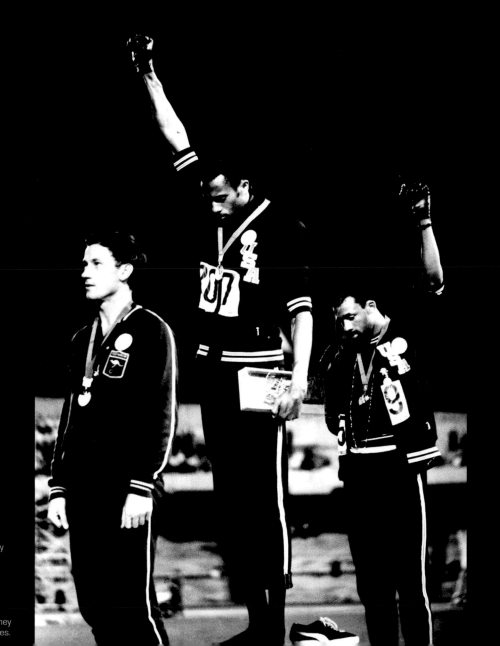

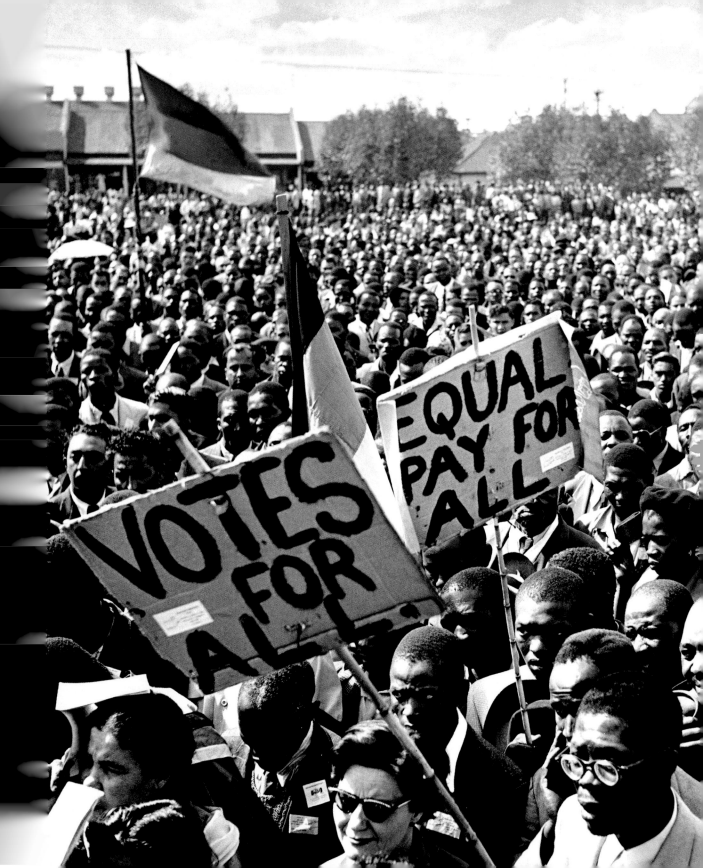

Left: 6 April 1952, Fordsburg, Johannesburg, South Africa. Crowds in Red Square with placards demanding equal pay and votes for all at an African National Congress (ANC) rally held to mark the 300th anniversary of white settlement in the country. Jurgen Schadeberg

Right: 21 March 1960, Sharpeville, near Johannesburg, South Africa. Crowds gather to protest against the law requiring them to carry passes at all times. Photographer unknown

Below: 21 March 1960, Sharpeville, South Africa. The bodies of dead and wounded lie in the street after police opened fire on the crowd demonstrating against the pass law. Sixty were killed and hundreds injured. Photographer unknown

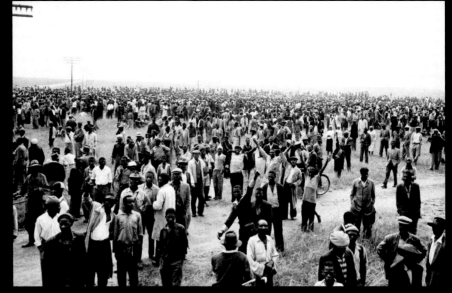

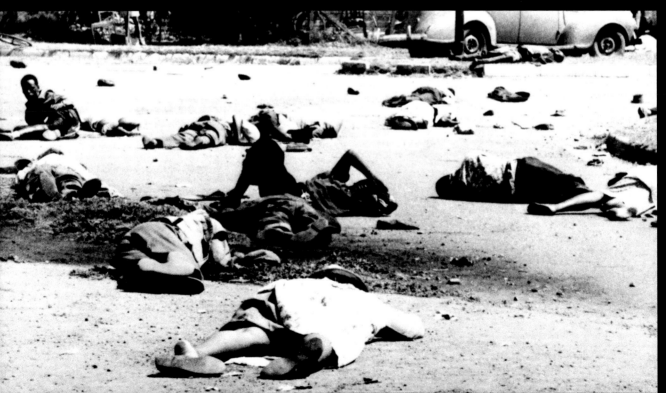

Anti-Apartheid

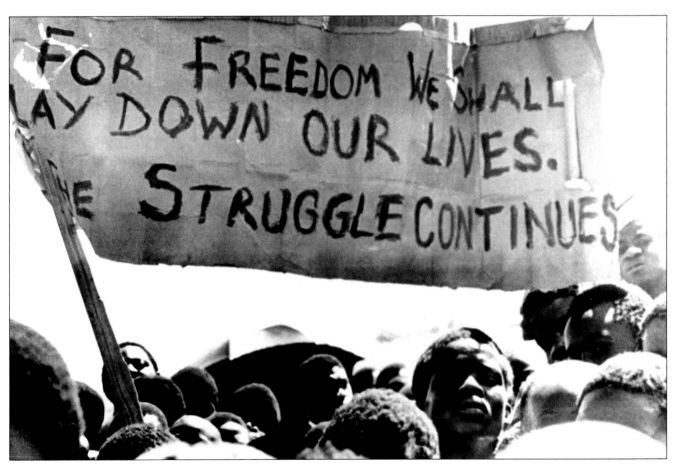

Above: 18 October 1976, Johannesburg, South Africa. A banner is held above black students in the township of Soweto, where they rallied after the funeral of a 16-year-old black student who died in jail. Photographer unknown

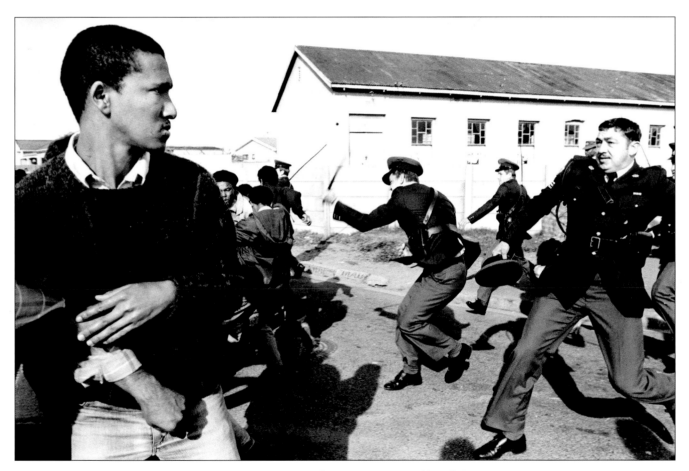

Above: 1985, Athlone, South Africa. Police charge a group of United Democratic Front demonstrators marching to Pollsmoor Prison in Cape Town in an attempt to free political prisoners. Aparthaid continued in South Africa until 1994. Gideon Mendel

Overleaf: 11 June 1963, Saigon, Vietnam. Thich Quang Duc, a Buddhist monk, burns himself to death in protest against persecution of Buddhists by the South Vietnamese government. Malcom Browne

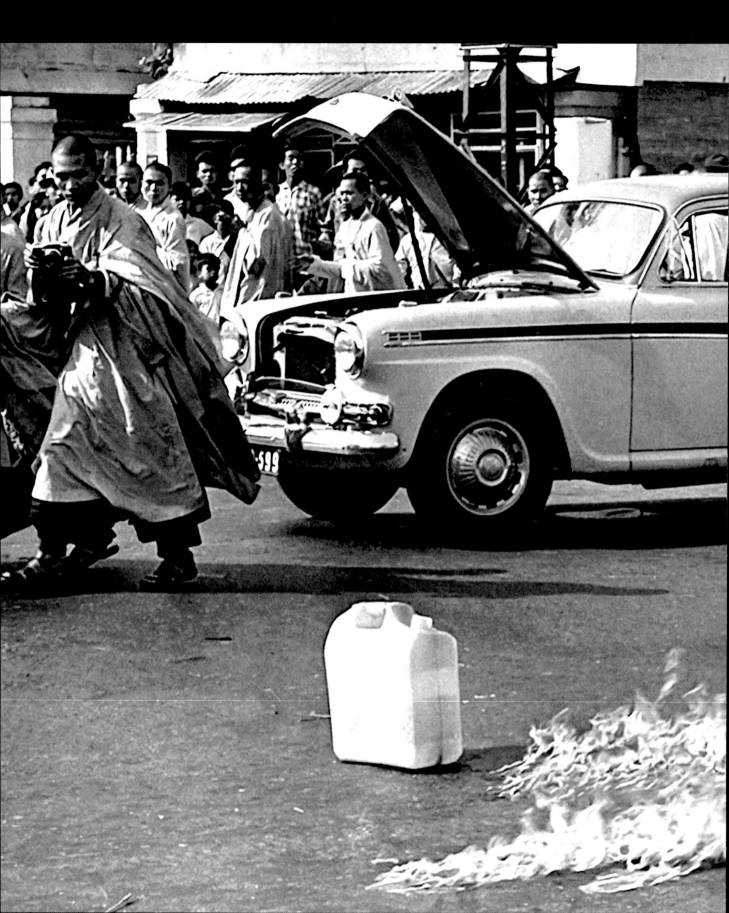

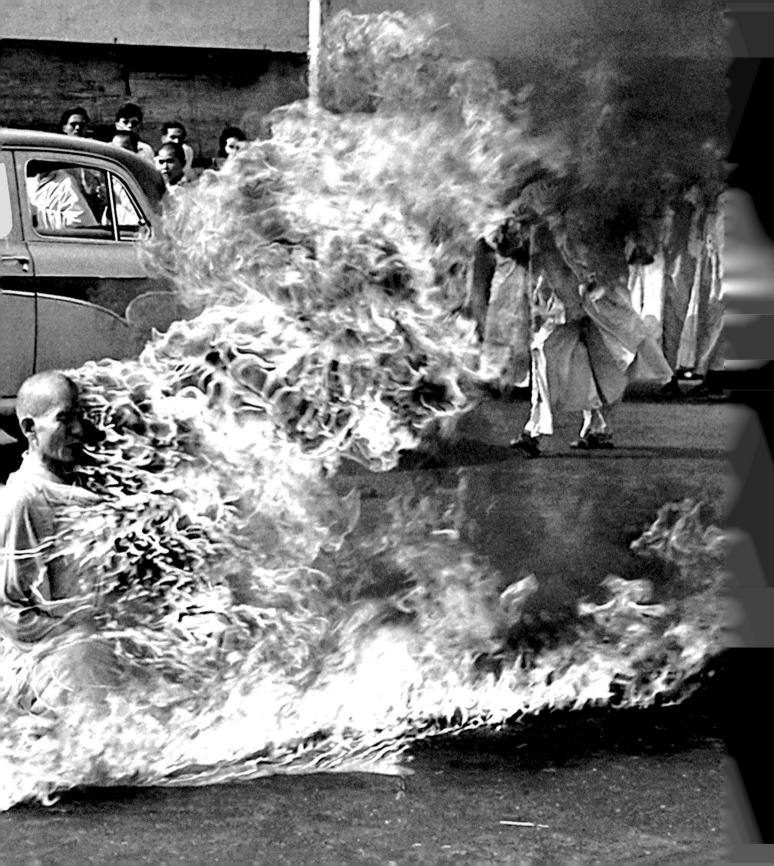

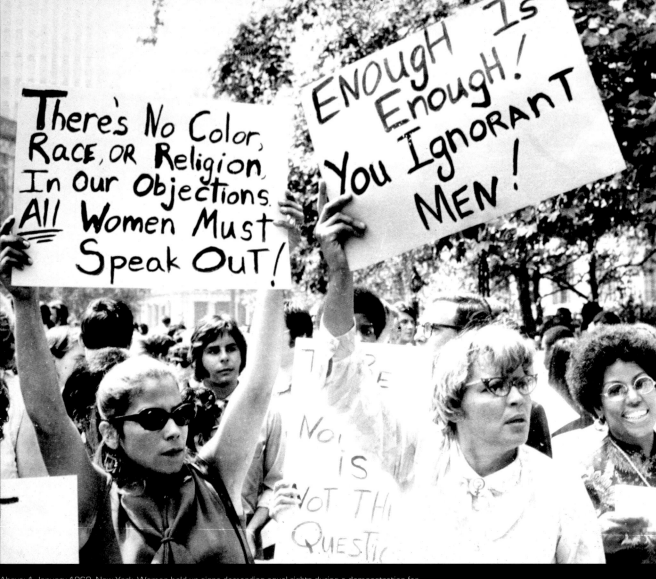

Above: 1 January 1968, New York. Women hold up signs demanding equal rights during a demonstration for women's liberation, also known as second-wave feminism. This sought to put an end to inequalities between the

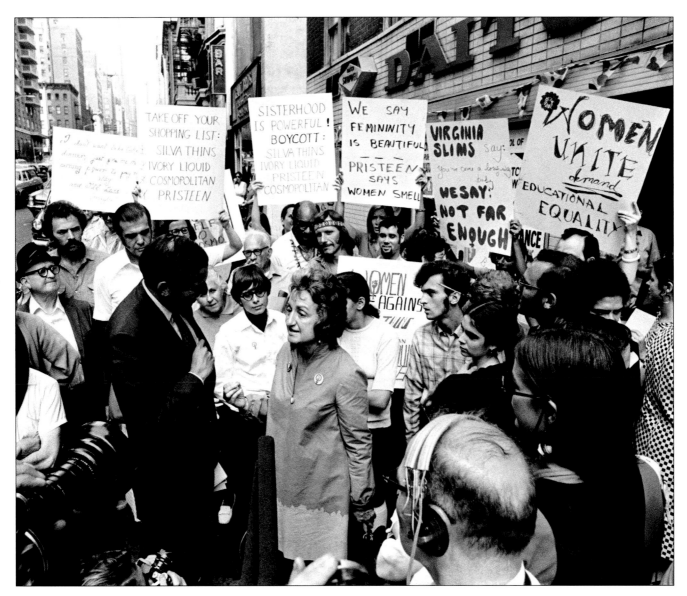

Above: 29 August 1970, New York. National Organization for Women president Betty Friedan being interviewed by the press during a march in New York City to mark the fiftieth anniversary of the passing of the Nineteenth Amendment, which granted American women full suffrage. JP Laffont

Overleaf: 1 January 1968, London. An Equal Pay for Equal Work demonstration in Trafalgar Square. Three female bus conductors with placards demand equal rights to their male colleagues. Homer Sykes

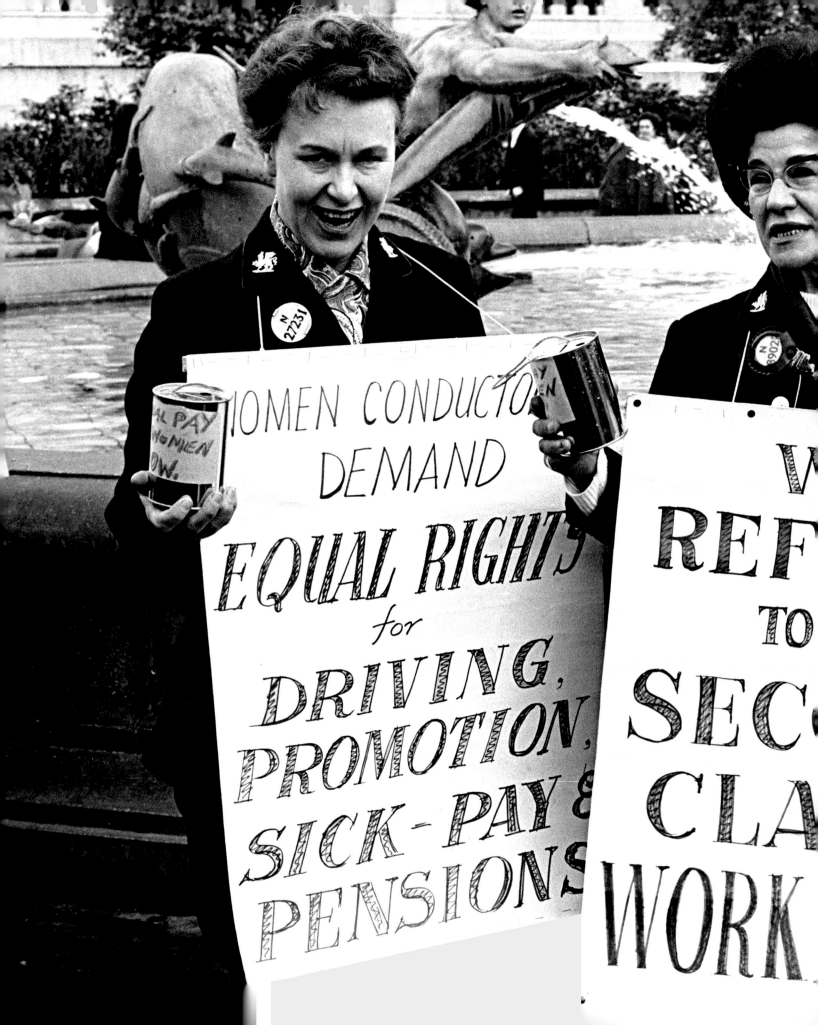

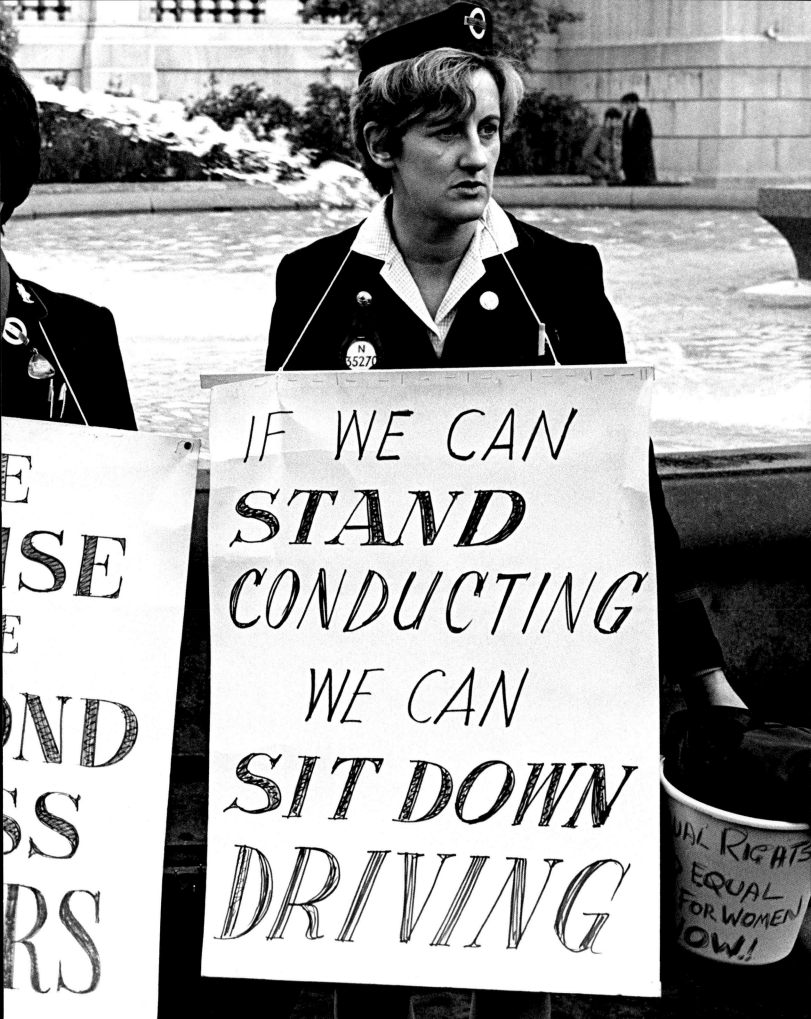

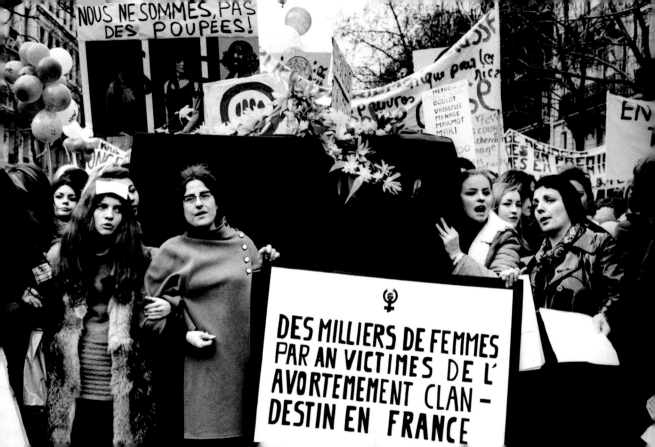

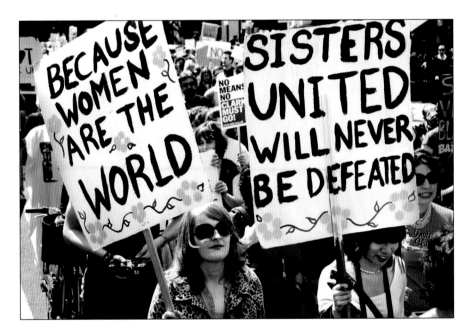

Opposite: 20 November 1971, Paris. Women's rights demonstration demanding the legalization of abortion and free contraception information. Gilles Peress

Left: 4 June 2011, London. In response to the words of a Canadian policeman who said that "women should avoid dressing like sluts in order not to be victimized", women around the world take to the streets to insist that sexual assault is an act of violence by the perpetrator, not something inspired by the victim – no matter what she (or he) is wearing or how they behave. David Hoffman

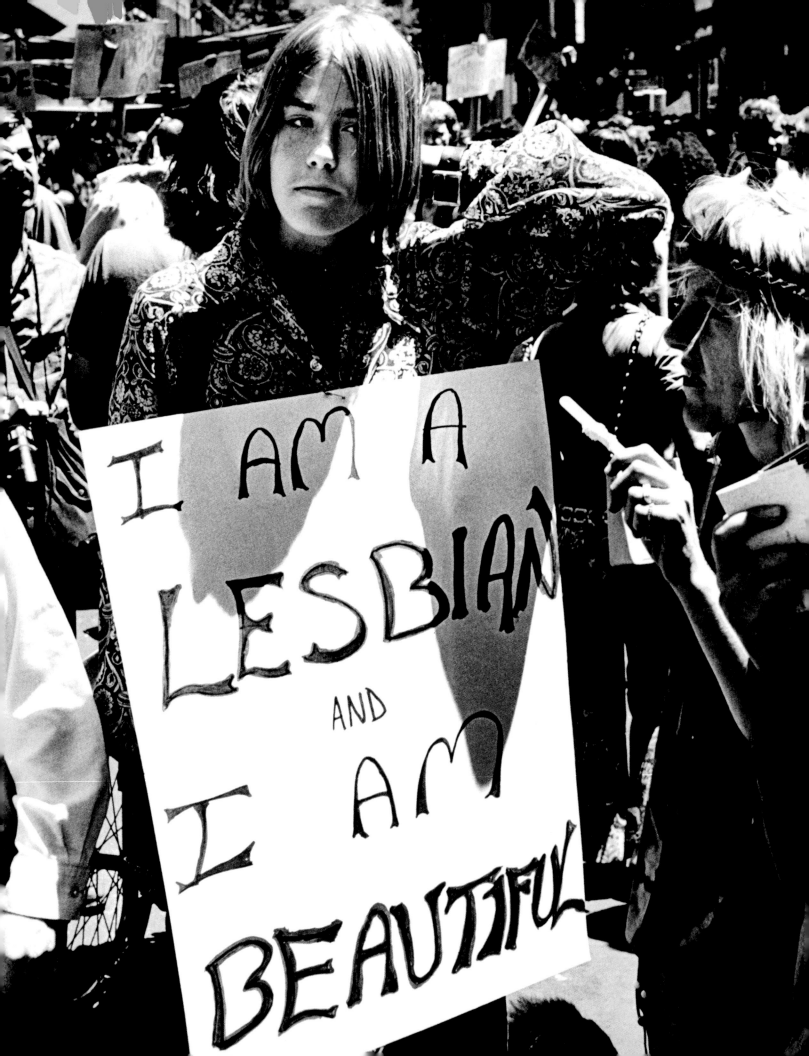

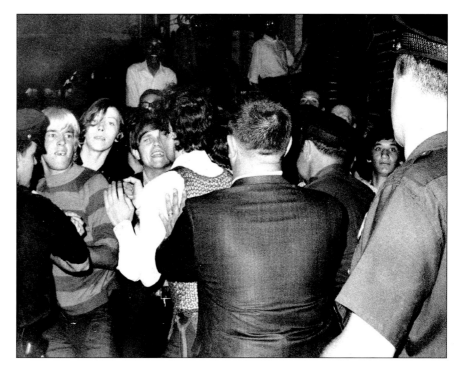

Left: 1968, New York. Demonstration for the decriminalization of homosexuality. Leonard Freed

Right: 27/28 June 1969, New York. Stonewall Inn nightclub raid. The crowd attempts to impede police arrests outside the Stonewall Inn on Christopher Street in Greenwich Village. This raid triggered a series of riots which are now seen as the start of the Gay Rights movement in the United States. Photographer unknown

Below: March 1993, Washington, DC. A march for gay and lesbian rights. Demonstrations asking for equal rights for same-sex couples continue to this day. Constantine Manos

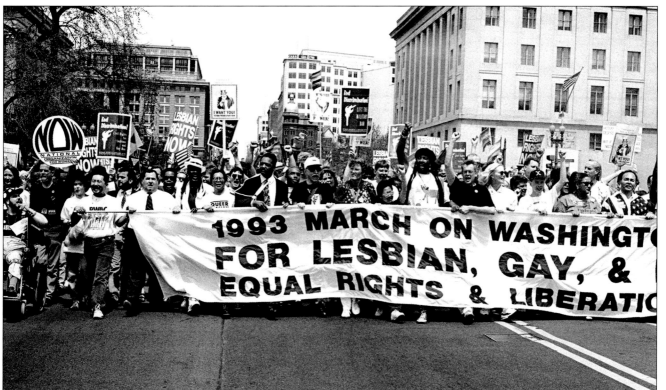

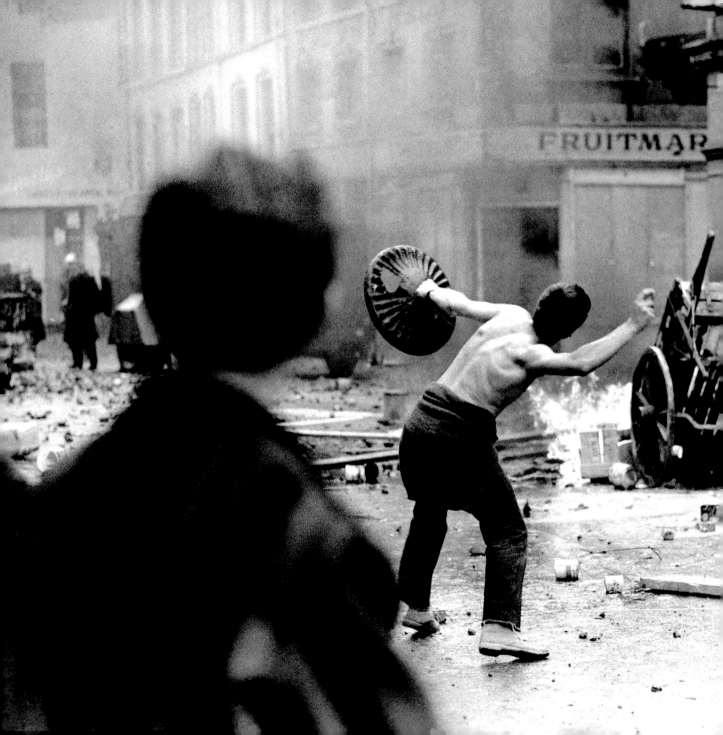

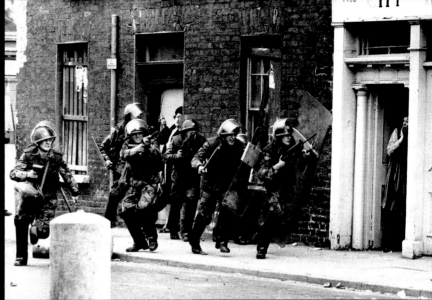

Left: August 1969, Bogside, Londonderry, Northern Ireland. A campaign for equal rights for Catholics in Northern Ireland had been going strong since the spring of 1968. In August 1969 tensions escalated and a three-day riot ensued. Thousands of Catholics were driven from their homes and this is largely seen as the start of the "Troubles". Giles Caron

Above and below: 1970 and 1971, Londonderry, Northern Ireland. British troops were initially sent to the province to protect Catholics from attack following the violence against them in August 1969. However, they were soon seen as an oppressing force by Catholics and became a focus for violence themselves. Don McCullin

Overleaf: 13 August 1979, Belfast, Northern Ireland. Riots on the tenth anniversary of the arrival of British troops in the province. Peter Marlow

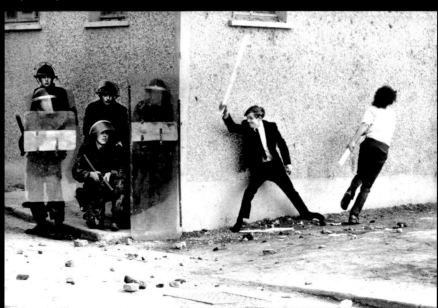

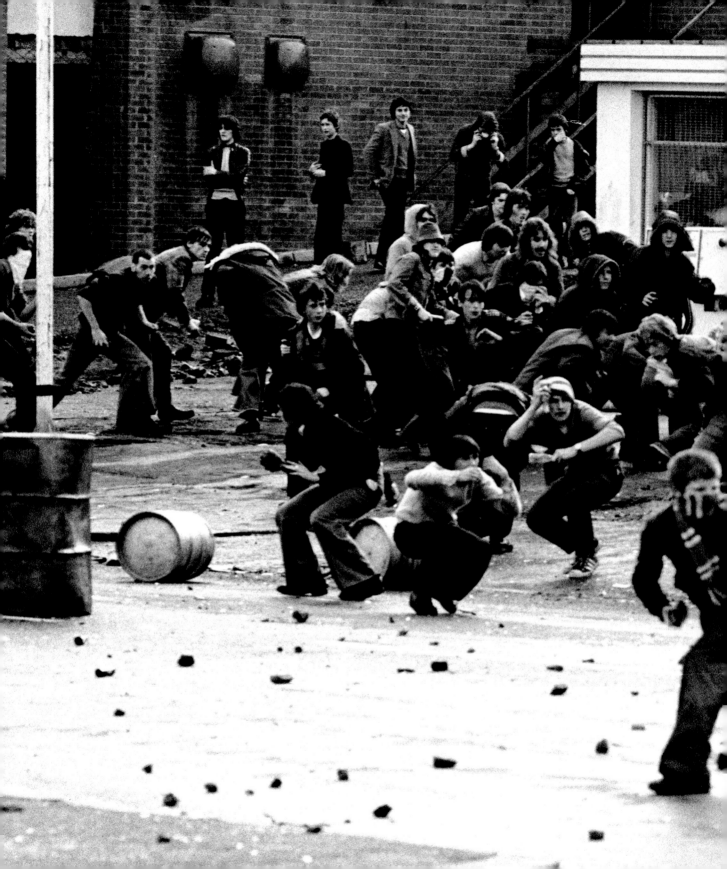

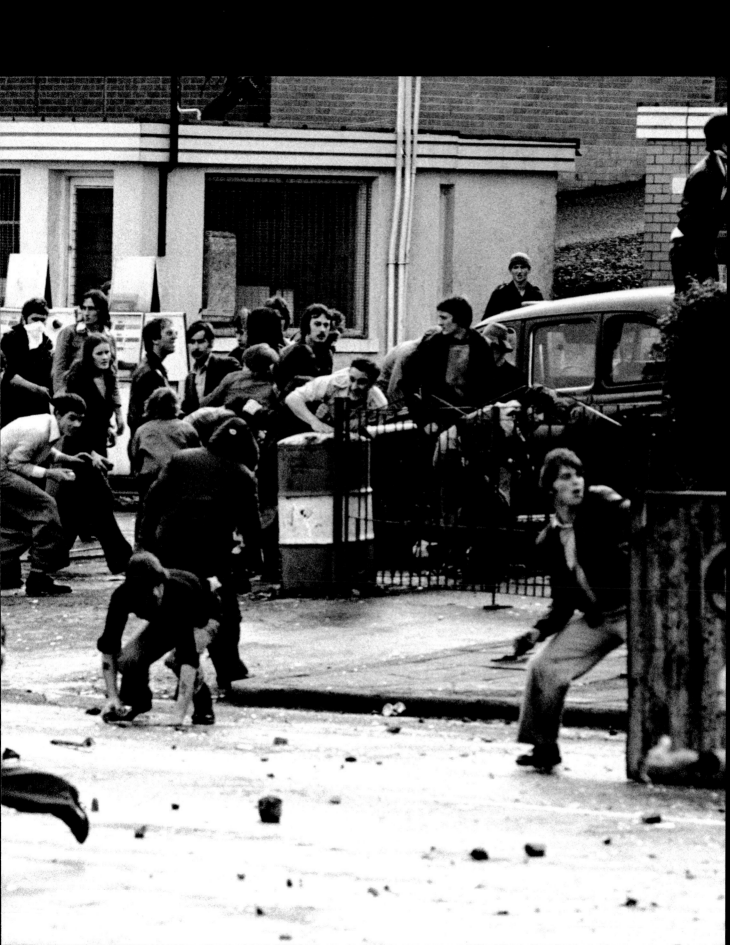

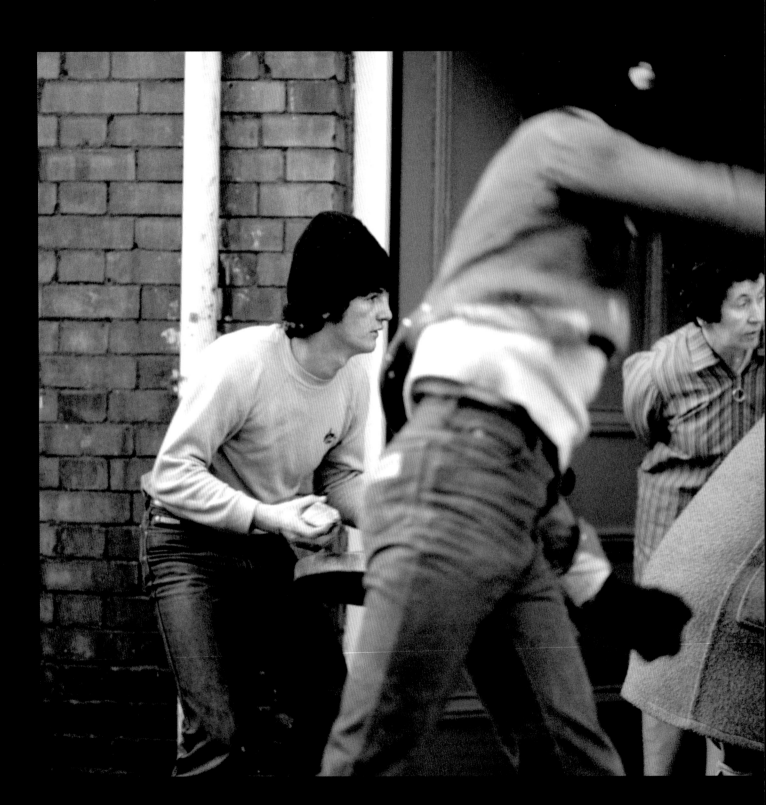

"I worked in Northern Ireland extensively from the mid-seventies to the mid-eighties. I have a vivid memory of the first trip during the Queen's Silver Jubilee in 1977 when, at the end of a relatively peaceful and good-natured march down the Falls Road, the march was halted by the RUC and a riot developed as the marchers started tearing up paving stones and street signs to hurl them at the British army. Soon rubber bullets were fired towards us and I got my first taste of a Belfast riot.

Later, in April 1981, the hunger strikes led by Bobby Sands, Provisional IRA volunteer and Maze Prison inmate, had been in progress for one month. Protests and riots were rife. On Easter Sunday, 19 April, 19-year-old Gary English died, having been struck by a British army Land Rover under attack from petrol bombs. As English lay on the ground unconscious, the vehicle was reversed over his body. Another young man, Jim Brown, had moments earlier been killed by the same Land Rover.

As I stood in a doorway of a terraced house in the Bogside area of Derry, out of the line of fire of plastic bullets which were winging down the narrow street, I was photographing the very incongruous sight of a lady in her housecoat, watching the riot unfold on her doorstep. Looking down the street towards a British Saracen armoured car, a young Catholic boy crept along a wall, unseen by the soldiers waiting with their shields, to hurl a petrol bomb. This was such a typical scene during that time. Both in Derry and Belfast what struck me most was the incongruity of such violence against the utter charm and humour of Northern Irish Catholics. To be in the centre of a riot on the Falls Road as a well-spoken young English photographer, it seemed quite amazing to be able to ask at any door to use the toilet, and most likely be offered a cup of tea.

There was also later in the eighties a feeling that the mere presence of a few photographers was enough to start an incident, the scenes had been rehearsed so many times before, it was becoming a dangerous form of street theatre, I tried to be sensitive to this and be careful that what I was photographing was not happening as a result of my presence.

For a photojournalist that period was truly unique: flaming petrol bombs, rubber bullets fired at night in the Ardoyne, hooded boys looking like medieval executioners, burning hijacked cars and buses, British army Saracen armoured cars thundering through the streets. The sheer drama of the street protests and the spirit and kindness of the participants was something I will never forget."

Peter Marlow

Left: April 1981, Bogside, Londonderry, Northern Ireland. Riots following the deaths of two Catholic teenagers, accidentally killed by British army troops who drove into a group of rioters hurling petrol bombs. A local resident looks on at the street battles between the youths and the army. Peter Marlow

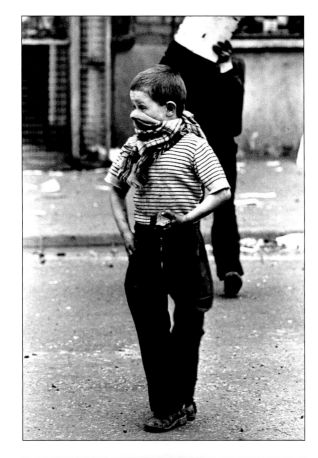

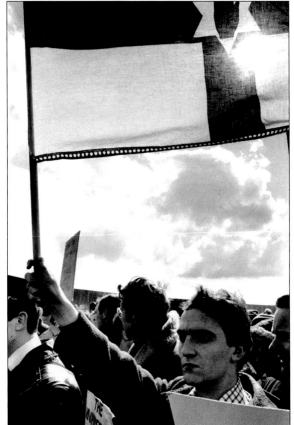

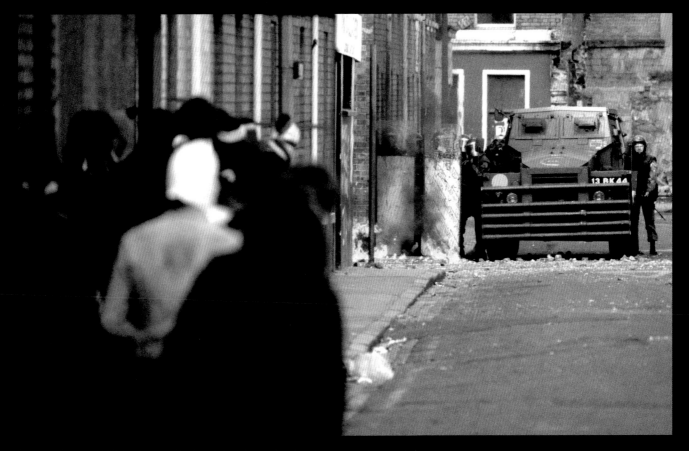

Left, top: 13 August 1979, Londonderry, Northern Ireland. A young boy throwing stones at the army during a riot on the tenth anniversary of the arrival of British soldiers in the province. Peter Marlow

Left, bottom: 1981, County Down, Northern Ireland. A demonstration outside the Maze Prison in support of the hunger strikers. These hunger strikes were the culmination of six years of protest against the removal of Special Category Status in 1976 which meant those convicted of paramilitary activity were imprisoned as criminals rather than prisoners of war/political prisoners. Peter Marlow

Above: April 1981, Londonderry, Northern Ireland. Rioters confront soldiers hiding behind shields and an armoured vehicle during riots triggered by the deaths of two Catholic teenagers accidentally killed by British army troops. Peter Marlow

Below: 6 February 1970, Alcatraz Island, San Francisco, California. A man stands outside a tepee set up on Alcatraz during the American Indian Movement's takeover of the Federal penitentiary. Photographer unknown

Right: July 1978, Capitol Hill, Washington, DC. American Indian Movement members at the end of the five-month "Longest Walk" from San Francisco to Washington in protest against proposed anti-Indian legislation. The bills that triggered the protest were never passed into law. Wally McNamee

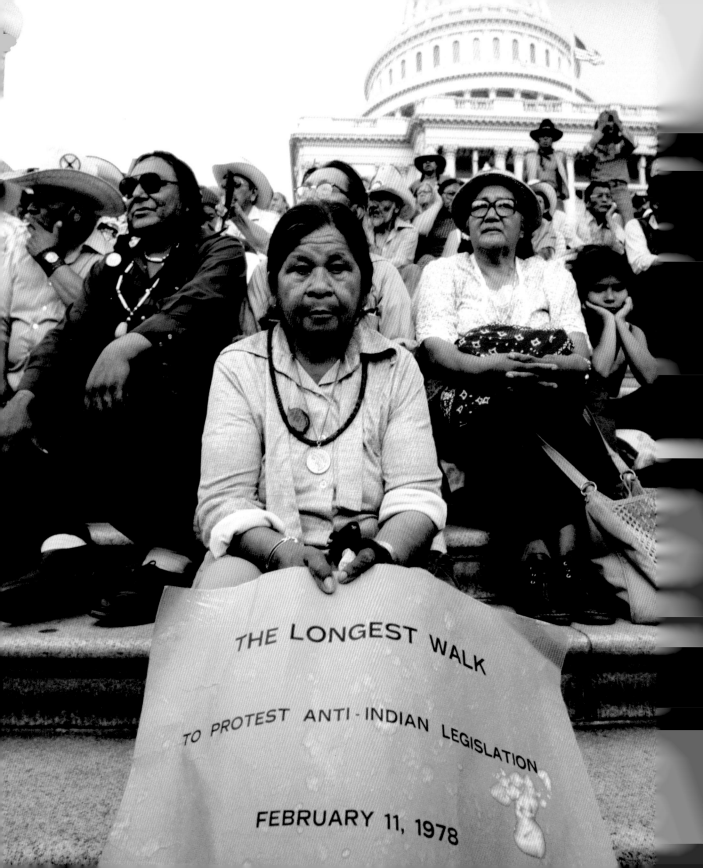

THE LONGEST WALK

TO PROTEST ANTI-INDIAN LEGISLATION

FEBRUARY 11, 1978

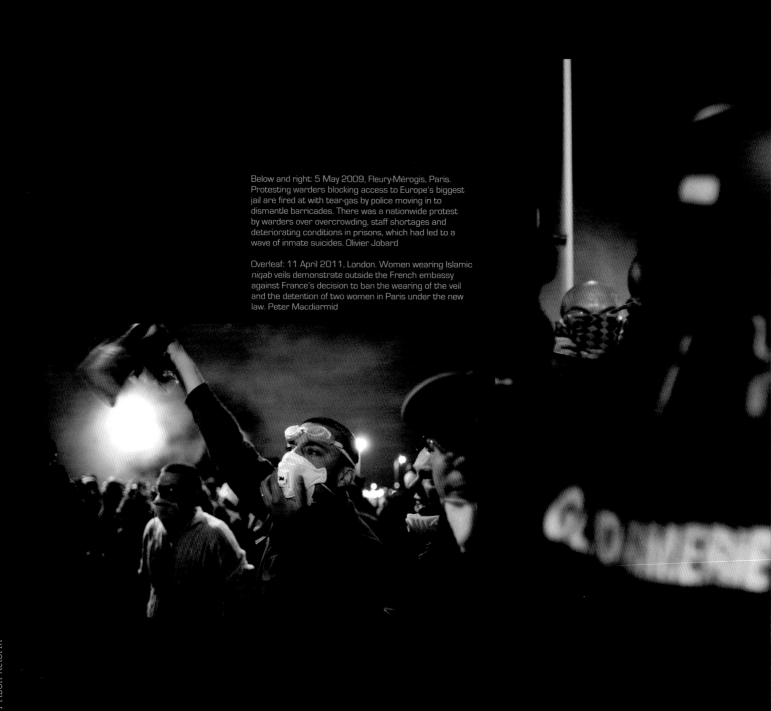

Below and right: 5 May 2009, Fleury-Mérogis, Paris. Protesting warders blocking access to Europe's biggest jail are fired at with tear-gas by police moving in to dismantle barricades. There was a nationwide protest by warders over overcrowding, staff shortages and deteriorating conditions in prisons, which had led to a wave of inmate suicides. Olivier Jobard

Overleaf: 11 April 2011, London. Women wearing Islamic *niqab* veils demonstrate outside the French embassy against France's decision to ban the wearing of the veil and the detention of two women in Paris under the new law. Peter Macdiarmid

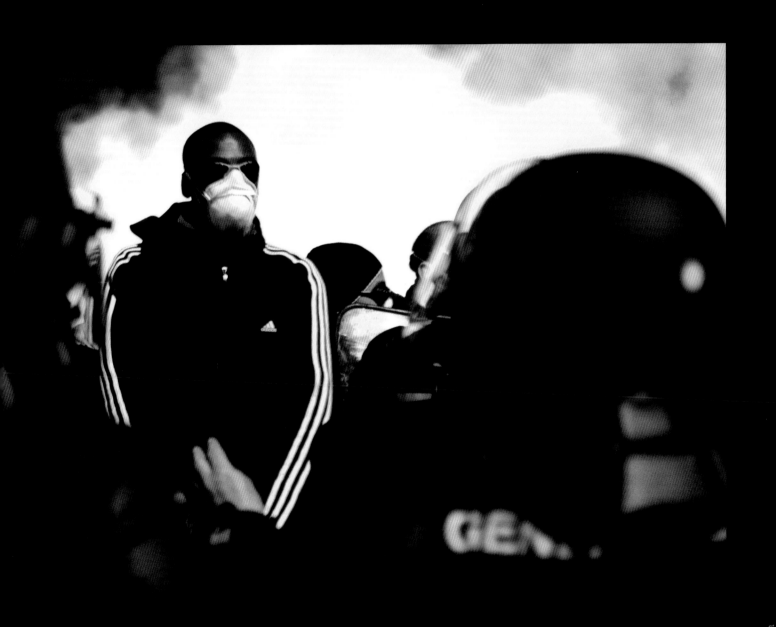

Idealists
and
Activism

The Ramparts Wall Poster

(CEDAR BEGINS TO FALL (FIRE)

TEAR GAS IN
THE PUMP ROOM

(SOBER)

BY JAKE MCCARTHY
© 1968 The Daily Wor...
THE PUMP ROOM — BEFORE THE...
IN CHICAGO WAS AN INDEX, WAS A SYMBOL OF
AND TELEVISION FILM SHOWED IN CHIC...
THE WORST HAPPENED THROUGH THE...
FALL 1968...

Idealists and Activism

If there have always been anti-war campaigners, the advent of nuclear weapons gave obvious additional impetus to peace movements. This was hardly a surprise. By the late 1950s, the nuclear powers between them had sufficient stockpiles of weapons to blow up the world several times over. But while, at any rate in theory, "Mutually Assured Destruction" carried its own safeguards by making nuclear conflict unthinkable, the threat was nonetheless such as to make protest against it a moral imperative for many people – although only in the West. The Soviet Union clamped down absolutely on those who might have been tempted to protest against its own military adventures. (After its invasion of Afghanistan in 1979, despite being embroiled in what turned out to be its own version of Vietnam, the Soviet Union never had to contend with the massive popular protests that eventually forced the United States to cut its losses in Southeast Asia.)

It was also the case that until the Cuban missile crisis in October 1962, when the unthinkable – nuclear war – briefly seemed only too plausible, there was relatively little anti-nuclear protest in the United States. Americans in general, conscious of their role as leaders of the free world, were hardly likely to object to their own military potency, especially given their ingrained anti-Communism. It was Europe that saw the most sustained early campaigns against nuclear weapons. Although eminently respectable and certainly well-meaning, these were always vulnerable to the charge that they were anti-Western and, by extension, pro-Soviet. However

indignantly denied, it was a claim that turned out to be in effect largely true. Among much else, the extent to which Moscow had coordinated and financed anti-nuclear movements in the West became clear after the fall of the Soviet Union in 1991. Post-war protest movements in the West often had difficulty distinguishing between the freedoms that sustained them and what sought to overthrow them in the guise of encouraging them.

The best-known of these crusading movements was the Campaign for Nuclear Disarmament (CND), founded in Britain in 1957. High-minded and earnest, CND achieved a media coup with its Easter marches from London to the Atomic Weapons Research Establishment in Aldermaston, Berkshire, 83 kilometres (52 miles) from the capital.

In 1981, Britain and much of Europe were engulfed in another wave of anti-American anti-nuclear protests. It was sparked by the Reagan administration's decision to install cruise missiles in Europe to counter the Soviet deployment of SS-20 nuclear missiles. As Reagan's initiative had been energetically supported by the other totemic hate figure of the left, Margaret Thatcher, the response was an upsurge of left-liberal opinion. This took its most extreme form at the US airbase at Greenham Common in Berkshire in the south of England. Here, in September 1981, a Women's Peace Camp was established. It lasted until 2000. The Peace Camp was the embodiment of well-meaning progressive opinion, notions of peace embroidered by feminist demands in which the West rather than the Soviet Union tended to

be demonized. The Peace Camp made further headlines in April 1983 when a 23-kilometre (14-mile) human chain was organized around the entire airbase. At much the same time, membership of the otherwise languishing CND more than doubled.

Of infinitely greater significance was the earlier mobilization of American popular opinion against the Vietnam War. Part of the general liberation that swept the West in the late 1960s – in music, in politics, in sexuality – it proved equally irresistible. In the case of the anti-war demonstration at Ohio's Kent State University in May 1970, it also proved fatal, and the killing of four students there by the National Guard more or less guaranteed a radical re-evaluation of America's role in Vietnam. As early as April 1967, 400,000 had attended a rally in New York against the war (on the same day, 100,000 demonstrators took part in a parallel march in San Francisco). In October the same year there was a massive anti-war demonstration in Washington, DC. The protests were by no means confined to the US. In March 1968 there was violent rioting in Grosvenor Square, site of the US embassy in London. The Paris protests that May included a significant anti-war element. In October 1969, half-a-million attended an anti-war rally in Washington. By May 1971 approval ratings for the war had fallen to 28 per cent. Counter-culture had met mainstream middle-American opinion. That said, a victory march in April 1970, which supported the war, drew 50,000 demonstrators to Washington, DC.

The collapse of the Soviet Union in 1991 and the consequent easing of East–West tensions took

much of the sting out of the peace movement in the West. But the Gulf War of 2003 ramped up protest again. Whereas the first Gulf War in 1990–91 saw a broad coalition united in common purpose against the clearly illegal invasion of Kuwait by Iraq and, consequently, broad agreement as to its validity, the second provoked a bitter backlash against the intended invasion of Iraq by a new US-led coalition. On 15 February 2003, there were coordinated protests in 800 cities across the globe. In London alone, one million took to the streets. Against a background of popular protest on this scale, Western governments were always on the back foot, whatever their military might. The reputations of the two most hawkish Western leaders, George Bush and Tony Blair, never recovered. Predictably attempting to exploit this anti-war sentiment, Iraq immediately organized its own demonstrations. Few saw them as more than state-orchestrated propaganda.

The establishment of Women for Peace, later renamed the Community of Peace People, in Northern Ireland in 1976 was genuinely a grassroot activist response to the province's seemingly unstoppable cycle of sectarian violence. It was founded by Betty Williams, a Protestant, and Mairead Corrigan, a Catholic and aunt of three children who had been killed by a car driven by an IRA getaway driver, himself later shot. The cross-sectarian support they received made headlines across the world and saw both awarded the Nobel Peace Prize in 1976. Yet as of mid-2011, renewed violence in Northern Ireland underlined the almost insuperable difficulties of reconciling two communities sundered by almost 400 years of bigotry-fuelled intolerance.

A similarly striking instance of ordinary women awakening shamed consciences was provided by the Mothers of the Plaza de Mayo in Argentina, formed in 1977. Perhaps 30,000 young Argentinians were rounded up, often tortured and then murdered by a series of authoritarian Argentinian governments in the so-called Dirty War of 1970–83. These were the "disappeared". Even moderate Argentinian governments have proved reluctant to concede the State's obvious role in this systematic extermination of its opponents.

Since at least the 1970s, a new group of activists has emerged: environmentalists. Their sincerity can hardly be doubted, nor their skill in using protest to effect. Yet what were once fringe groups have since moved centre-stage, their influence swelling with their funding. The likes of Greenpeace and Friends of the Earth have been transformed into special-interest lobbying groups of substantial influence. As an ironic consequence, green activism, certain of its moral superiority, has looked increasingly strident. That said, it has lost nothing of its campaigning intelligence and effectiveness. At the same time, the cack-handed sinking of Greenpeace's flagship, *Rainbow Warrior*, in Auckland, New Zealand, in 1985 by French special agents only reinforced the certainty of green movements that an unholy combination of big business and unscrupulous government was ranged against them.

The near meltdown of the US nuclear plant at Three Mile Island in 1979, followed in 1986 by the explosion of the Chernobyl nuclear plant in the Soviet Union, fed the apocalyptic tendencies of some in these and similar green organizations. That in both cases the death tolls never approached the numbers claimed as certain did nothing to lessen anti-nuclear sentiments. No-one died as a result of the Three Mile Island meltdown; the Chernobyl death toll was 57. However, long-term consequences may be another matter. While in 2005 the UN reported "no evidence of a major public health impact attributable to radiation exposure" from Chernobyl, a 2011 report by the European Committee on Radiation Risk suggested the eventual death toll may reach 1.4 million. Reactions were similar when the Fukushima nuclear reactor was put out of action by the tsunami that swept northern Japan in March 2011: fortunately there have been no deaths as a consequence of radiation yet, but the situation will be monitored by many for years to come.

Climate change, or global warming, with its creed that humanity is causing irreversible damage to the Earth's climate for short-term economic advantage, is the current rallying point of green activists. The heart of the green claim is that the science is settled and the consequences of this disruption of the Earth's climate will be calamitous. But the issue continue to give rise to vocal polemicists on both sides. Politics, inevitably, intrudes, and there is a great deal at stake – emotionally as well as financially. But whatever the focus, the fact that so much of the agenda is set by environmentalist groups underlines their success as the heirs of the political radicalism of the 1960s.

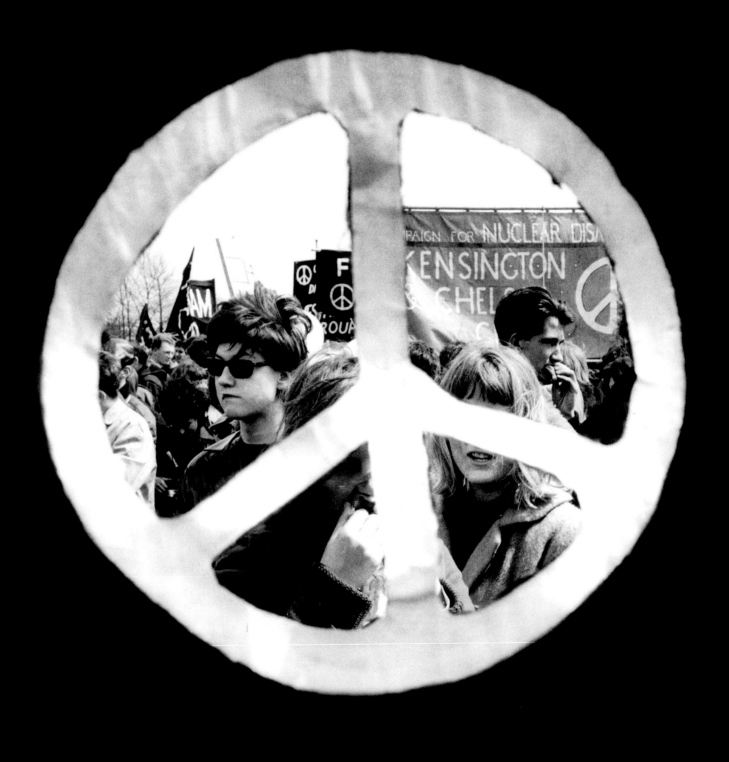

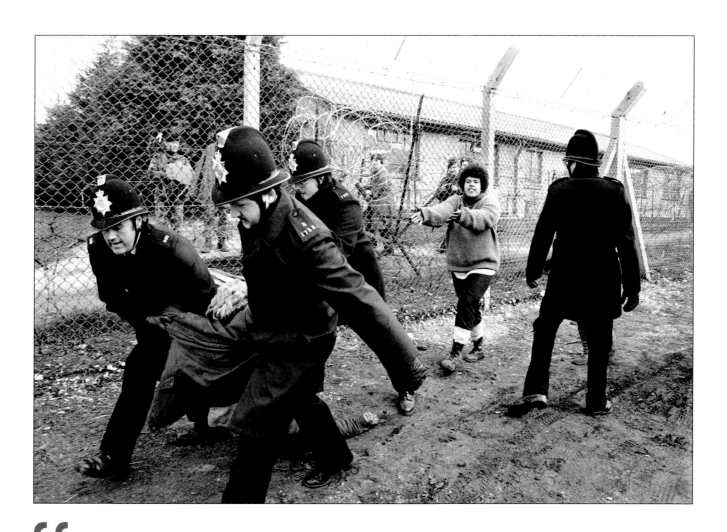

I spent quite a bit of time photographing the arrival of "cruise", the protest went on for a long time. At the beginning there was a lot of media activity but eventually it settled down and the women were in for a very long haul. It was an intimidating place to photograph. One American news anchor made the mistake of asking the women to stop chanting and singing during a broadcast and they proceeded to dance around him and his crew with balls of wool, weaving in and out of them, binding them up in a web of wool and eventually the guys couldn't move. It was very funny. You had to be diplomatic with them.

Occasionally the council would try to evict the women around the camp and this picture is from one of those times. The police would arrive with court orders and take down the shelters outside the gates. It made little difference, the women were back within 24 hours.

Greenham was a wonderful example of protest at its best. It was non-violent and caused maximum embarrassment for the government. It's a great lesson in how to do it. The women at Greenham were the first protesters to use the law to fight the council and government. Throughout they maintained the respect of normal people.

Tom Stoddart

Opposite: 21 April 1963, between Aldermaston in Berkshire and London. Headed by the Campaign for Nuclear Disarmament (CND), anti-nuclear protest marches covering the 83 kilometres (52 miles) between the Atomic Weapons Research Establishment near Aldermaston and London were held regularly from 1958 onwards. Photographer unknown

Above: 1 December 1983, Greenham Common air base, Berkshire, England. A woman protesting against deployment of nuclear missiles at the base is arrested. The Greenham Common Women's Peace Camp was set up beside the base in 1981, and lasted in some form, despite evacuations, for 19 years, even after the removal of the last missiles in 1991. At its peak in the early 1980s it involved tens of thousands of women. Tom Stoddart

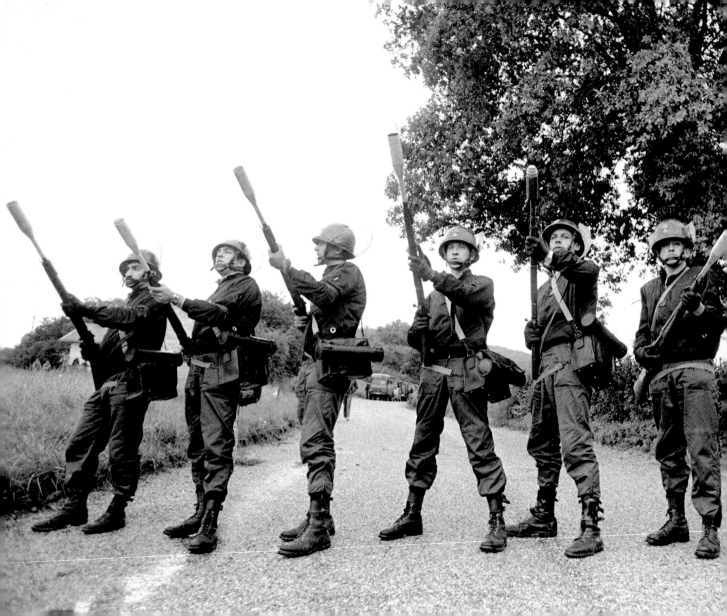

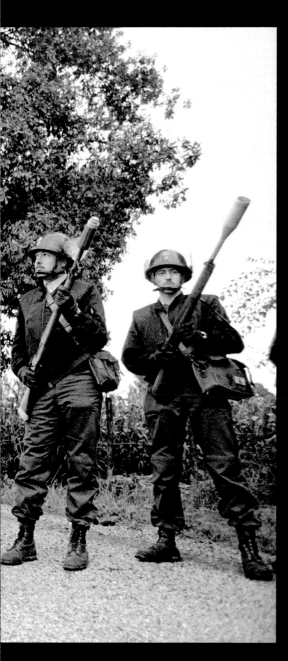

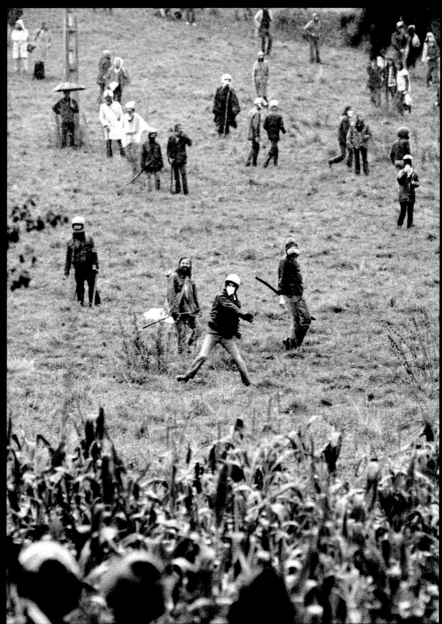

Above left and above: 31 July 1977, Creys-Malville nuclear power plant, Isère *département*, France. The two sides of a confrontation between French riot police (left) and 60,000 European anti-nuclear activists (right) protesting against the Superphoenix fast-breeder reactor at the site, a plant run by one of the world's largest nuclear-

Left: 1 October 1969, Central Park, New York City. A student protester carries a placard making his feelings plain during a large anti-Vietnam War rally. Bernard Gotfryd

Above: 1965, New York City. Young men burning their draft cards in protest against the Vietnam War and compulsory military service. Hiroji Kubota

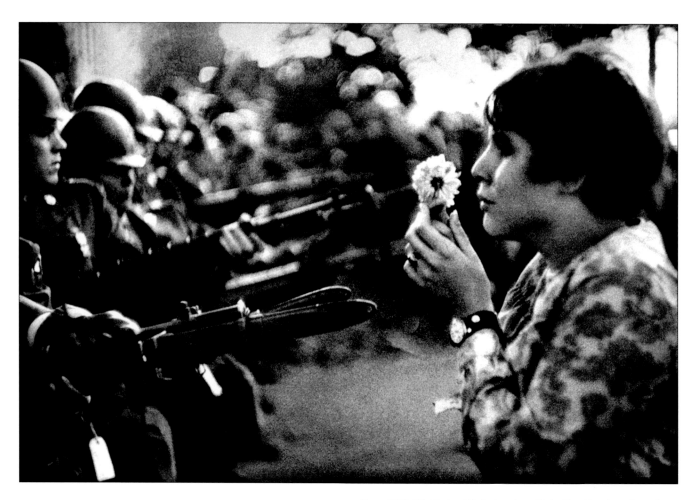

Above: 1967, Washington, DC. An American girl, Jan Rose Kasmir, confronts the National Guard outside the Pentagon during an anti-Vietnam War protest. This march helped to turn US public opinion against the war. Marc Riboud

Right, top: 1969, Washington, DC. Anti-Vietnam War demonstration. That year, around two million Americans took part in protests across the land. Bruno Barbey

Right: 1968, Central Park, New York City. Anti-Vietnam War demonstration. The eagle symbolizes the American nation. W. Eugene Smith

Far right: 11 May 1970, Wall Street, New York City. The "Hard Hat Riot", begun by construction workers, was a counter-protest in support of the war. The "red mayor", New York's John Lindsay, had refrained from clamping down on the anti-war movement. W. Eugene Smith

Overleaf: 1971, Washington, DC. Protesters against the war in Vietnam now included veterans back from the front, some of whom had been prisoners of war. Leonard Freed

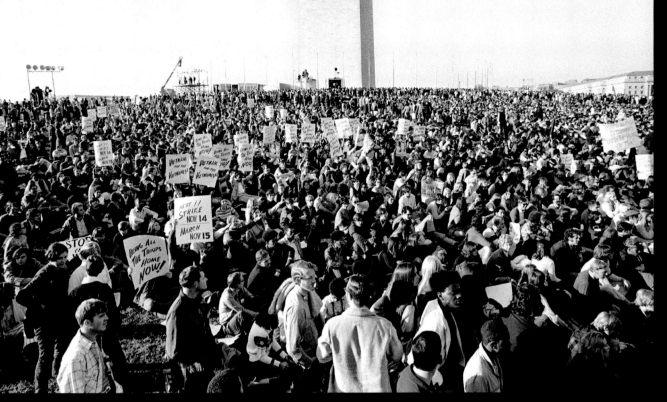

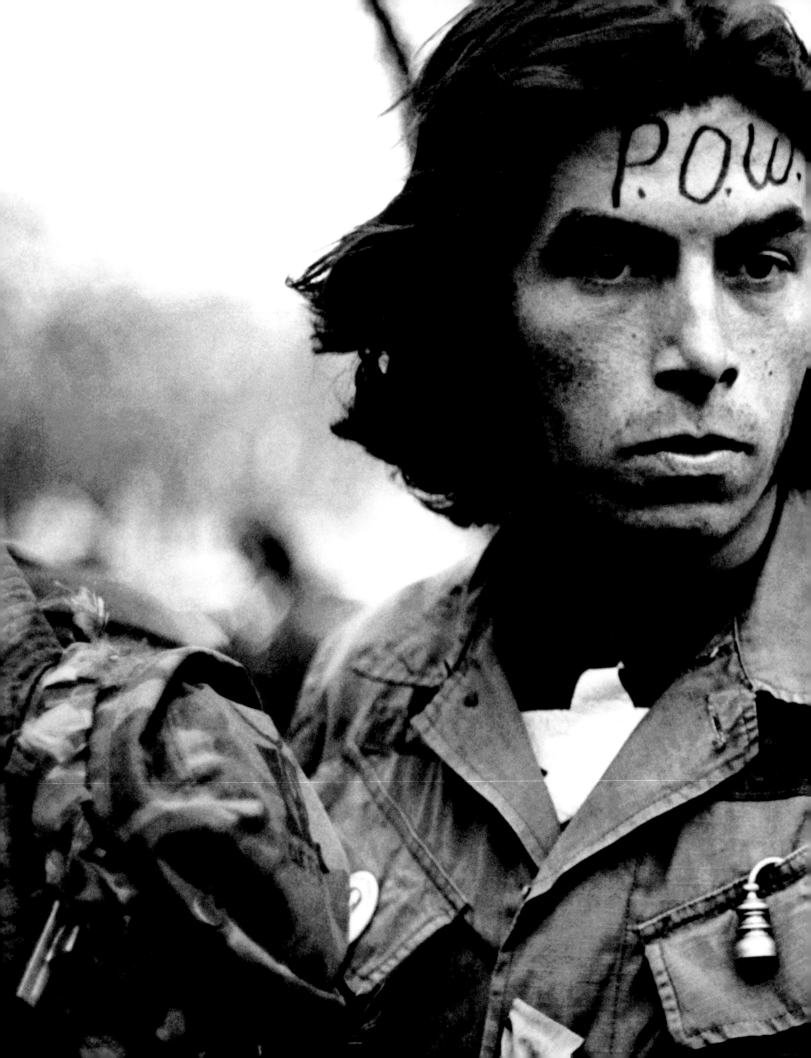

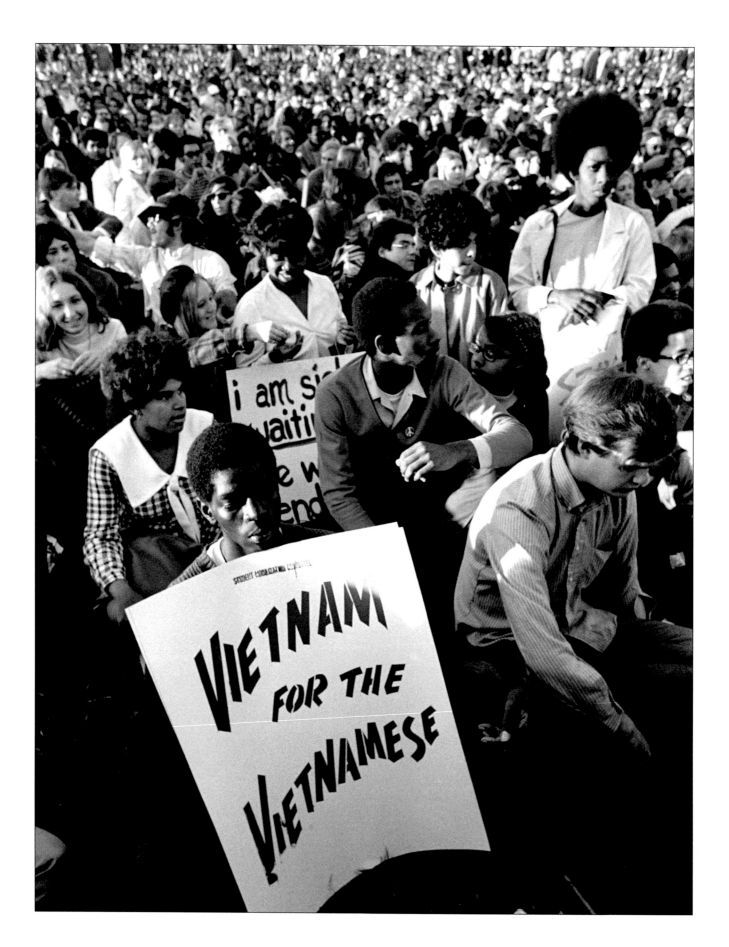

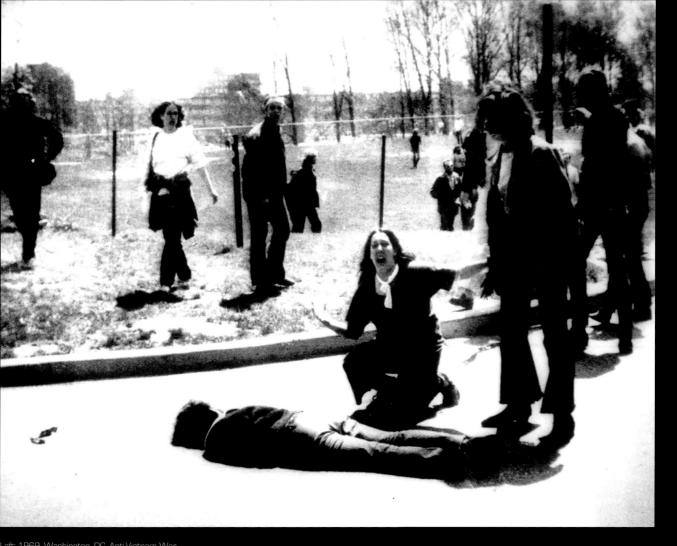

Left: 1969, Washington, DC. Anti-Vietnam War
demonstration. Protesters came from all parts of
the American melting pot: from diverse cultural
backgrounds, classes and racial groups. Bruno Barbey

Above: 4 May 1970, Kent State University, Kent, Ohio.
Mary Ann Vecchio kneels by the body of a student shot
dead by National Guardsmen who fired into a crowd of
anti-Vietnam War demonstrators, killing four. John Filo

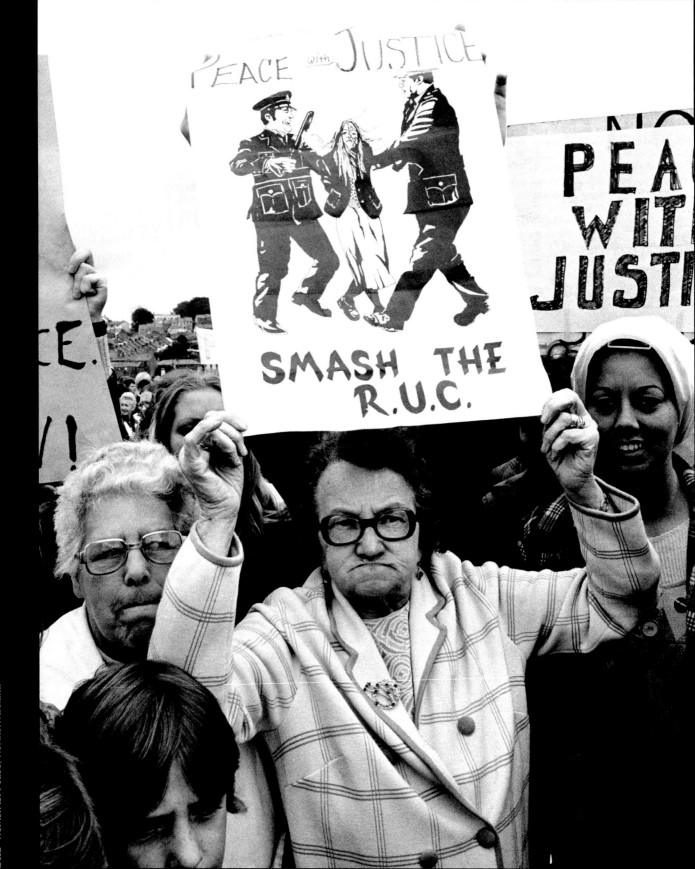

The poster text within image: "PEACE with JUSTICE", "SMASH THE R.U.C.", "PEACE WITH JUSTI", "CE.".



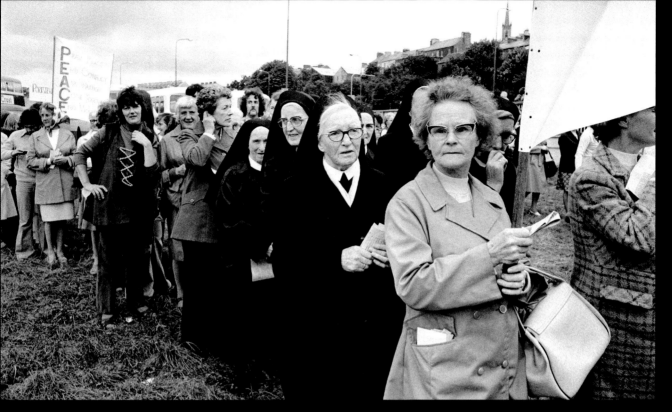

Left and above: 1976, Londonderry, Northern Ireland. A protest organized by the Women for Peace movement, later renamed Peace People. The movement, which began that year, brought together Catholics and Protestants in an attempt to overcome differences and end violence from extremists on both sides. Two of its founders, Catholic Mairead Corrigan Maguire and Protestant Betty Williams, were awarded the 1976 Nobel Peace Prize. Peter Marlow

Below: 21 November 1977, San Martin Square, Buenos Aires, Argentina. Members of the Mothers of Plaza de Mayo, whose children "disappeared" in 1976–83, staging their weekly protest. Photographer unknown

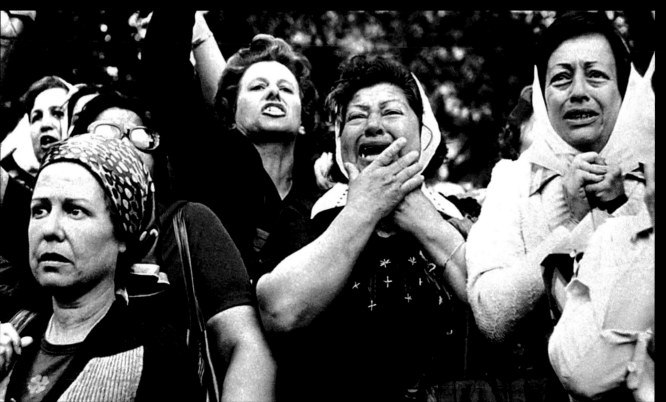

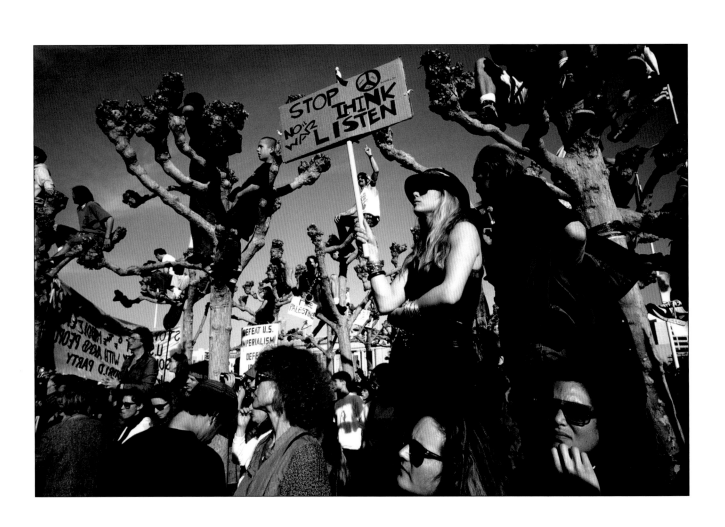

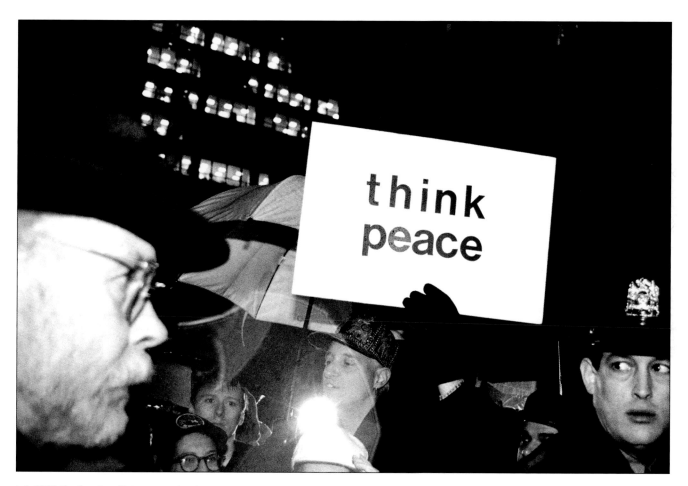

Left: 1991, San Francisco. Protestors against the Gulf War even climb leafless trees to make their point dramatically. Paul Fusco

Above: 1991, USA. Protesters demonstrating against the Gulf War. Erich Hartmann

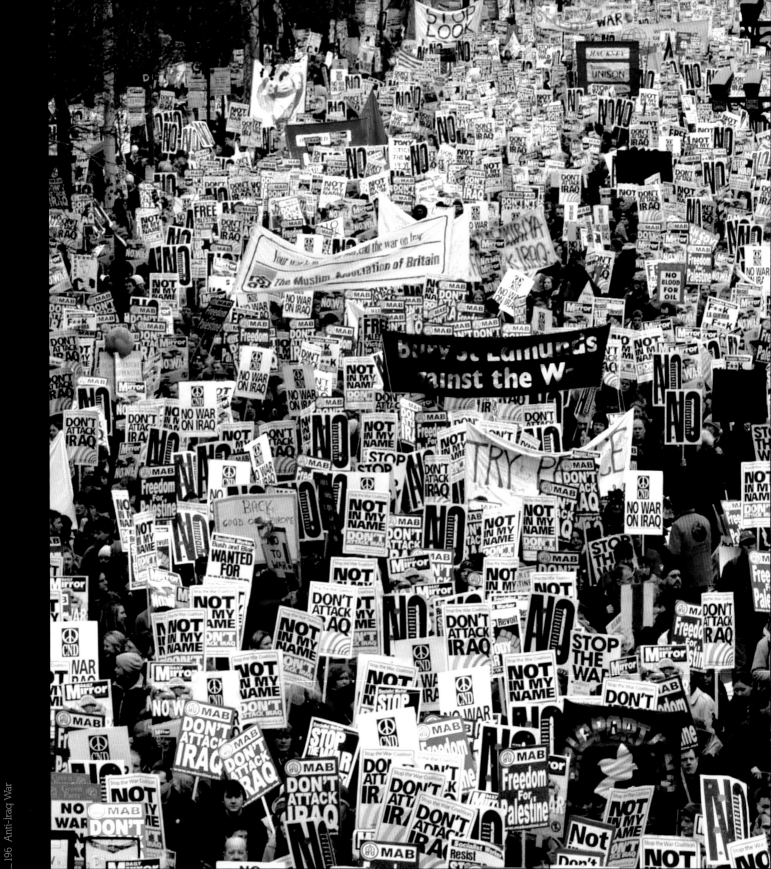

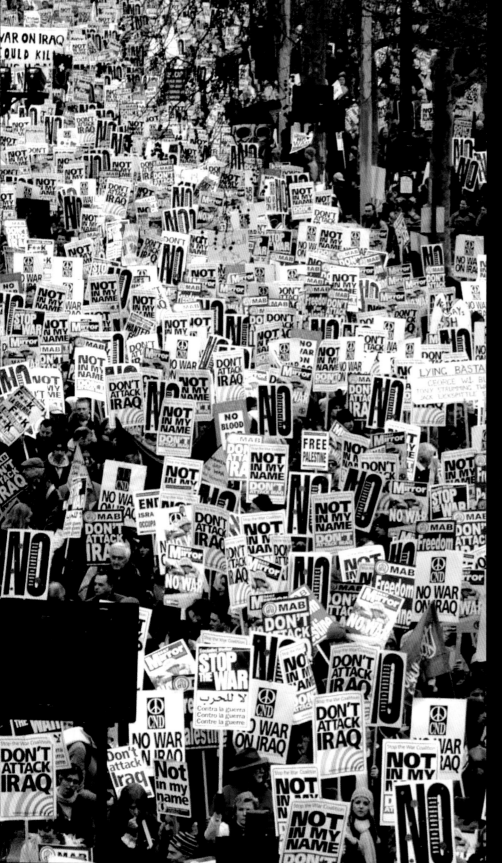

"

The build-up to the war in Iraq was in full swing when over a million people crowded the streets of London to march against it. Unlike in the US, there was never much belief in the UK in the reasons given for the invasion, and the cynicism and anger of the marchers was palpable as wave after wave of them streamed past my position. This demonstration dwarfed all those that I have photographed, before or since. Everywhere you looked there was a wall of people, it actually made it very difficult to get a good picture and the only way to try to give some feeling of its power and size was to get a position looking over it. This photograph was taken from a bridge near Embankment at the beginning of the demo. I like the surveillance cameras, high above the demonstrators. There is never really any doubt in the UK that you are being watched a large part of the time, and there was no doubt that the government saw the strength of feelings ranged against them. Despite this, there was a bittersweet feeling in the air, as most people realized that despite the enormity of the turnout, the government were locked on course and would more than likely not take a blind bit of notice.

Andrew Testa

"

Left: 15 February 2003, Piccadilly, London. This demonstration against the Iraq War was the largest march to date in British history. Andrew Testa

"197 Anti-Iraq War"

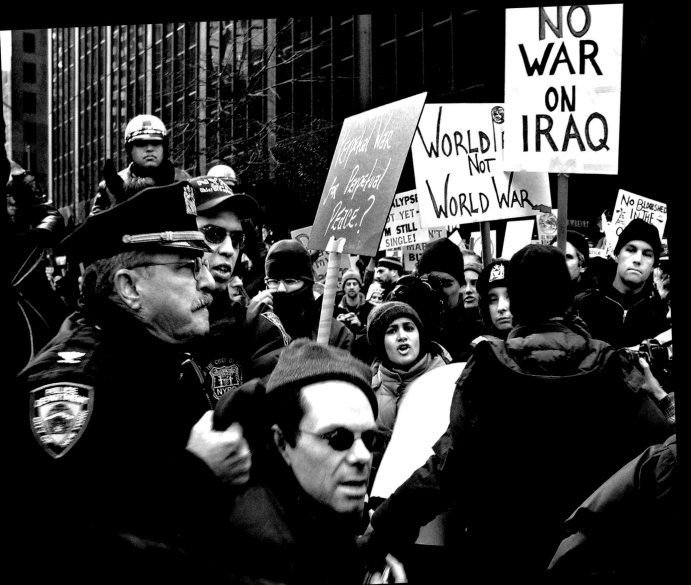

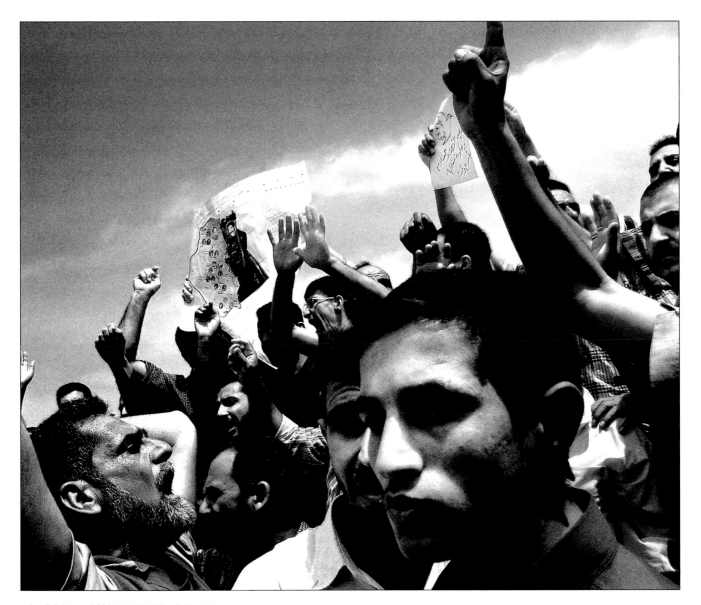

Left: 15 February 2003, New York City. Police try to
control protestors during demonstrations against the
Iraq War. Alex Majoli

Above: 13 April 2003, Baghdad, Iraq. Protestors
chanting anti-war and anti-President Saddam slogans
in front of the Sheraton Hotel, where US marines
stood guard. Alex Majoli

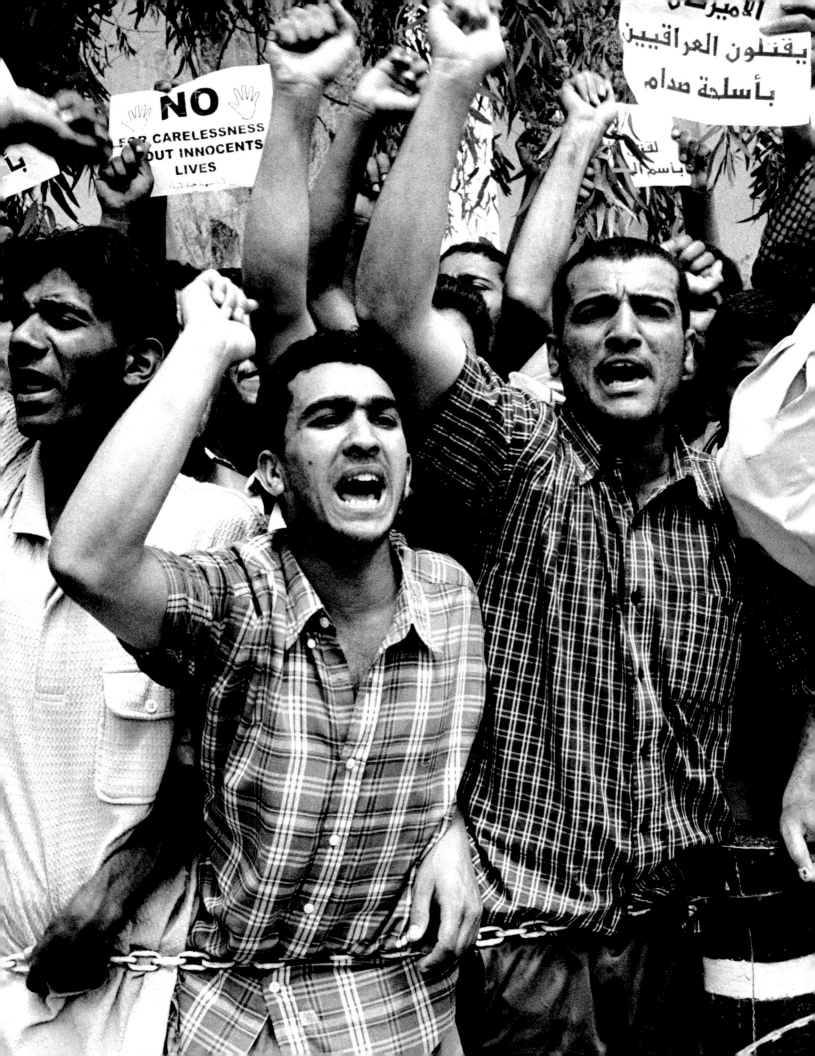

Left: 2003, Baghdad, Iraq. Shia Muslim militants
demonstrate against the occupation of Iraq by US
armed forces. Abbas Attar

Above: 7 November 2003, Baghdad, Iraq. Near
coalition forces' headquarters, around 500 Iraqis
chant anti-American slogans in protest against the
arrest of 36 clerics. Kharim Ben Khelifa

"In the early 1970s a group of American expatriates and Canadian pacifists borrowed a Quaker tactic and sailed protest boats into nuclear test zones. We began thinking that citizens needed to expand peace and human rights actions to defend nature's rights. The peace group The Don't Make a Wave Committee began staging ecology actions and became "Greenpeace". In 1975, we set out in a fish boat to disrupt whalers. I learned to stand up in a moving inflatable boat, with a rope around my waist, to take photographs. After two months at sea, we intercepted a Russian whaling fleet, used our inflatables to shield whales, and I took these photographs."

Rex Weyler

Left: 1975. Approaching the Russian whaler *Vostok*. Rex Weyler

Above: 1976. Whale flukes on a Russian ship. Rex Weyler

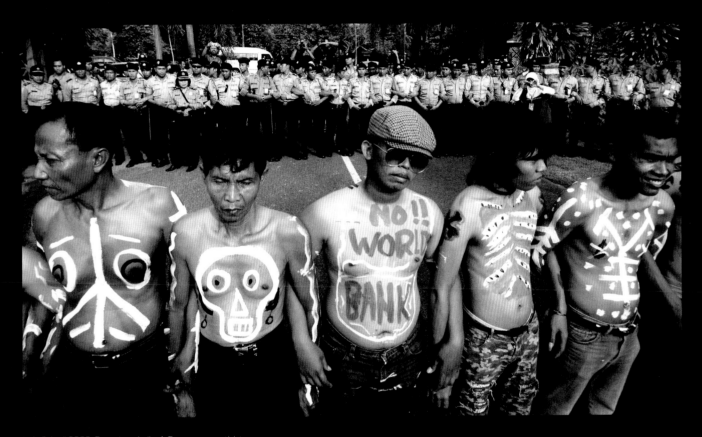

Left: 9 April 2008, Bangalore, India. A Greenpeace activist takes part in the People-in-Blue campaign, which warned that if greenhouse-gas emissions continued at the same rate, there would be a significant rise in global temperature and the South Asian region could face a wave of migrants displaced by the impacts of climate change, including sea-level rise, drought and monsoon variability. Manjunath Kiran

Above: 7 December 2007, Nusa Dua, Bali, Indonesia. Local environmentalists demonstrate at the UN Climate Change Conference, which was trying to lay the groundwork for a new agreement on tackling the problem. Sonny Tumbelaka

Overleaf: 14 December 2007, Nusa Dua, Bali, Indonesia. Environmentalists from around the world demonstrate at the UN Climate Change Conference. Talks on combating climate change were mired in bitter rows over how far various countries would commit to curbing greenhouse-gas emissions. Officials haggled deep into the night, with the United States on one side and the European Union and developing countries on the other. Jewel Samad

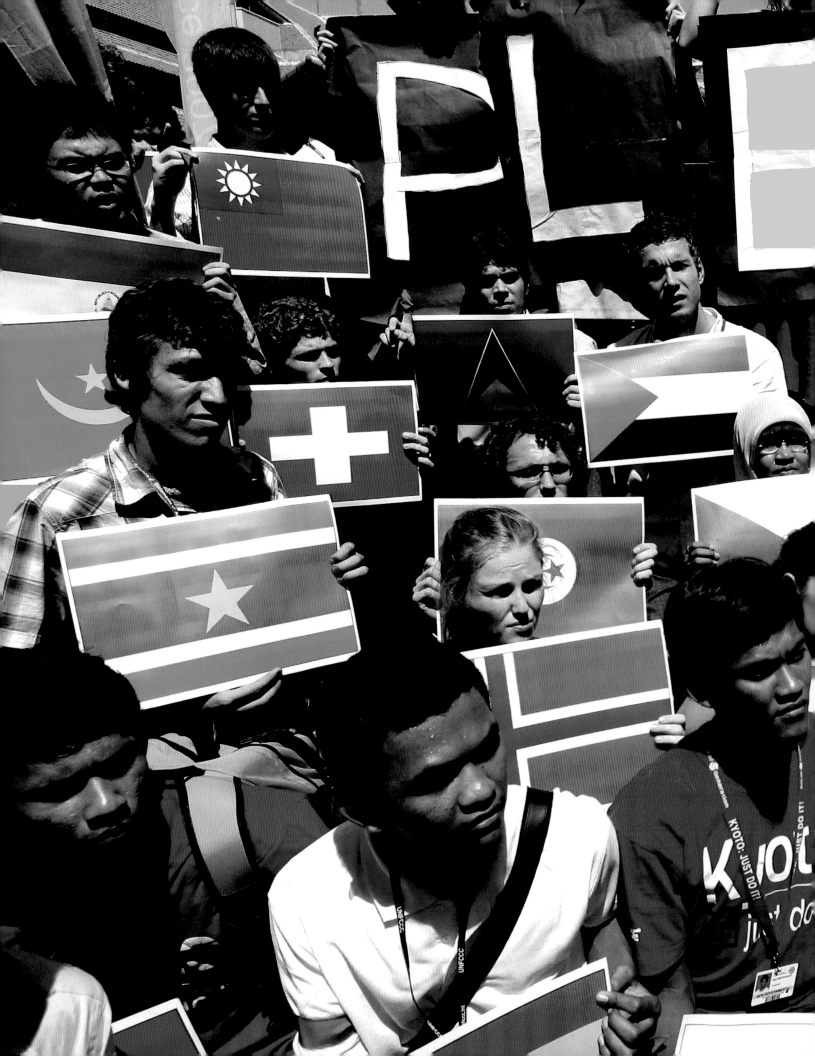

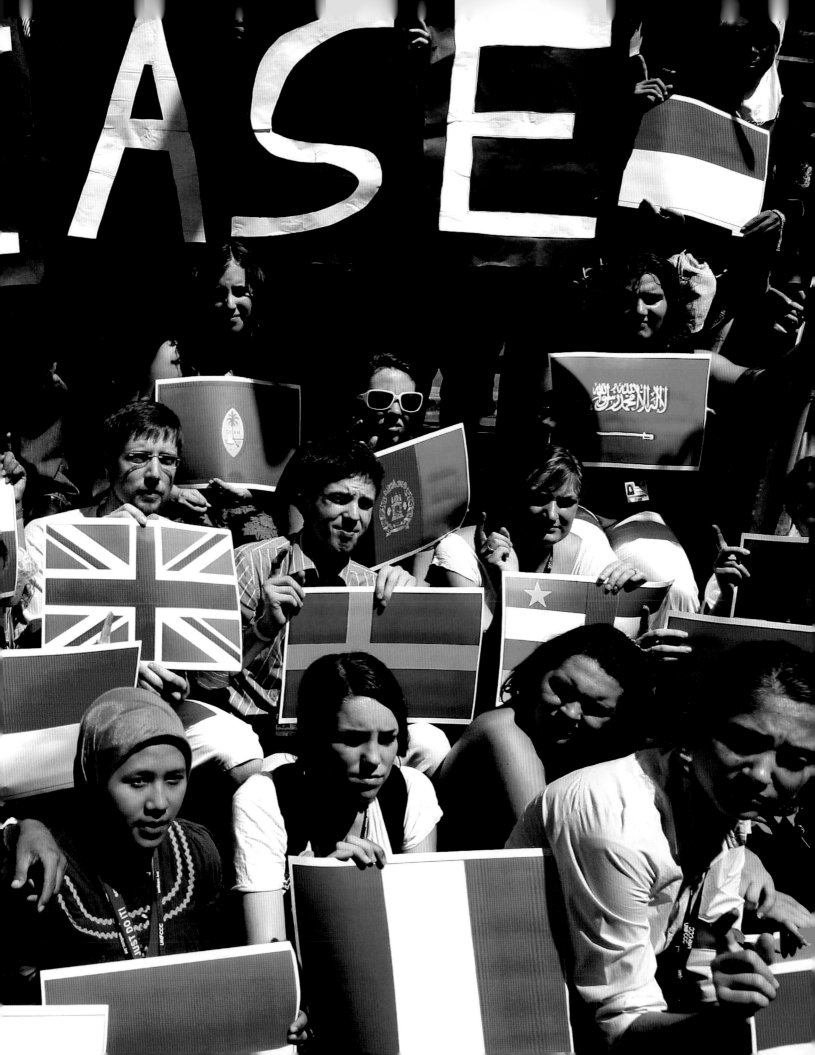

Credits

Acknowledgements:

The publishers would like to thank the following people for their valuable assistance with the preparation of this book:

Julian Alexander and Ben Clark, Lucas Alexander Whitley Ltd

The photographers who kindly gave their time to provide quotes for the book: Alfredo d'Amato, Bruno Barbey, Ben Curtis, Corentin Fohlen, Stuart Franklin, David Hoffman, Karim Ben Khelifa, Andrew Kaufman, Joseph Koudelka, Paul Lowe, Peter Marlow, John Moore, Mads Nissen, Ivor Prickett, John Sadovy, John Stanmeyer, Tom Stoddart, Andrew Testa, Ami Vitale, Rex Weyler

The picture agencies and researchers who went the extra mile: Chris Barwick, Jonathan Bell (Magnum), Paula James (Panos), Hayley Newman, Martin Gibbs & Caroline Theakstone (Getty Images), Suzy Cooper & John Moelwyn-Hughes (Corbis), Greg Watts (Rex Features), Laura Wagg & Lucie Gregory (Press Association Images), Neil Burgess (NB Pictures), Kim Lee (Reuters), Tracey Howells (Photoshot)

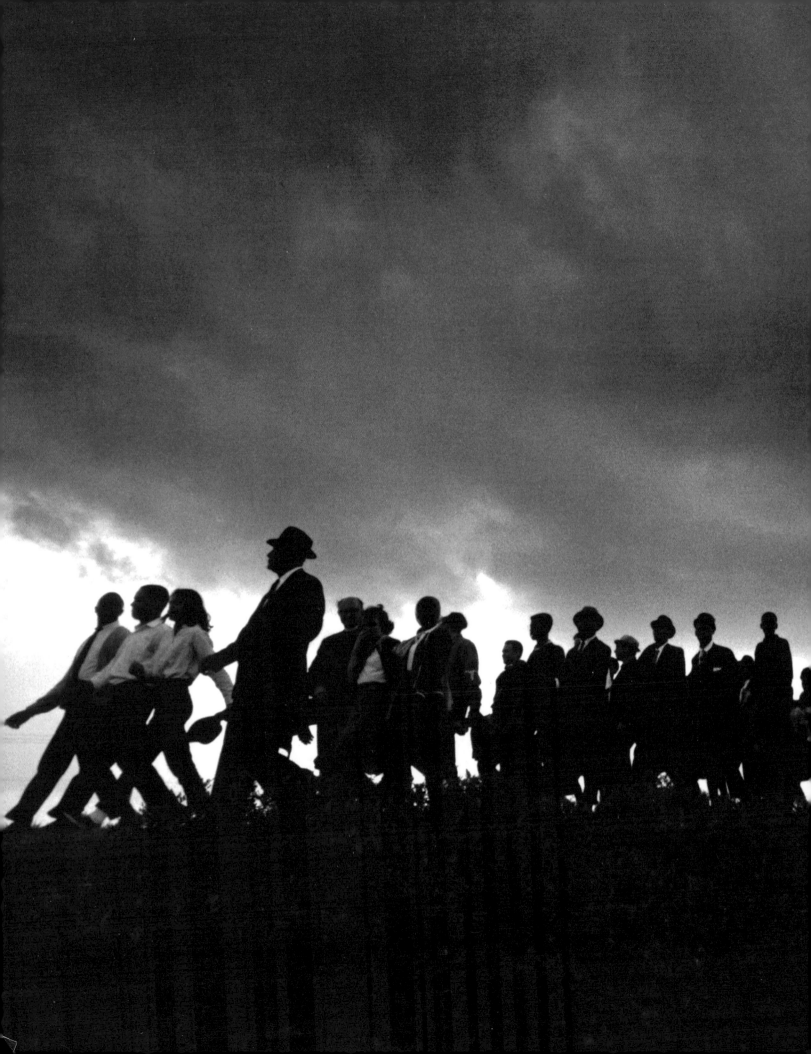